IMAGES
of America

ARLINGTON
175 YEARS

No. 169 Arlington. C. M.

Dobell's Selec. Arr. from Thomas A. Arne

1. Christ is the way to heav'n-ly bliss, And Christ the on - ly door;
2. 'Tis thru this door, and this a - lone, That thou art led to God;
3. Je - sus will guide thee on to heav'n And give thee en-trance in.

My soul pur - sue no way but this, For this a - lone is sure.
Then rest on what The Lord has done, And plead His pre-cious blood.
And God will own thy sins for-giv'n, How - ev - er vile they've been.

ARLINGTON NAMED, 1844. Arlington was named by founder Robert Hurd after his favorite religious hymn from the Presbyterian hymnal. Hymn No. 169 shown above is one of several hymns that use the "Arlington" common meter tune. The meter for the tune is 8.6.8.6, and the arrangement was by the famous English composer Thomas A. Arne. It is not known which hymn titled "Arlington" was Hurd's favorite. (Courtesy of Don Steinman.)

On the cover: TOLEDO AND OHIO CENTRAL RAILROAD STATION. A steam locomotive prepares to stop at the Arlington railroad station in the early 1900s on the old Toledo and Ohio Central Railroad line. The track was laid through Arlington in 1889 and would become an important factor in the growth of the town. It provided rail transportation for both people and freight moving in and out of the area. (Courtesy of Leslie Lazenby-Hunsberger.)

Jemima. This is an incredible program that helps Dad's learn how and what to write to their children wives and loved ones. The primary reason is for Dad's to leave a written legacy for theirs. I am very excited about it and hope to introduce it to our congregation soon.

March 23, 2009

Dear Tom and Judy

It's a shame I didn't find this sooner!

I am sure Aunt Virginia would have really
enjoyed reading it. It's more than just
a coincidence that I should happen
on this book at a Walgreen in Columbus
Ohio! And imagine the surprise of

...publisher wrote he finds that
all your books on Arlington, Ohio
have been sold.'

Though I've not been anywhere near
as prolific as Aunt Virginia, I do
enjoy writing. Recently I became
"certified to hold) Letters from Dac)"

the thought of producing the "Fires of memories" from Aunt Virginia. I'm sure you'll see some of the tales and place the mentioned in this book.

I hope you enjoy it. You'll see the Wagner family represented on page 19.

Many Blessings to you,

Vic

IMAGES
of America

ARLINGTON
175 YEARS

Eagle Creek Historical Organization
and the PACE Students of Arlington School

ARCADIA
PUBLISHING

Published by Arcadia Publishing
Charleston SC, Chicago IL, Portsmouth NH, San Francisco CA

Printed in the United States of America

Library of Congress Catalog Card Number: 2008920499

For all general information contact Arcadia Publishing at:
Telephone 843-853-2070
Fax 843-853-0044
E-mail sales@arcadiapublishing.com
For customer service and orders:
Toll-Free 1-888-313-2665

Visit us on the Internet at www.arcadiapublishing.com

*This book is dedicated to those people who worked so hard to prepare for
Arlington's first history book in 1984 in celebration of the town's 150th
birthday. It is also dedicated to the old pioneer families who settled this
area, many of whose descendants still call the Arlington area their home.*

CONTENTS

ACKNOWLEDGMENTS

The Eagle Creek Historical Organization (ECHO), founded in 1988, is a nonprofit history organization dedicated to researching, documenting, and preserving the history of southern Hancock County. It was the current ECHO president Don Steinman's idea to write this book for the community. He has spent countless hours culling through information and photographs from his own historical collections to write sections of this book. Tom Kroske, current ECHO treasurer, shared his great storehouse of town information gleaned from his years growing up in town and as a town businessman and former fire chief. His help writing captions, proofing, and running errands were invaluable. Another integral part of the team was our enthusiastic photographer, Leslie Lazenby-Hunsberger, who extended the hours of her studio, Imagine That, to work with us. She also shared her archives of historic Arlington pictures and moved everything to higher ground when the floodwaters came in August. We also wish to thank everyone from ECHO and the community who submitted pictures and provided information.

The Arlington School Program Alternatives and Curriculum Enrichment (PACE) class and teacher, Deb Anderson, were excited to team up with ECHO on this project. The students studied the local history book and interviewed longtime Arlington residents and local businessmen to gather facts for the project and then worked on the computers writing captions and organizing photographs for the layout.

The students involved in this project were sixth graders Allie Begg, Andrew Hunter, Koltin Marquart, Ryan McDowell, Arden McMath, Sara Oler, Beth Anne Palmer, Brittan Reichley, Tyler Starr, and Alyssa Willow; fifth graders Hunter Bernhardt, Justin Rice, Aaron Starr, and Travis Whitaker; and fourth graders Lauren Alexander, Michael Bils, Zach Carman, Abbey Dempster, Haley Dillon, Zachary Durliat, Cody Essinger, Dylan Frazier, Matthew Glick, Shayna Helms, Patrick Kessler, Lydia Sorensen, Taylor Vogelsong, and Alyssa Wallwey.

We would like to extend our thanks to those who live in our hometown who have shared their knowledge and time with us and to Arlington School for its support and use of technology.

And, finally, thanks to Arcadia Publishing for believing in us and giving us the opportunity to make this book.

INTRODUCTION

As Arlington prepares to celebrate its 175th birthday in 2009, we can only imagine what the early settlers of our area saw on arriving here in 1834. A heavily forested area with a small stream running through it probably seemed to be an ideal place to put down their roots. After all, owning a piece of America, land of the free, has always been a dream for freedom-loving people everywhere. They probably imagined that someday it would be a thriving city with all the attributes of the finer cities of the eastern seaboard.

Arlington never quite reached city status. You would have to qualify it as a small town or village. With many new homes being built, the population today is roughly 1,400 people, the highest it has ever been. Many rural people retire here from nearby farms, and it serves as a bedroom community for people who work in area cities.

Using today's prevailing attitude of "bigger is better," you could say that Arlington has not lived up to the early expectations of its forefathers. We tend to disagree, and argue that small-town living and a rural lifestyle is what life is all about. There is no better place to raise children. They can be in numerous activities in the local school, and the education they receive there prepares them well for adulthood. The environment here can be considered extremely safe, witnessed by the fact we have no police force. The community's park and swimming pool provide wholesome summer activities. The area is heavily churched, providing the spiritual emphasis needed to make outstanding communities. There is no question that life in present-day Arlington revolves around the churches, school, and community park.

In the 1830s, 1840s, and 1850s, the lifestyle in Arlington and the surrounding area was basically rural, and farming was almost everyone's occupation. The town was the business center of activity that supported the rural lifestyle. By the 1860s, general unrest in the country brought on the Civil War. Many area men joined the Union army. Some never made it back to the area they called home. Arlington can be proud of the Civil War heritage these men provided.

The 1870s marked little change in the town's growth, but by the 1880s, changes were coming. The railroads played a big part in the growth of the town, with two railroads dissecting the town. Business growth became evident, and people started discovering Arlington as a progressive town, with jobs available and good living conditions.

The 1890s and early 1900s brought continued growth with businesses and mills employing large numbers of people. The second decade of the 20th century brought telephones and the town's own electric system, and a number of local men fought in World War I.

Social changes highlighted the early 1920s, and this period ended with tough economic times. But people were still progressive and hardworking and pulled together to make Arlington a hub

of business activity. Progress was made in education with the consolidation of the area one-room schools into a centralized new school building that was the pride of the community.

By the time the 1930s rolled around, Arlington was a bustling town. People needed jobs to survive in the tough economic climate, and they found them at the numerous businesses in the town. People lived in Arlington, people worked in Arlington, and people spent their money in Arlington. This time of community togetherness was unparalleled in the history of Arlington.

The 1940s brought progress from the tough economic times, but World War II brought a time of sacrifice in the lives of the people of Arlington. Again the Arlington area sent a large number of its sons and daughters to fight for the cause of freedom. On the home front, it was survival and doing without many material items that people thought to be the necessities of life.

As they entered into the 1950s, jobs in the bigger cities lured people from the smaller towns. Agriculture became more mechanized and less labor intensive. While Arlington still had a good cross section of businesses, times were changing and people were driving more and farther, and spending less time and money in town. Arlington men again went to the service, fighting in the Korean War.

The 1960s and 1970s brought further regression in the business community, and in the early 1970s, the town lost its local weekly newspaper, the first time in 75 years that the community did not have a local voice to keep the community aware of school, business, and social news. Several local men spent time serving in the Vietnam War.

The 150th birthday celebration in 1984 was an event that marked pride in the community, and the 1990s were marked by visits by two presidents, George Herbert Walker Bush and William Jefferson Clinton. Both came by train and stopped and spoke and stayed at the village park for a considerable part of the day. It is rare for a town of this size to have visits from two such distinguished men.

As Arlington entered into the 21st century, it became apparent that it is now a bedroom community, and the number of businesses has declined appreciably. While the style of living in this small town has changed, it is still a very progressive town as small towns go. We still have businesses that many small towns are suffering without. It is still a great place to live and raise a family. Patriotism still flourishes, as evidenced by Arlingtonians having served in Operation Desert Storm and Operation Iraqi Freedom. What the future holds is only limited to the dedication, drive, and desires of the people who make up the village of Arlington and the surrounding area. People have lived, laughed, and loved here for almost 175 years in a place they called home. There are not any elegant buildings and no mansions for homes. We are just Arlingtonians, living a simple and satisfying life that puts new meaning in the old saying, "There is no place like home."

This book, *Arlington: 175 Years*, is intended to be a supplement to Arlington's first history book written in 1984. We have attempted to use material that was not pictured or covered in the 1984 book and to cover events that changed the community in the last 25 years.

We hope you will enjoy the pictures and historical content of this book. We have strived to be as accurate as possible in telling and preserving the history of Arlington, Hancock County.

One

EARLY YEARS
1834–1880

This area of Ohio was untamed Native American land, somewhat wet and swampy, heavily forested with oak, ash, walnut, and elm trees. Both water and game were abundant and the soil very productive. It was heaven for the Wyandot and Ottawa Indians who lived and traveled here. Their influence diminished after the War of 1812, and the government eventually removed them from the area.

By the mid-1830s, people were coming to northwest Ohio in record numbers. Robert Hurd, his sons Lorenzo, Wellington, William, Anson, and Jared, and his son-in-law Joseph Fitch sought abundant and cheap land. They came from near Twinsburg, which was then in Portage County, and from August 30, 1834, through December 2, 1836, they would file on seven parcels of land in present-day Arlington at the land office in Bucyrus. They cleared the land and built log homes, and most of the family had moved here by 1839.

While the town had no official name, early on it was called Hurdtown, Hurdville, and Hurdville Village. Robert Hurd was one of the men instrumental in founding Madison Township, of which Arlington is a part, on June 1, 1840. It was formed from parts of Van Buren and Delaware Townships and consists of 24 sections and 15,360 acres.

Robert Hurd and his family were staunch Presbyterians, and Hurd's favorite song from his Presbyterian hymnal was named "Arlington." On November 4, 1844, he had 16 lots recorded under a town named Arlington. The town would experience slow growth and by 1880 had 136 residents. Early businesses were a hotel, blacksmith, dry goods store, grocery, brickyard, cheese factory, sawmill, shoemaker, and doctor. Most merchants were also farmers and lived in town and farmed nearby.

Arlington and the surrounding area supplied many soldiers for the Union army during the Civil War. Some were personal bodyguards for Gen. William T. Sherman during his march to the sea. Arlingtonians can be proud of their ancestors' fight to save the Union and their part in freedom for all people.

While Arlington was just a sleepy, small town up until 1880, the following years would show considerable growth.

N.B.

When you write again be ouse and tell me whether you will come after me or not for if you do not Esther and I shall be grass widows here together—Perhaps you may not be sorry if you do come if you should happen to get some help about plowing & planting which may maybe impossible keep all such things in mind and write what time you think you will be here Remember what I tell you mind I tell you This is from Snip E J Markle

Be sure and keep this wrapper letter and all out of sight I would not have it seen lar by any one but you — E . . .

ELIZA MARKLE'S LETTER, 1843. This letter sent by Eliza Markle to her husband, Joel, in present-day Arlington talks of his coming to get her to help with spring planting and if he did not come she would be a "grass widow." This suggests she was tiring of her long separation from her husband as she was living near Twinsburg in present-day Summit County. Joel Rutherford Markle was a farmer, and early farmers lived in small settlements and went out in the surrounding fields each day to work. Joel was also justice of the peace from 1849 to 1855. In this capacity, he served as a local magistrate, administering summary justice in minor cases, committing people for trail, administering oaths, and performing marriages. He would eventually move to nearby Findlay and work as a buggy maker. In 1900, his cousin the famous Buffalo Bill Cody came to visit him. Joel died in 1903. (Courtesy of Don Steinman.)

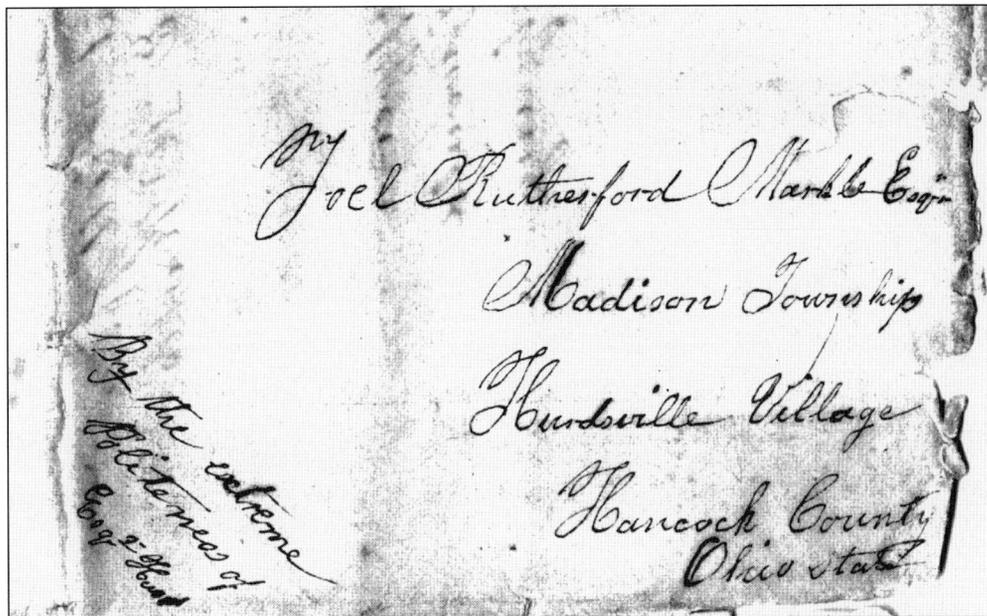

EARLY-1840s ENVELOPE. This was hand delivered by a member of the Hurd family to Joel Rutherford Markle from his wife, Eliza. This oldest-known piece of Arlington memorabilia is addressed to Madison Township, which was formed as a township on June 1, 1840. It was also addressed to Hurdsville Village, which means it was sent before Arlington officially was named on November 4, 1844. (Courtesy of Don Steinman.)

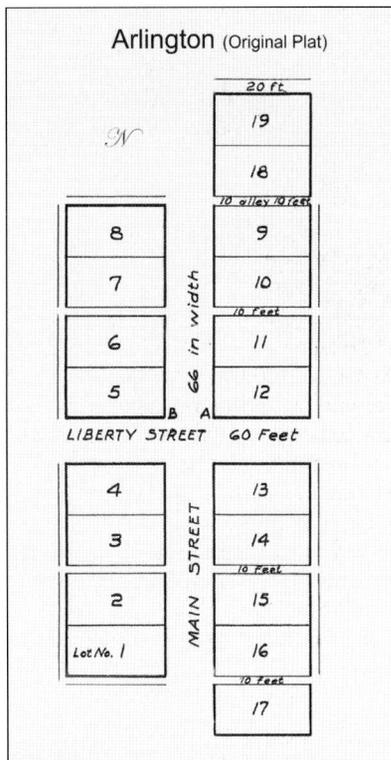

ORIGINAL PLAT MAP OF ARLINGTON, 1840s–1850s. Arlington was laid out by Robert Hurd in Madison Township, Hancock County. The original plot of 16 lots was acknowledged on November 2, 1844, and recorded on November 4, 1844, by John Adams, county recorder. Lots 17, 18, and 19 were added in 1853 but are still regarded by the county as part of the original plat. These 19 lots make up the center of present-day Arlington. (Courtesy of Deb Anderson.)

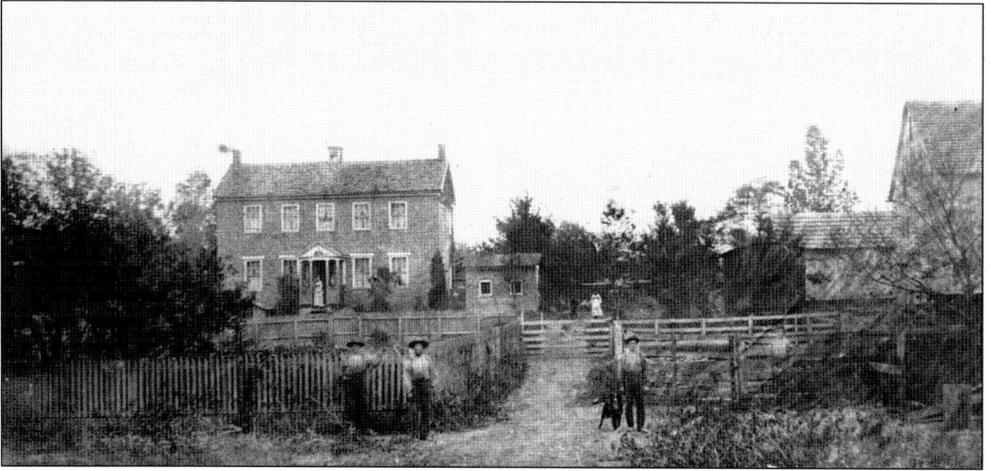

RURAL FARM PICTURE, 1860–1870. This rural farm on Township Road 70 was owned by Peter Traucht at the time this picture was taken. It is currently owned by Robert and Patty Hollister. The brick home was built in an L shape in 1853, probably with bricks made on the farm. A one-room schoolhouse and another area brick home were also built by Traucht. The walls are three bricks thick. This would have been one of the nicer homes in the Arlington area in 1853. (Courtesy of Lillian Crates.)

EARLY-PERIOD ARLINGTON FARM HOME, 1881–1882. Homes built in rural Arlington came a long way in the late 1800s from the old log cabins that preceded them. An example is the Wertenberger farm just southeast of Arlington. It was a beautiful home for its period and built roughly eight years after the barn was built. It was in the Musgrave family for many years until it was destroyed by fire in the 1950s. (Courtesy of Leo and Muriel Musgrave.)

LAND OFFICE RECORDING, 1837. The government placed land up for sale as early as 1820 in this area. One went to the government land office in Bucyrus, where entries upon and sales of public land were registered. Certificate No. 16045 is for James E. Careins, who filed on land in Delaware Township. The certificate was signed by a land office representative in the name of Pres. Martin Van Buren. (Courtesy of Juanita Rinehart.)

BARN RAISING, 1874. This is a picture of an 1874 barn raising on the Wertenberger farm, just southeast of Arlington on the present farm of David Musgrave. Thirty-two men, two boys, and seven women are in the picture. They used gin poles and ropes to erect the walls, which were in sections and already had the holes for the ladders. It was a major project and took a lot of engineering. (Courtesy of Leo and Muriel Musgrave.)

13

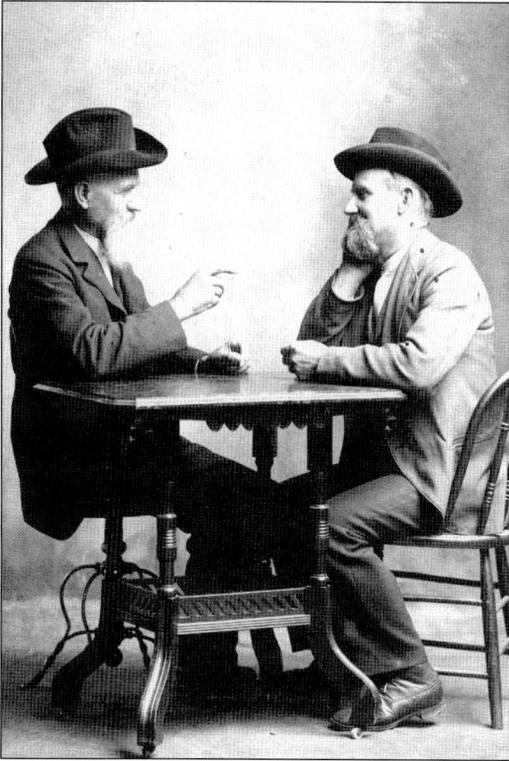

CIVIL WAR VETERANS, C. 1875. Arlington brothers Elias Riegle (left) and Philip Riegle are shown discussing some of the 23 Civil War battles they fought in as members of the 66th Illinois Sharpshooters. They were also personal bodyguards for Gen. William T. Sherman. To be a sharpshooter, one needed to shoot a hanging rope in half at 200 yards with two out of three shots. (Courtesy of Tom Kroske.)

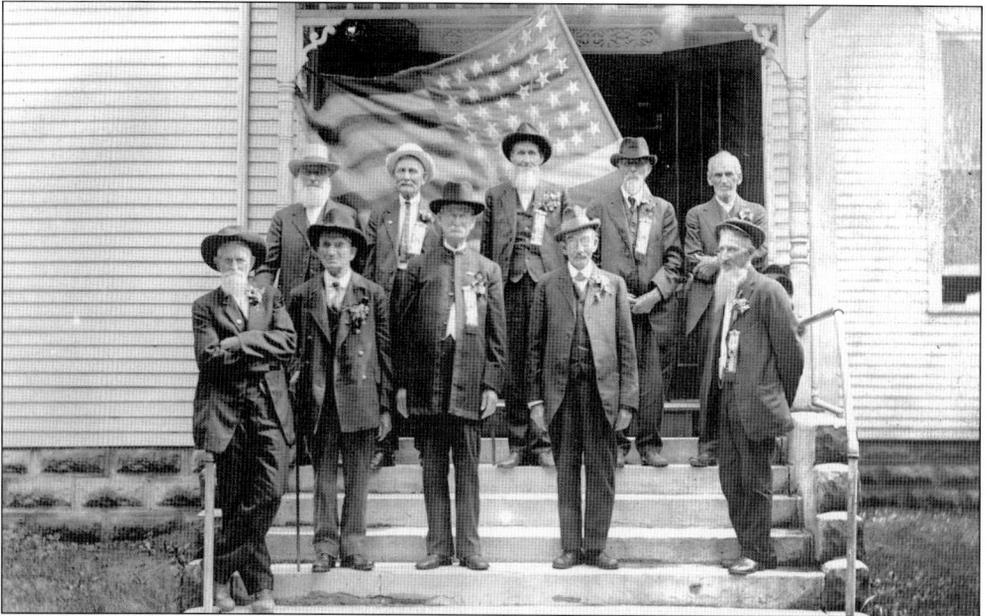

CIVIL WAR VETERANS, 1800S. These veterans got together on the steps of the Methodist Protestant church on East Liberty Street. From left to right are (first row) N. B. Anderson, two unidentified men, Mike Arys, and Frank Holmes; (second row) Jesse Treece, Al Gay, unidentified, Henry VanAtta, and Tom Anderson. These Civil War veterans were proud members of the Welker Post of the Grand Army of the Republic (GAR). (Courtesy of Joe Schaaf.)

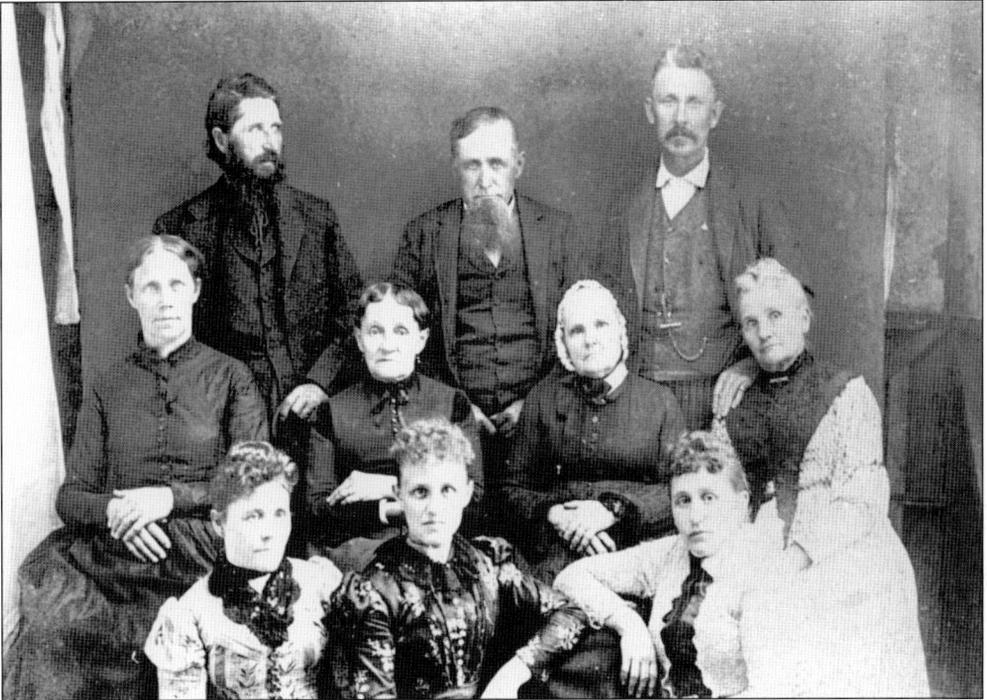

PIONEER FAMILIES OF ARLINGTON, 1870S. Some of Arlington's pioneer families posed for this 1870s picture. Among the families represented here are Holmes, Gay, Vail, and Halderman. The Holmes family had Civil War veterans, the Gay family ran the Hotel Gay, and the Vail family were businessmen and accomplished musicians. (Courtesy of Leslie Lazenby-Hunsberger.)

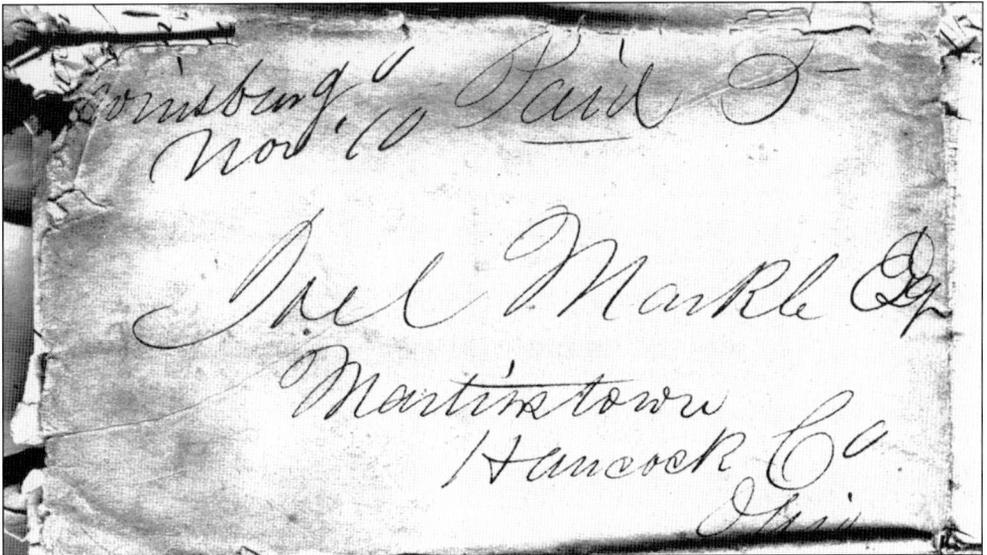

MARTINSTOWN LETTER, NOVEMBER 10, 1845. This letter is addresses to Joel Markle, Martinstown, Hancock County. Martinstown's 46 lots were plotted by Martin Hollabaough and recorded on October 19, 1936. The town was located at the present north edge of Arlington, the land north of Fellowship Drive. It had a post office early on, but only a few lots were developed. (Courtesy of Don Steinman.)

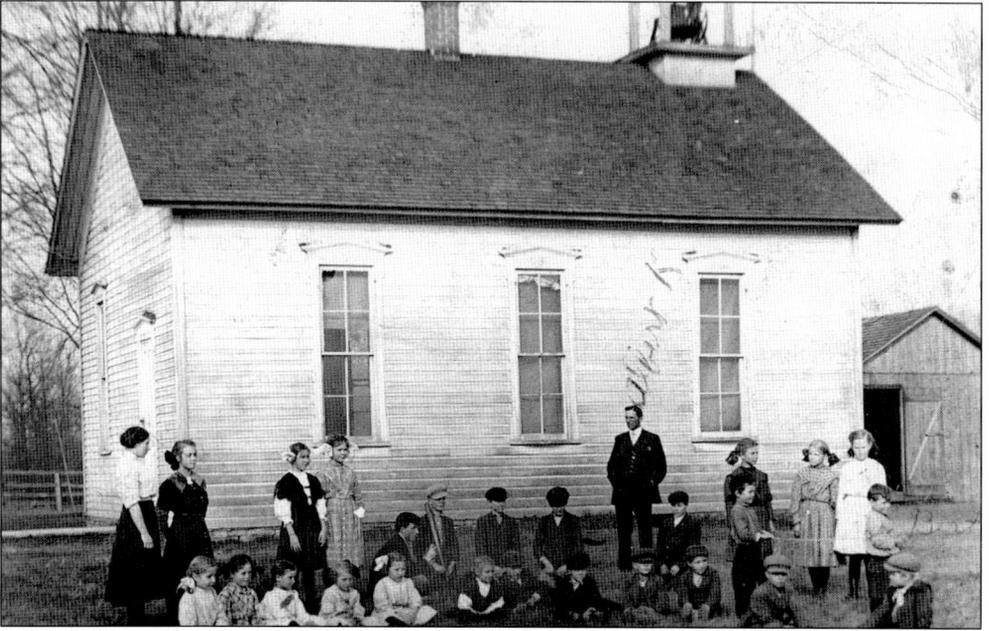

MARTZ SCHOOL, 1912. This was a typical one-room rural school near Arlington. The school was wood frame, and the teacher was Albert Kroske. It was named after the Martz family, which owned several farms in the area. It was located on Township Road 68 just north of Township Road 30 on the Robert Orwick farm. Students from seven rural schools eventually were combined into the Arlington school system. (Courtesy of Joe Schaaf.)

JESSE TREECE AND WIFE. Jesse Treece was born on February 23, 1835. He was the last living Civil War veteran from the Arlington area. The town celebrated his 100th birthday and the 100th anniversary of the town with a big community birthday party at the school. They invited all the living pioneers of the town as guests. Uncle Jesse, as he was called, died in 1936. (Courtesy of Tom Kroske.)

Two

BOOMTOWN
1881–1920

Arlington counted 136 residents for the 1880 census, but all of that was about to change with the construction of the railroads. Millard Fillmore was president when the tracks came through close to the north end of town running east to west. In 1890, more tracks were laid on the east side of town running north and south. From 1883 until 1914, seventeen new town plat additions were recorded. The census in 1900 totaled 738 people, five and a half times the number of residents just 20 years earlier!

Arlington was a hub of activity according to the *Arlington Gazette* published in 1898. It noted that the Arlington Mills shipped flour throughout the state in addition to milling for people locally. Area businessman P. A. Riegle paid the highest market prices for wool, pelts, furs, and seeds, which brought a lot of business into town. The sawmill of Crates and Hempey employed 16 men who filled orders from various parts of the country. The newspaper ran advertisements for a drugstore; two general stores; dealers in furniture, carpets, musical instruments, and boots and shoes; a bakery; two hardware stores; implement dealers; two hotels; a grocery and dry goods store; a tinsmith; a millinery; blacksmiths; wagon sales; a tonsorial parlor; and a livery stable. In 1900, a hoop mill employing roughly 35 men was built on the east side of town.

The community was incorporated in 1892 and was home to two Methodist and two Lutheran churches. The bustling town had dirt roads. A water wagon was used to keep down the dust, and a lamplighter lit the town lanterns until 10:00 p.m. Plank sidewalks and hitching posts lined Main Street. The council purchased four dozen buckets for firefighting in 1894. A new town hall was built in 1896, but in 1897, the town suffered a setback when fire burned many businesses on the east side of North Main Street.

By 1900, the town had telephones, and in 1908, a light plant provided electric power during limited hours. Arlington was growing and modernizing and was a hub to the farmers around it.

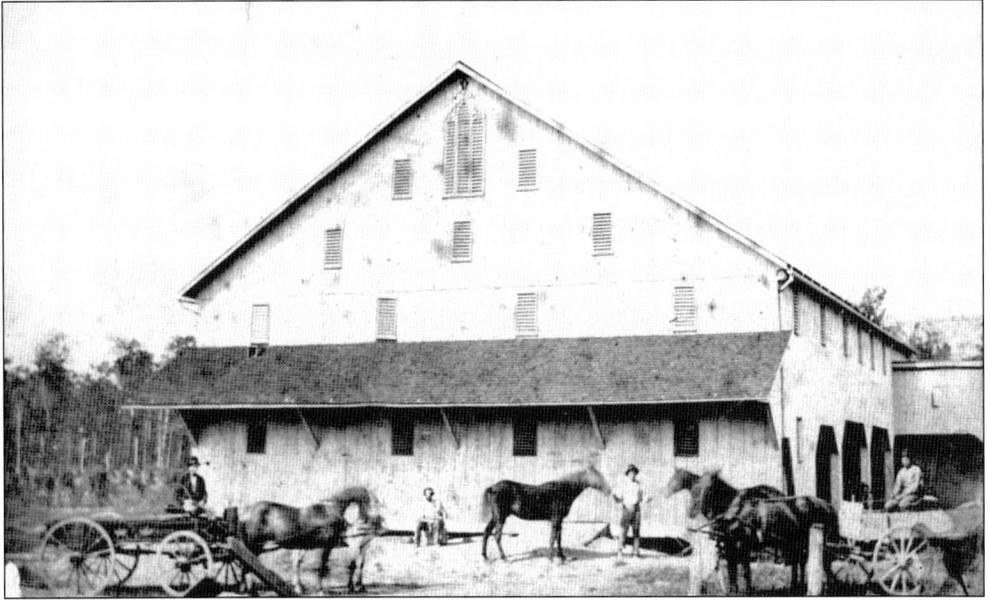

PIFER FARM, 1900S. This barn sat on the farm of Adam Pifer at 11402 County Road 31. It was a very large wood frame barn with plenty of storage space for hay and straw. Barns were important to farmers, the hub of work on the farm, and a source of pride. (Courtesy of Ruby [Smith] Jolliff Gehrisch.)

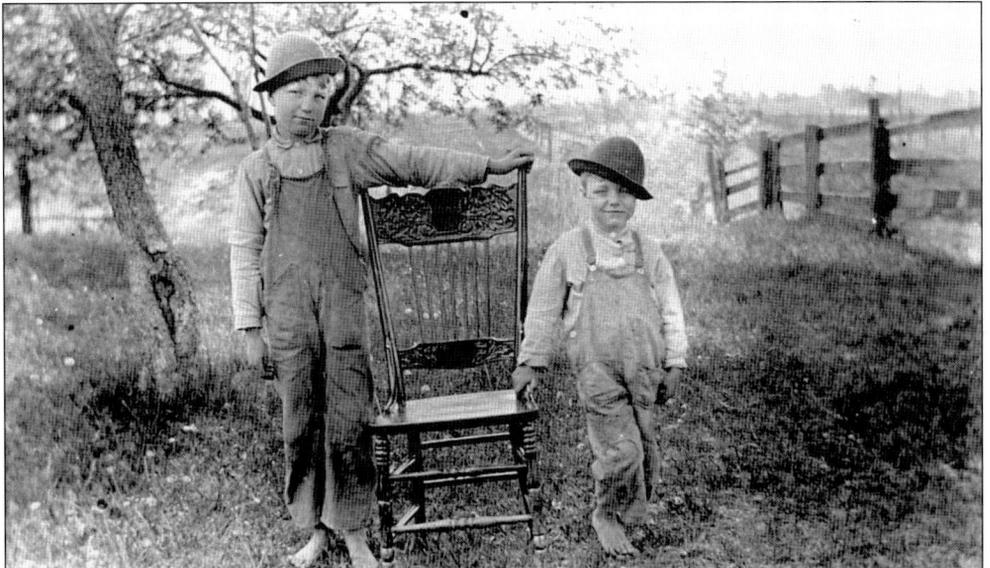

WEIDMAN BROTHERS, 1900. The picture above is of Milo and Chester Weidman. The Weidman family was one of the early families in the area. Note the wooden fence on the right and the boys' bare feet, bib overalls, and early-1900 hats. (Courtesy of Jody Weidman.)

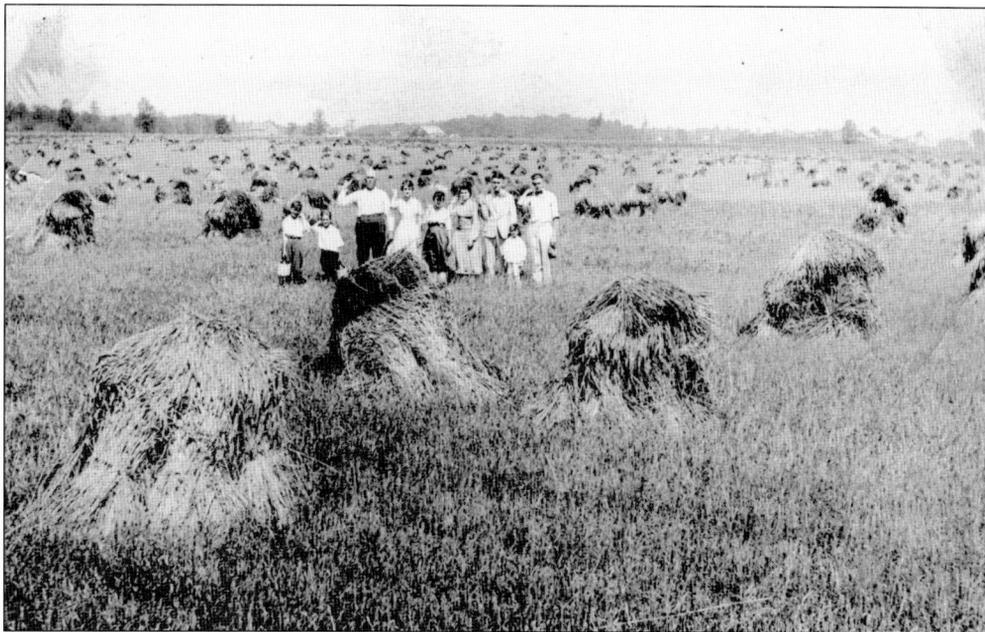

SHOCKING WHEAT, 1917. The people in the photograph are Archie Wagner and his wife, Luly, with their children, Boyd, Everett, Gertie, Vesta, Roosevelt, Jesse, and Marion (Jim). The photograph was taken in an 11-acre wheat field in July 1917 that averaged 50 bushels per acre. His entire crop of 43 acres averaged 32¾ bushels per acre. (Courtesy of Jo Ann Wagner.)

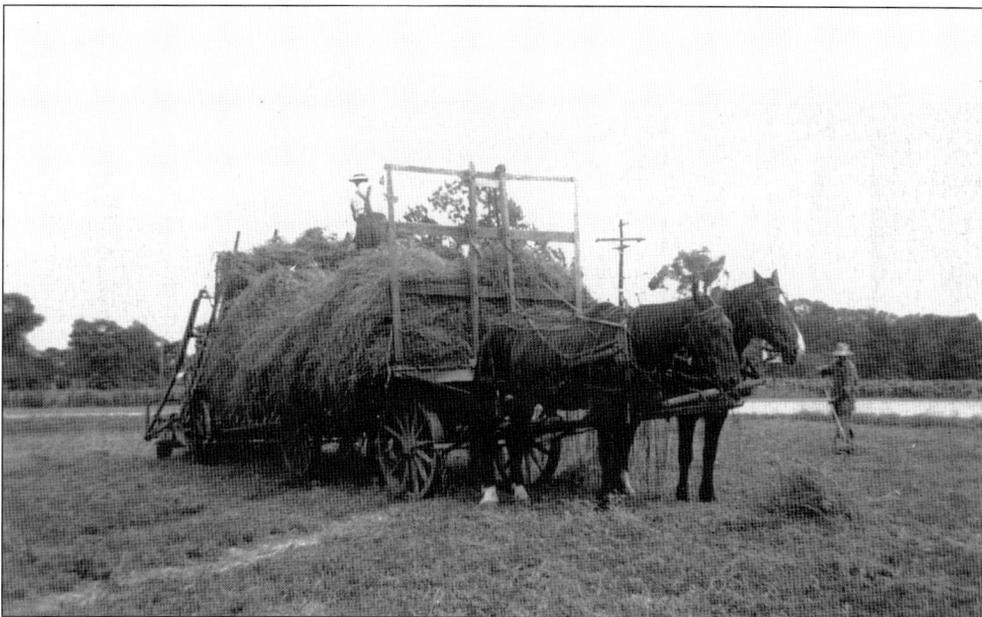

MARQUART HAY FARM. Hay was an important food source for farm animals. The picture shows cutting hay in the days before bailing when they used forks to throw it on the wagon. Orley Marquart and Charley Marquart, father and son, are making hay on Dale Kimmel's lot, north of the house. Farming was the source of income for most of the population. (Courtesy of Ann Rankey Welch.)

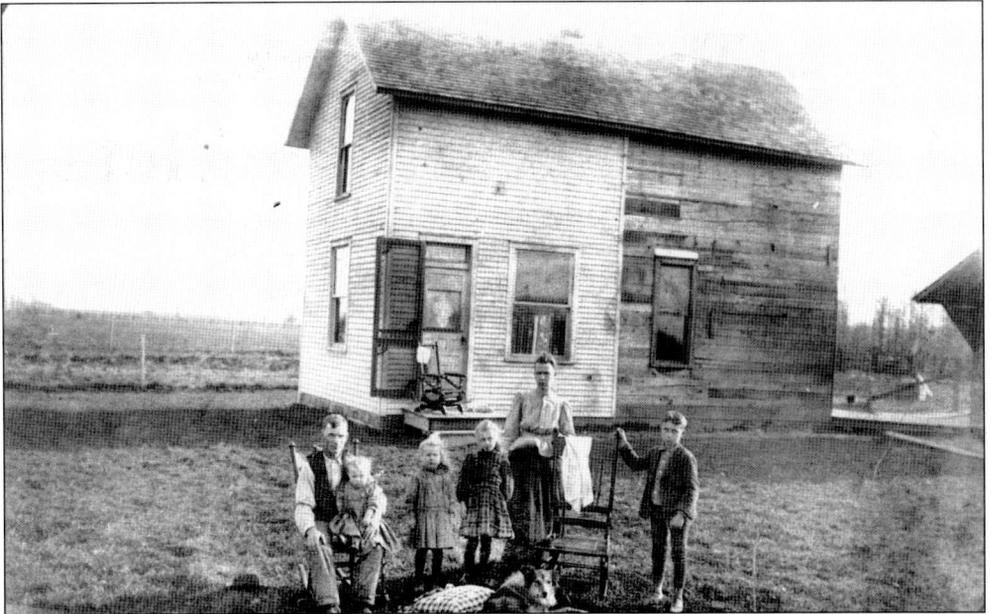

BEACH FARMHOUSE, 1900S. This farmhouse was located at the southwest corner of Madison Township 31 and U.S. 68. From left to right are Philip Longworth holding his daughter Audrey, Garcia and Jesse (the other daughters), Atlanta (Philip's wife), and their only son, Roy. The house may have been half that size since only half is sided. At least six people had to live there! (Courtesy of Juanita Rinehart.)

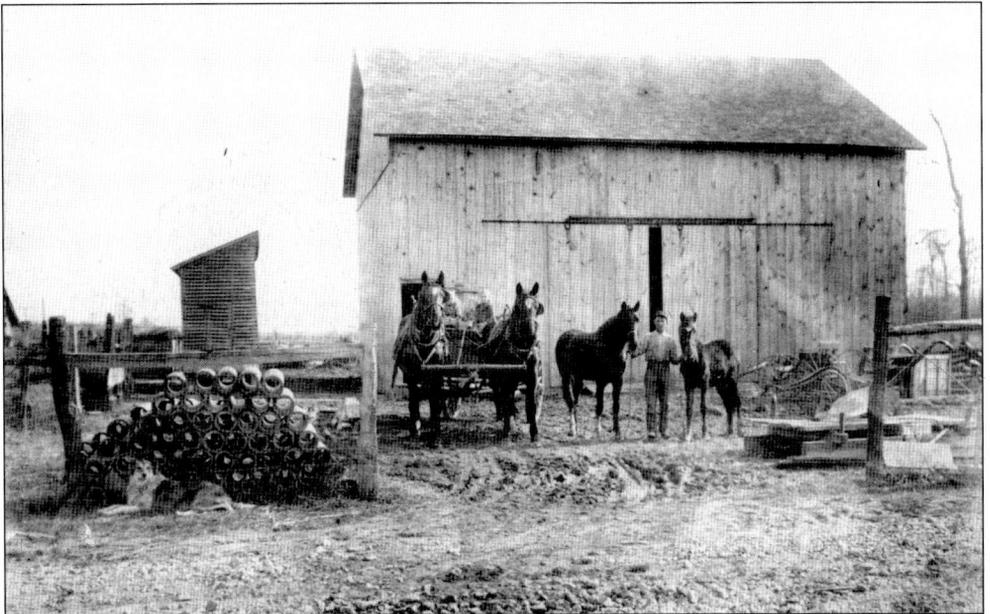

BEACH FARM, 1900S. These horses, the barn, and the wagon were located one mile south of Arlington at the southwest corner in Madison Township 31 and U.S. 68. Horses were very important to farmers. They plowed fields, helped plant and harvest, and transported extra crops to the grain elevator, in addition to providing transportation for the family. (Courtesy of Juanita Rinehart.)

...The Arlington Flock...
American Rambouillets,

The World's prize wool winners
at the Paris Exposition, 1900...

Bred and owned by

P. A. RIEGLE,

**CHOICE STOCK
FOR SALE.**

ARLINGTON. OHIO.

PHONE 12.

P. A. Riegle Sheep Advertisement, 1900. P. A. Riegle owned a lot north of the Akron, Canton and Youngstown Railroad (AC&Y) tracks in the Wardwell's Addition. He owned an award-winning flock of American rambouillet sheep. These large sheep originally bred in France are known for their long, fine wool and quality mutton. The sheep were sold worldwide. Once a man from South America asked to buy his best sheep for a price that made Riegle wear a broad smile. (Courtesy of Leslie Lazenby-Hunsberger.)

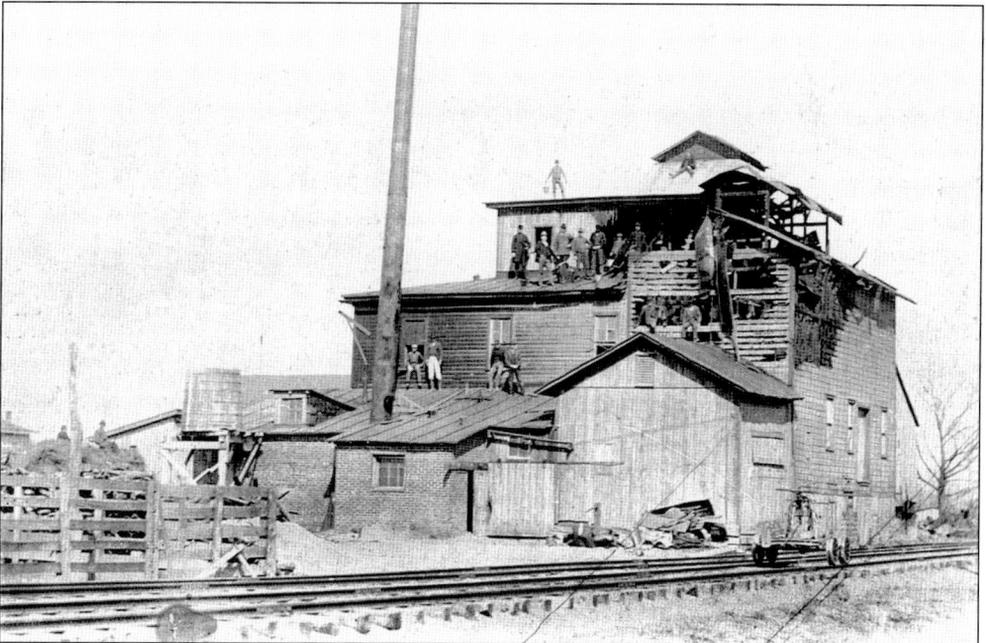

Elevator and Flour Mill, 1900. An elevator was built north of town on railroad land in 1882 beside the new Cleveland, Delphos, and St. Louis (later the AC&Y) tracks. In 1884, Peter Traucht bought the old Waterloo mill and rebuilt it by the elevator. It milled corn, wheat, grain, rye, buckwheat, and other grains with buhrstones. (Courtesy of Leslie Lazenby-Hunsberger.)

CRATES FARM, EARLY 1900S. This country house is located at 10979 County Road 24. Note the dirt road, wooden fences, and lack of power poles. The picture predates electricity and telephones for those living in the country. (Courtesy of Herbert and Lillian Crates.)

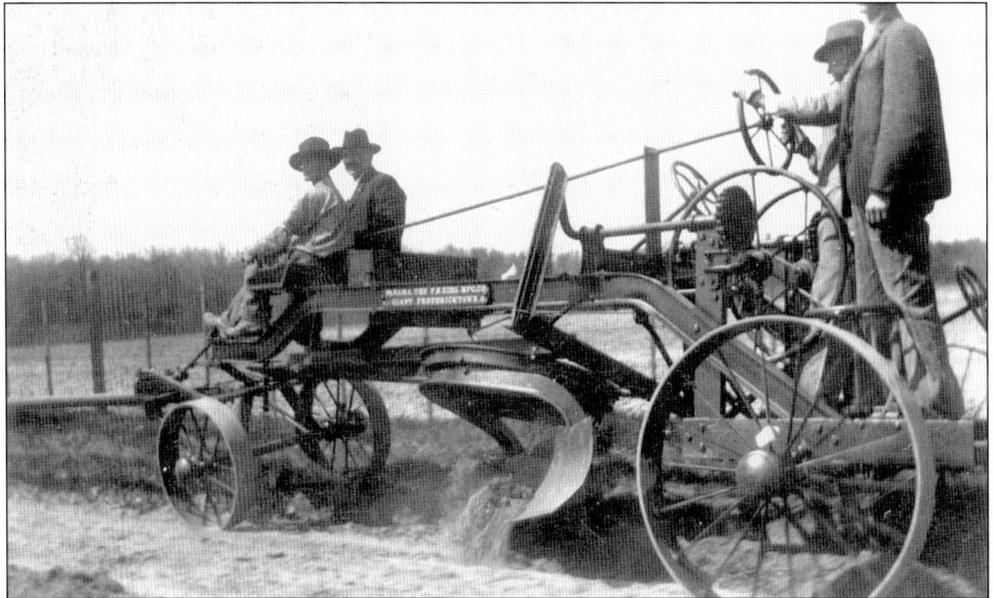

ROAD GRADER, EARLY 1900S. The road grader was used to smooth roads and remove ruts. It was horse drawn and had iron wheels. The road grader is being steered by Philip Longworth with George Myers standing beside him. After a heavy rain, the roads could be washed out, and the road grader would smooth out the road. (Courtesy of Juanita Rinehart.)

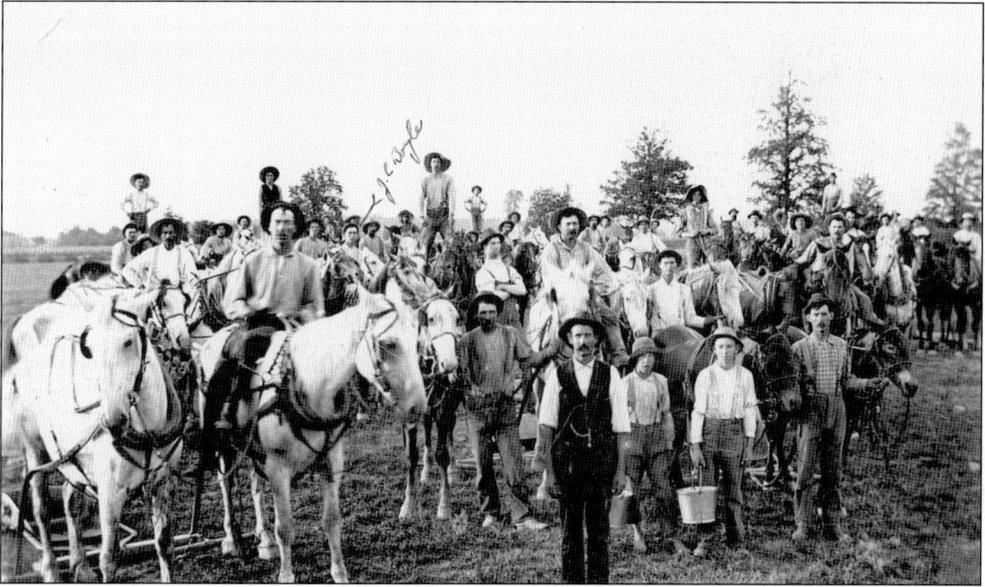

CONSTRUCTION OF THE **AC&Y, 1890**. The construction of the AC&Y took Arlington from a small rural village to a thriving town. The first office was a boxcar. In 1892, the railroad went from narrow gauge to standard gauge. It was nicknamed the "Pumpkin Vine" because it curved 149 times. (Courtesy of Leslie Lazenby-Hunsberger.)

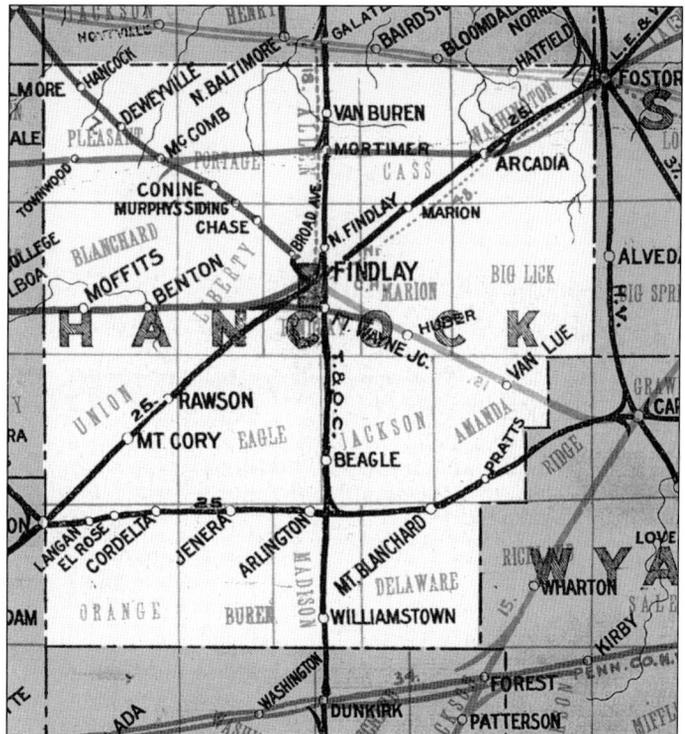

RAILROAD MAP SHOWING HANCOCK COUNTY, 1903. The railroad that runs down through the middle is the Toledo and Ohio Central Railroad (T&OC). Right above Arlington is Beagle Station, a train stop where people could get on the train and mail was delivered to Houcktown. Farmers knew that the railroad would be valuable for the transportation of their crops and animals. (Courtesy of Dennis Beard.)

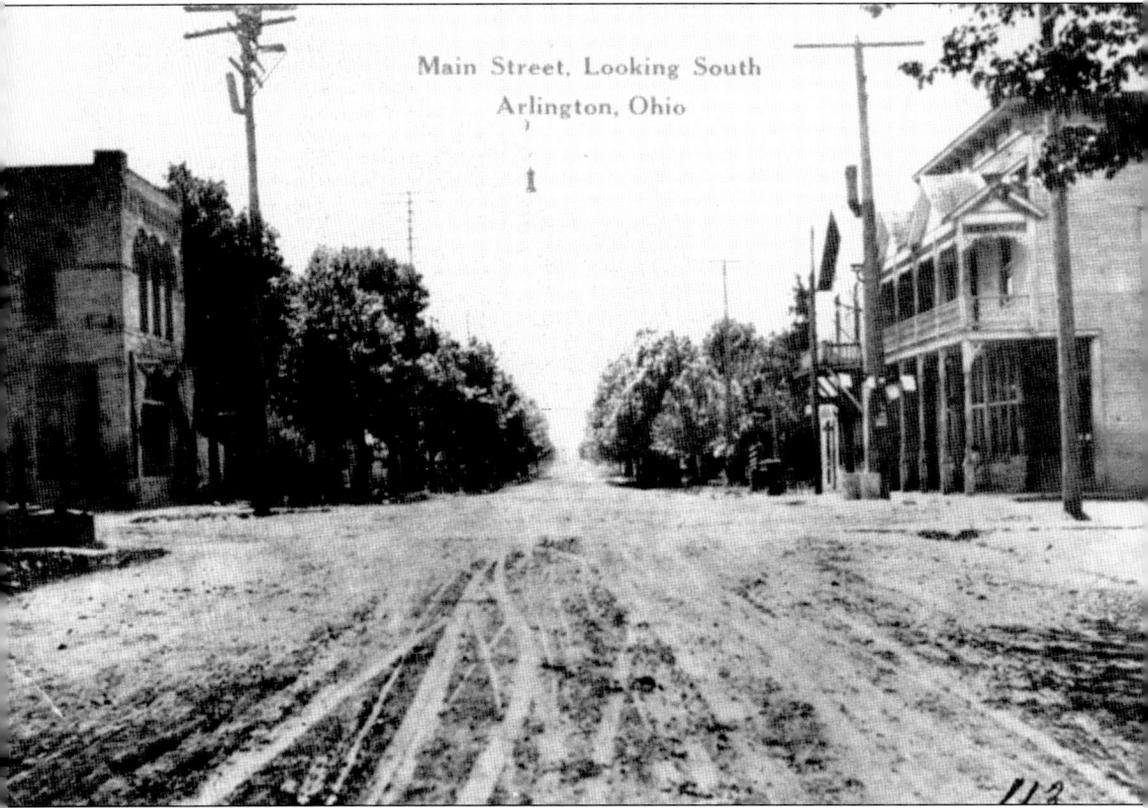

Main Street, Looking South
Arlington, Ohio

MAIN STREET, LOOKING SOUTH, 1910. The roads in Arlington were dirt, and there were no curbs. George Kimmel's new Ford automobile might have had some rough going. But walking was better as Arlington boasted of having more concrete sidewalks than any town its size in this part of the state. On this postcard, the town pump can be seen on the left. The pump and trough provided a place where people could stop and water their horses. The main street of the business district was lined with large trees whose limbs stretched well into the street, obscuring the vision of other businesses not on the square. (Courtesy of Paul Reusch.)

THE GHASTER AND HINDALL HOTEL, 1890S. The beautiful Ghaster and Hindall Hotel was built on the southwest corner of the square in the 1890s. There was a great rivalry between it and the Hotel Gay. Both operated livery stables and met the trains to offer their services. In the early 1900s, it was used by Frank Beach for a clothing store. (Courtesy of Greg Snyder.)

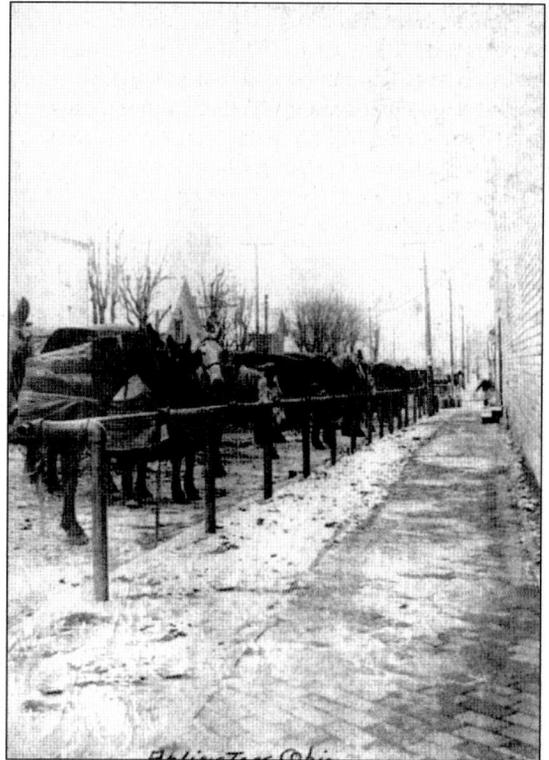

HITCHING POST, EARLY 1900S. This picture shows the north side of West Liberty Street. The Crates Building is on the right, and the hitching post is on the left. The horses are tied to the post while their owners are in town getting supplies. It is a busy Saturday when many people came into town. (Courtesy of Peggy Rinehart.)

ARLINGTON BUSINESS LEADERS, 1901. This poster contains advertisements for 15 business establishments located in the village of Arlington in 1901. The letters are hand painted, raised letters that are a dull silver or gold in color. Selected words were finished with shiny red and silver glitter. Some of the advertisements contained photographs or drawings of the wares offered in the establishments. It is not known where or how this poster was used or if any more exist. The poster was behind a painting that hung for many years in the Kroske home, pictured on page 35 of this publication. The poster was found after the painting was purchased in 1981 by a local antiques dealer at a public auction. (Courtesy of Jerry Pore.)

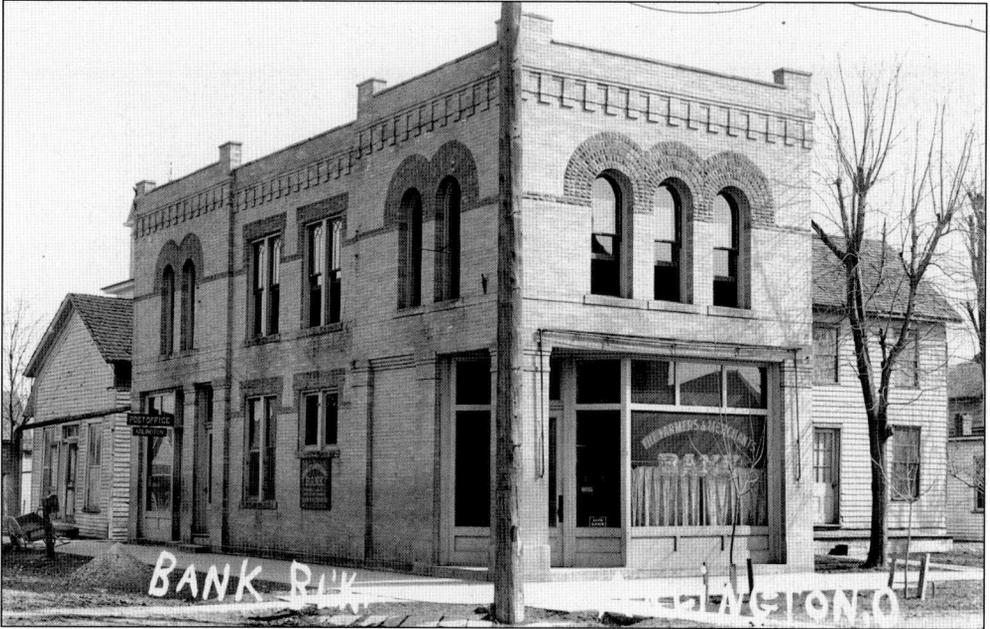

THE FARMERS AND MERCHANTS BANK, EARLY 1900S. The Farmers and Merchants Bank was chartered in 1900, and the building was constructed shortly afterward. This building was constructed on original lot 13, and the bank stayed at this location until 1966. Note the post office in the rear of the building. The home at the right of the bank has an interesting history. It was the first frame house in Arlington and in 1876 the home of Rev. Robert K. Davis. (Courtesy of Don Steinman.)

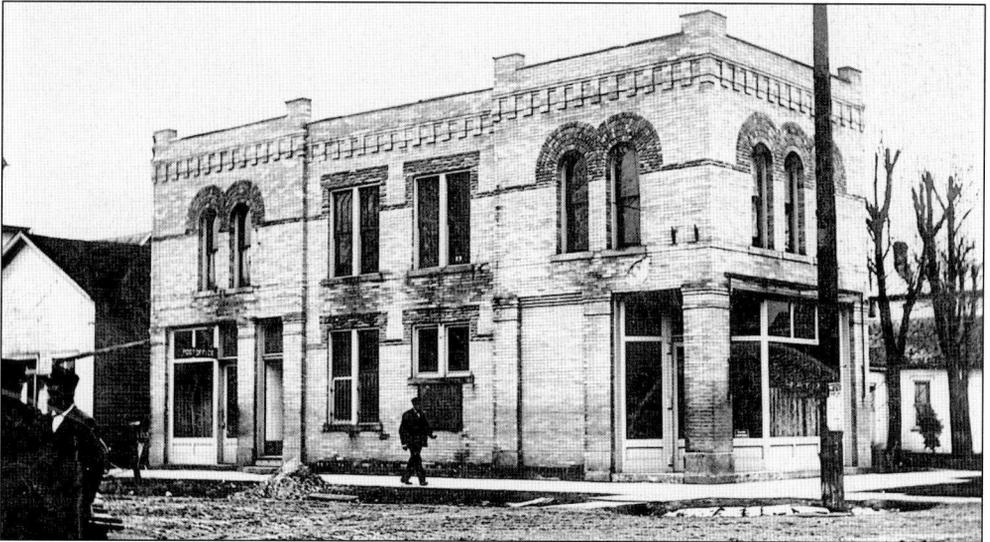

FARMERS AND MERCHANTS BANK, 1900S. The bank was located at 101 South Main Street and was only 15 feet wide. Harvey Solomon was the first president. The bank bought 300 bank calendars in 1908 and gave them out to its customers. In 1917, it voted to pay $5 to defray the expense of hiring a bloodhound to hunt down burglars. In 1919, a vault was purchased by the bank for $1,165. The vault door is still in use at Huntington Bank. The Farmers and Merchants Bank was in business for 79 years. (Courtesy of Leslie Lazenby-Hunsberger.)

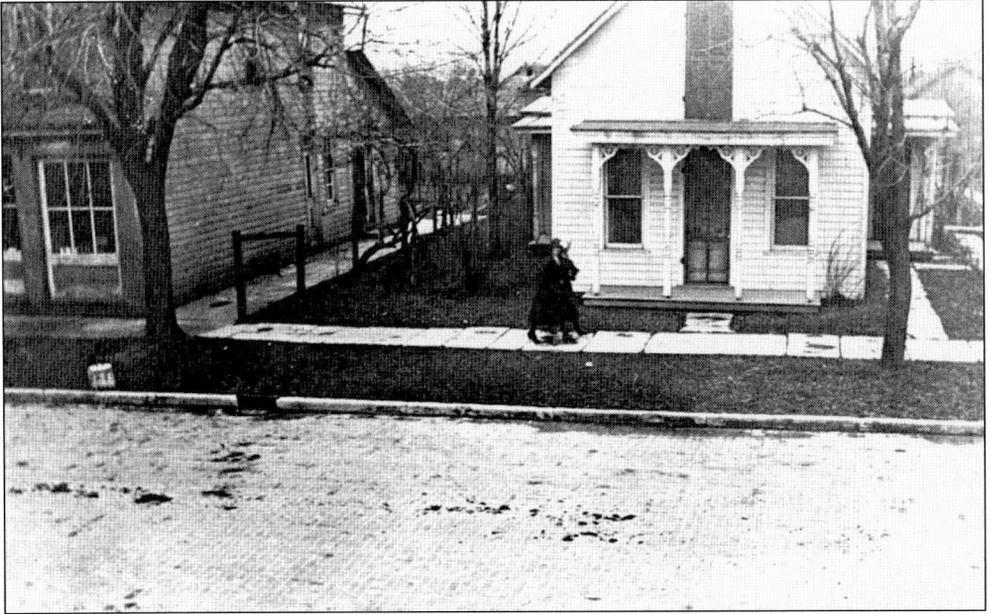

FISHER SHOE STORE AND DR. BEACH'S HOUSE, EARLY 1900S. The frame business building on the left is Fisher Shoe Store, located on the east side of North Main Street. This family business was started in the 1800s and did not close until 1926. The white frame house to the right was the home of Dr. Belizer Beach. Robert Hurd gave Dr. Beach 40 acres of land to locate here. (Courtesy of Leslie Lazenby-Hunsberger.)

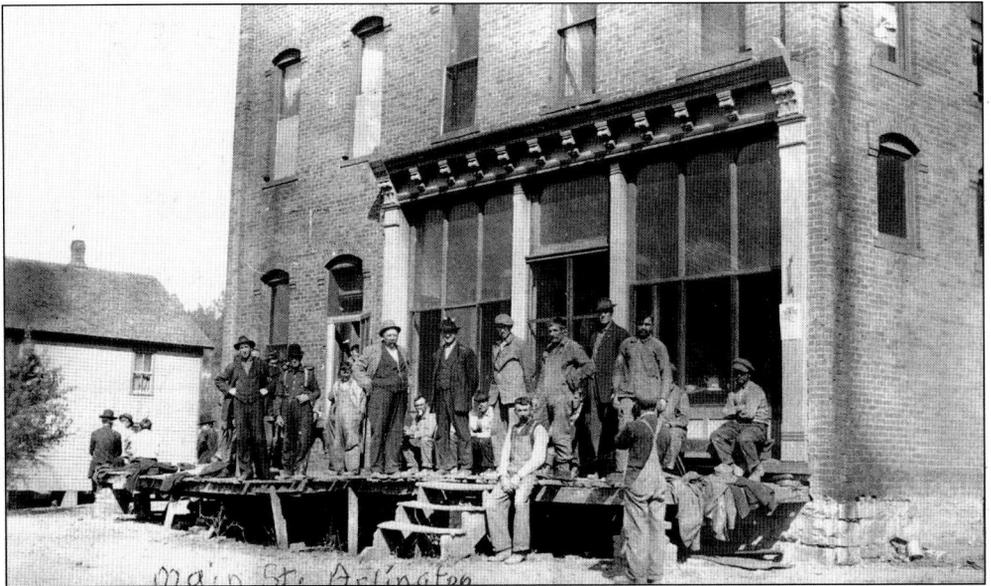

BUSINESS BUILDING ON MAIN STREET, 1895–1910. This postcard shows a large business building on Main Street in Arlington. The authors have been unable to identify this business or its location. It is thought that this may be a building that was destroyed in the 1897 fire that was located at the northeast corner of Park Drive and North Main Street. (Courtesy of Juanita Rinehart.)

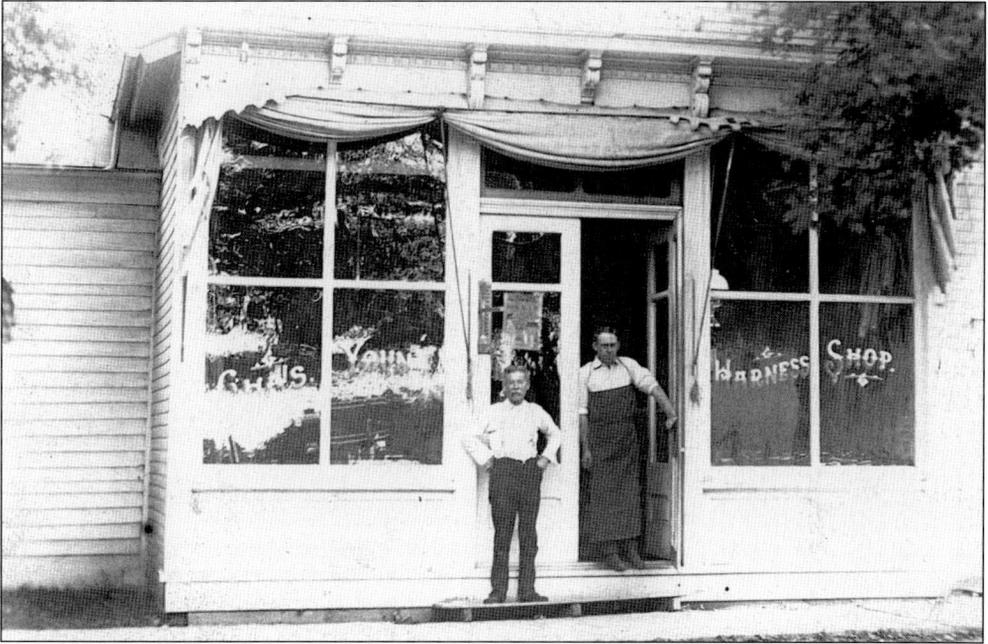

CHARLES YOUNG HARNESS SHOP, 1900S. The harness shop was in the second building north of the first alley on the east side of Main Street north of the square, lot 9 of the original plat. Later the *Arlingtonian* newspaper was located there. The harness shop sold and repaired harnesses. (Courtesy of Ann Ranky Welch.)

CHARLES YOUNG HARNESS SHOP ADVERTISEMENT, 1910. This winter advertisement is advising farmers to get ready for spring planting early by ordering their spring harness needs now. It was a handmade harness, not machine made. The shop also sold horse robes for when horses were standing at a hitching post and storm fronts for buggies, an enclosure to keep the weather out. (Courtesy of Leslie Lazenby-Hunsberger.)

Charles Young

ARLINGTON'S HARNESS SHOP

If In Need of a Good Harness, order Early and Have Them Ready for Spring

Our Harness are All Hand Made and you know they are better than Machine Made and Cost No More.

Robes at Cost

Our STORM FRONTS have Extra Wide Lights at $5.00

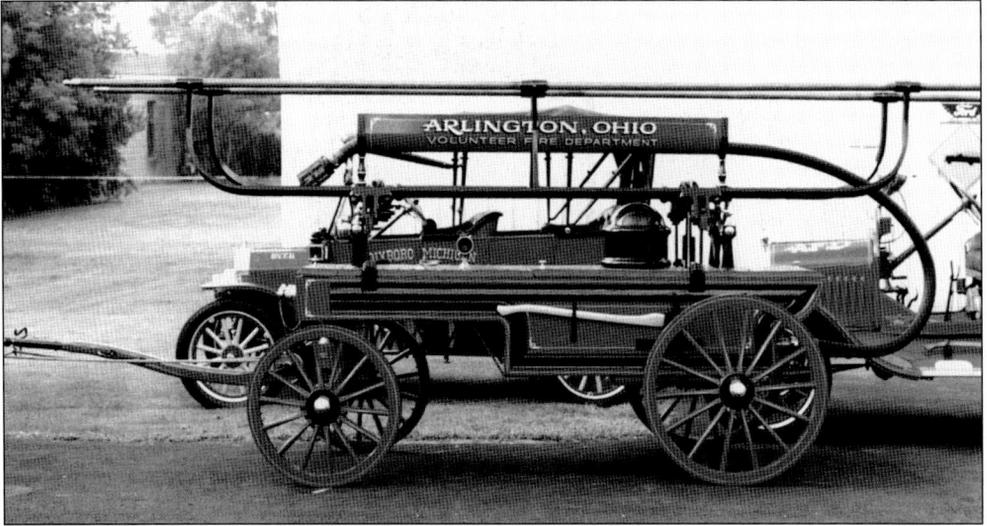

ARLINGTON'S FIRST FIRE ENGINE. This 1886 Gleason and Bailey Limited pumper was hand drawn and hand operated. This 2002 photograph shows the completely restored machine that is on display in the Michigan Firehouse Museum in Ypsilanti. It was purchased as a used machine in 1897. The pumping handles on either side folded down, and six men worked each side to pump water through two hose lines. (Courtesy of Tom Kroske.)

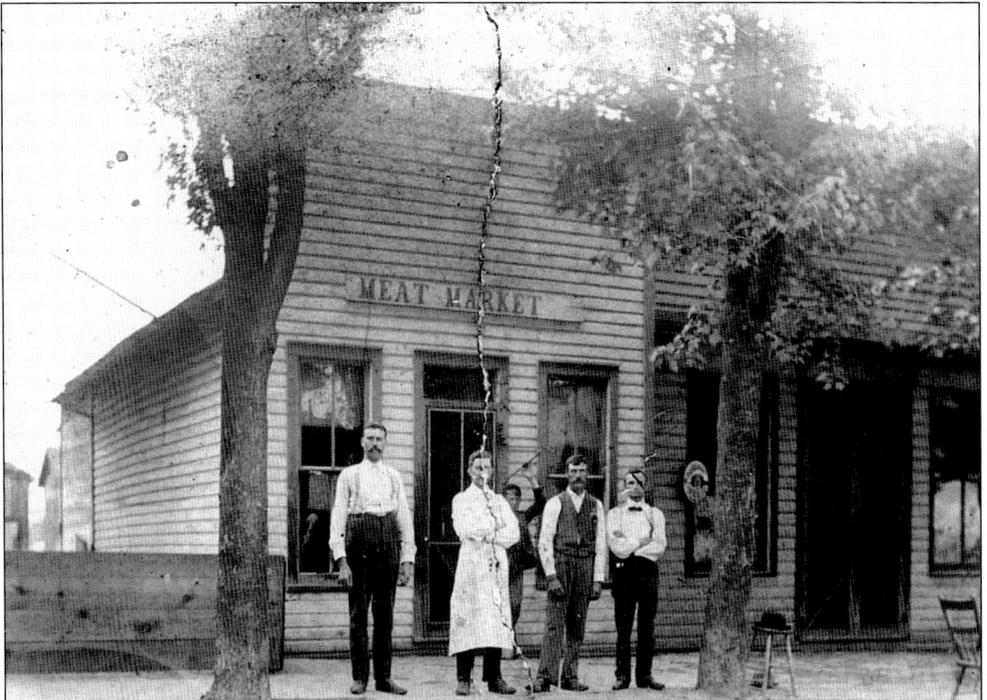

MEAT MARKET, BEFORE 1900. Standing in front of the meat market are, from left to right, the owners Charlie Tombaugh, Anson Swank, and brothers Martin and George Hosafros. This was a popular Main Street meat market. With no current-day refrigeration units, butchered meat was kept fresh with ice and sometimes smoked. A good meat business needed to anticipate its sales to keep its products fresh. (Courtesy of Mildred Fink.)

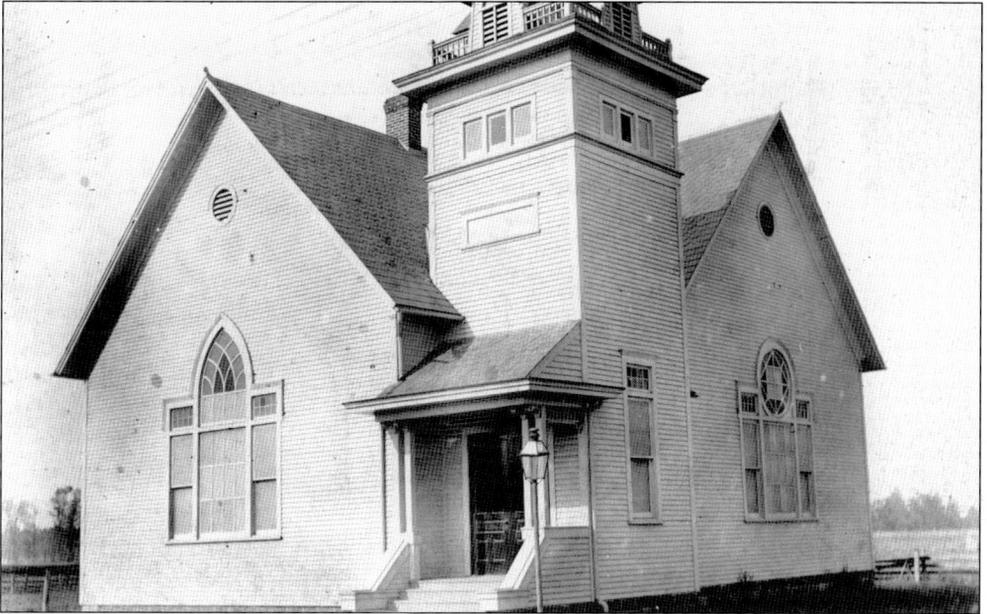

METHODIST PROTESTANT CHURCH, 1900. Built in 1859, this church was located on a lot on the south side of East Liberty Street, where the Eagle Creek Historical Organization (ECHO) cabin is now located. These are the only two buildings ever built on this property. The church was thought to have been torn down in 1941 after the nationwide merger of the Methodist Protestant and Methodist Episcopal denominations. (Courtesy of Don Steinman.)

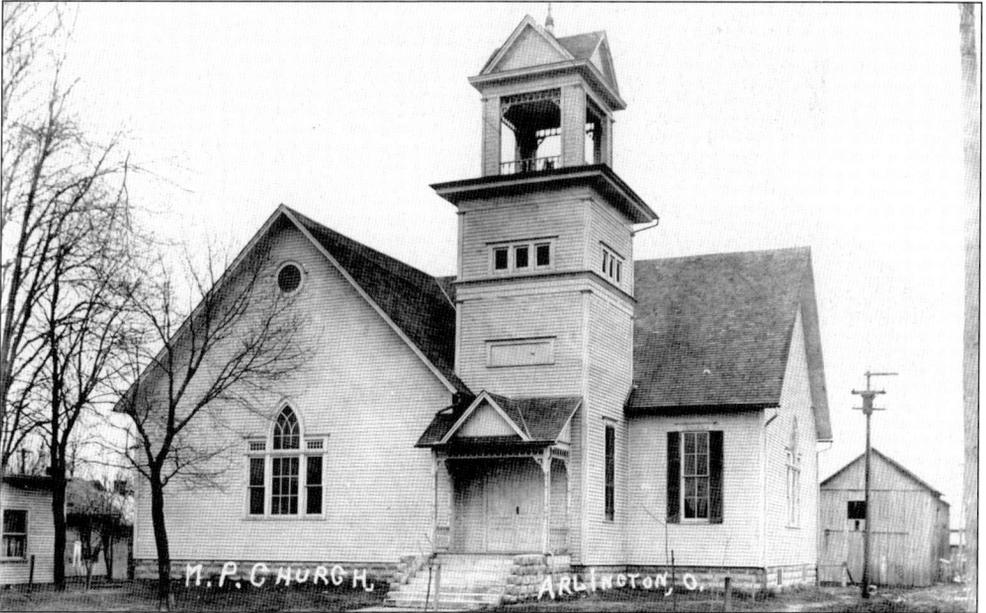

ADDITION TO METHODIST PROTESTANT CHURCH. In 1915, a large addition was made to the west side of the church. A choir room was added, and a basement was put under the church. The rest of the church was remodeled, and new quartered oak seats were put in the sanctuary. The church featured colored glass windows and a paneled choir loft behind the altar. (Courtesy of Paul Reusch.)

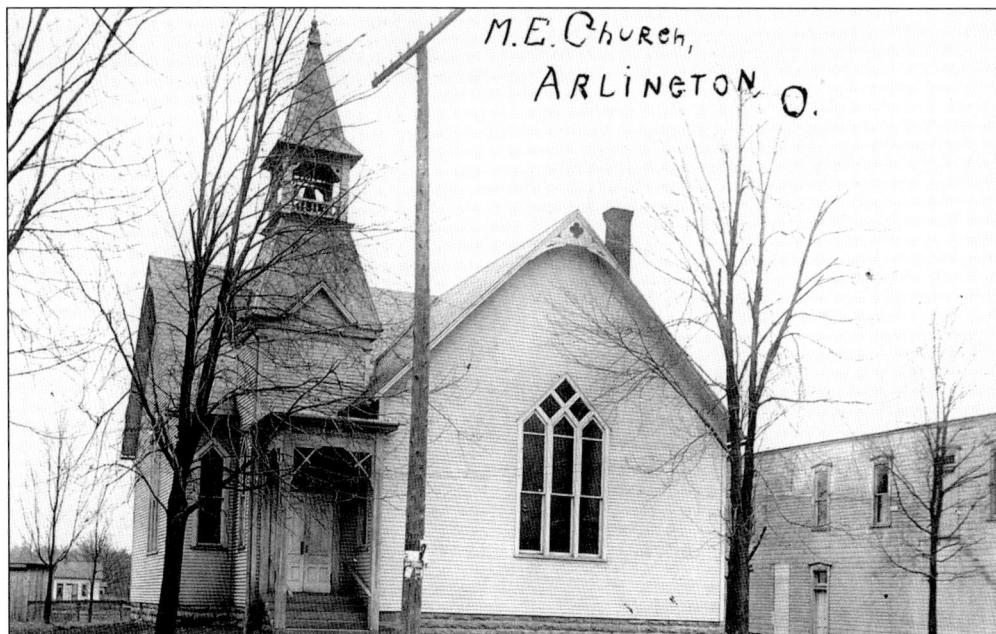

METHODIST EPISCOPAL CHURCH, 1907. This building was built in 1903 on the site of the original church, which was log and built in 1858. In 1920, a basement was put in that provided a dining room, kitchen, and Sunday school rooms. In 1934, the church acquired a Moller pipe organ, which has a total of 640 pipes. It is considered quite a treasure. (Courtesy of Don Steinman.)

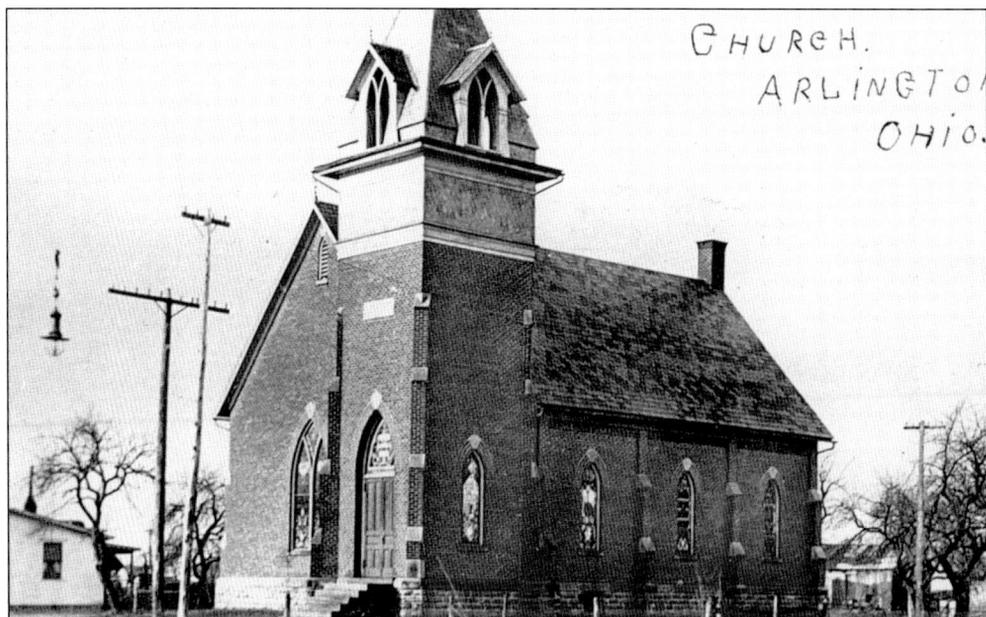

GOOD HOPE LUTHERAN CHURCH, 1901. This church was formally organized on July 2, 1900, and by November 10, 1901, the building pictured here was dedicated. It had a 618-pound bell that was rung every Saturday at sundown to announce the beginning of the Sabbath. It was also rung when a church member passed away; the length of the ringing was determined by the member's age. (Courtesy of Leslie Lazenby-Hunsberger.)

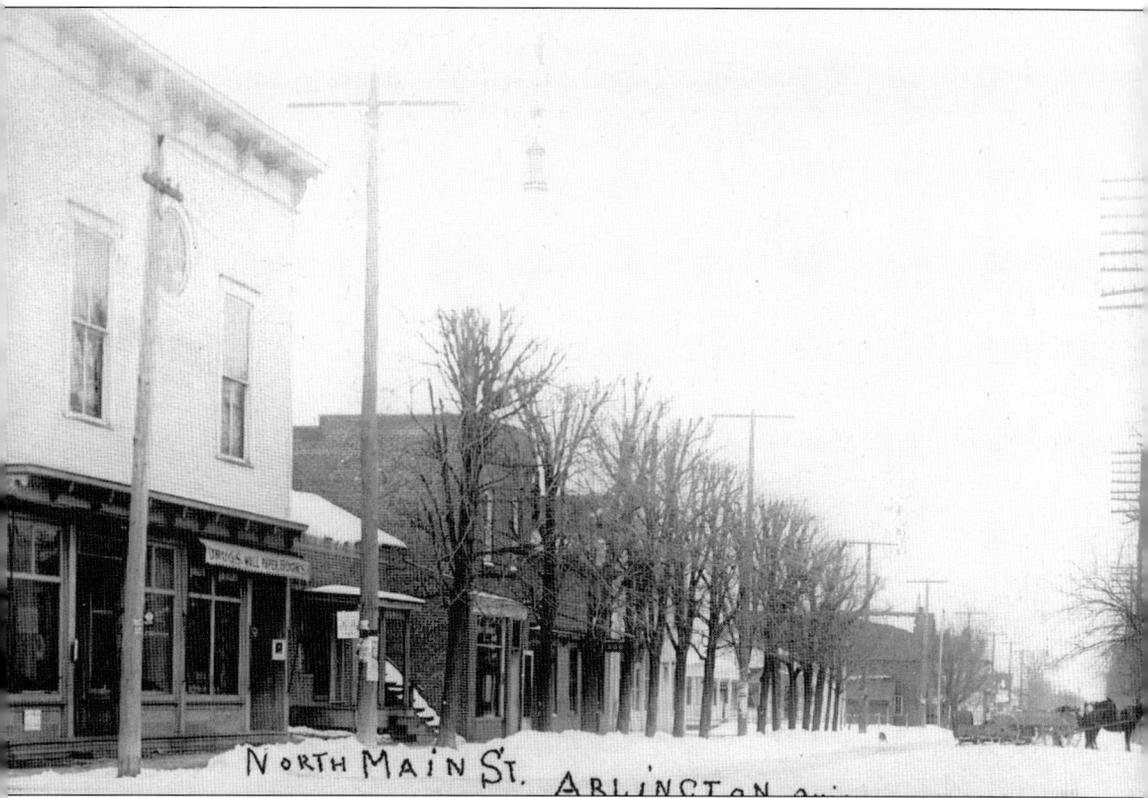

NORTH MAIN ST. ARLINGTON O.

STREET SCENE. 1906. Looking north from the square, along the west side of Main Street, on the left is the Crates Building. Built by John Crates in the late 1890s, the first floor was used by many business establishments. The second floor was known as the opera house. It had a raised stage at one end, and the main floor was used for seating and skating, and the school basketball team played games there. Next the first brick building in town, built in 1846 by Dr. Belizer Beach, was an inn known as the Stanford House. It was last occupied by a doctor's office. The next building was built in 1906 and housed the Hosafros and Swank Meat Market. In 1916, electric refrigeration was used to keep the meat cold. (Courtesy of Don Steinman.)

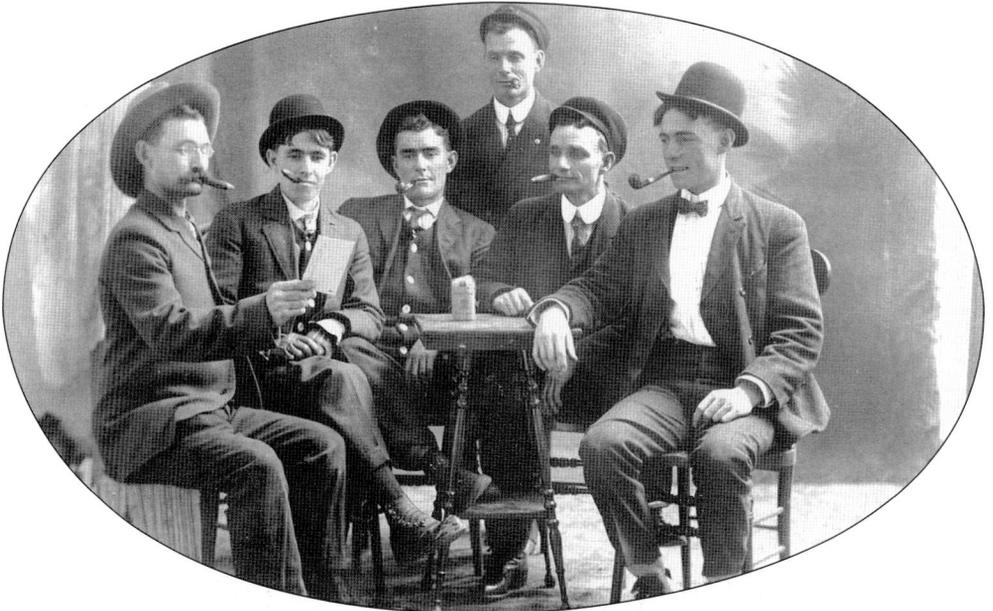

THE LONGWORTH BROTHERS, 1890s. Families were large in Arlington in the 1890s, and the Longworths were a good example. Pictured here from left to right are brothers Will, Bert, John, Philip, Sherm, and George Longworth. Notice their 1890s dress, especially the hats. They are gathered around a very small table, and some are setting on box crates enjoying some lively conversation. (Courtesy of Juanita Rinehart.)

HOUSE ON NORTH MAIN STREET, 1880. In 1880, Eli Bowman built this house. Later his daughter Celia (Bowman) Johnson lived there with her husband, Orville. The current owner is Martha Hodge. The left edge shows the barber pole of the W. A. Wells barbershop. The barbershop building was later the Dutch Boy Restaurant. (Courtesy of Leslie Lazenby-Hunsberger.)

KROSKE HOUSE, 1900S. Pictured is Nellie Kroske in front of her home on the southeast corner of North Cumberland and Deerfield Streets. Notice the wooden cistern pump by the post of the back porch, and the "knob and tube" electrical wiring on the outside of the house. (Courtesy of Tom Kroske.)

SOUTH MAIN STREET HOME, 1910. This house has been the property of Van and Jane (Hartman) Follas since January 12, 1981. The home was built in 1900, and in 1910, A. J. Metzler sent this picture of their home to her son Brice. The home was built from lumber from the schoolhouse that was located south of it. (Courtesy of Jane [Hartman] Follas.)

ARLINGTON GAZETTE.

Vol. 1. ARLINGTON, HANCOCK CC., O. THURSDAY, JUNE 9, 1898. No. 1

CENTRAL DRUG STORE

☀ **The Purity** ☀
Of our Drugs and Chemicals

Arlington will Celebrate.
The Glorious 4th to be Celebrated in
Good Old Fashioned Style by the
Citizens of Arlington and
vicinity.

The result of two public meetings
held in the City Hall, the first one on
Saturday, May 20th, and the second
one on last Saturday night, is that

J. R. Trovinger

Calls attention to the fact that he still handles

ARLINGTON GAZETTE, JUNE 9, 1898. One of the early Arlington newspapers was the *Arlington Gazette*. It was succeeded by the *Arlington Leader* and then the *Arlingtonian*. Both the *Gazette* and the *Leader* lasted only a short time. They lacked the capital and sufficient advertising to keep going. The *Arlingtonian* was a very successful newspaper from 1906 to 1971 with lots of advertising and family and town news. (Courtesy of Don Steinman.)

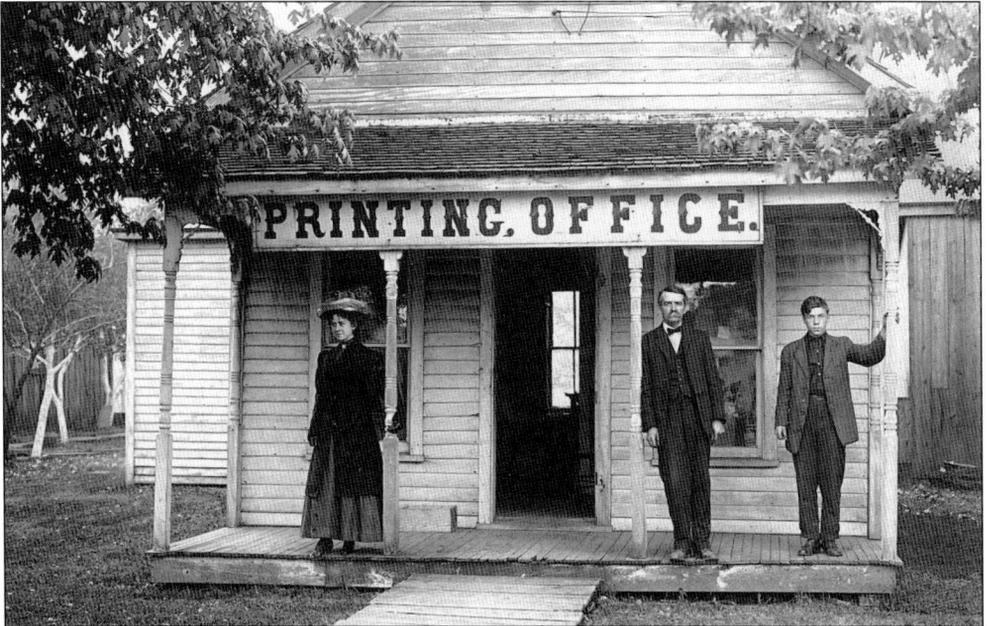

ARLINGTONIAN, 1920. The *Arlingtonian* office was located just north of the Home Bakery building on lot 14 of the original plat. The first issue of the *Arlingtonian* was published on February 27, 1906, and the last issue in 1971. There were three owners of the *Arlingtonian*: Frank Beitler, Cal Longworth, and Malinda Shoemaker. Pictured above are Olive (Beitler) Lehr, Frank Beitler (Olive's father), and Cal Longworth. Longworth was editor and publisher for 39 years. (Courtesy of Joe Schaaf.)

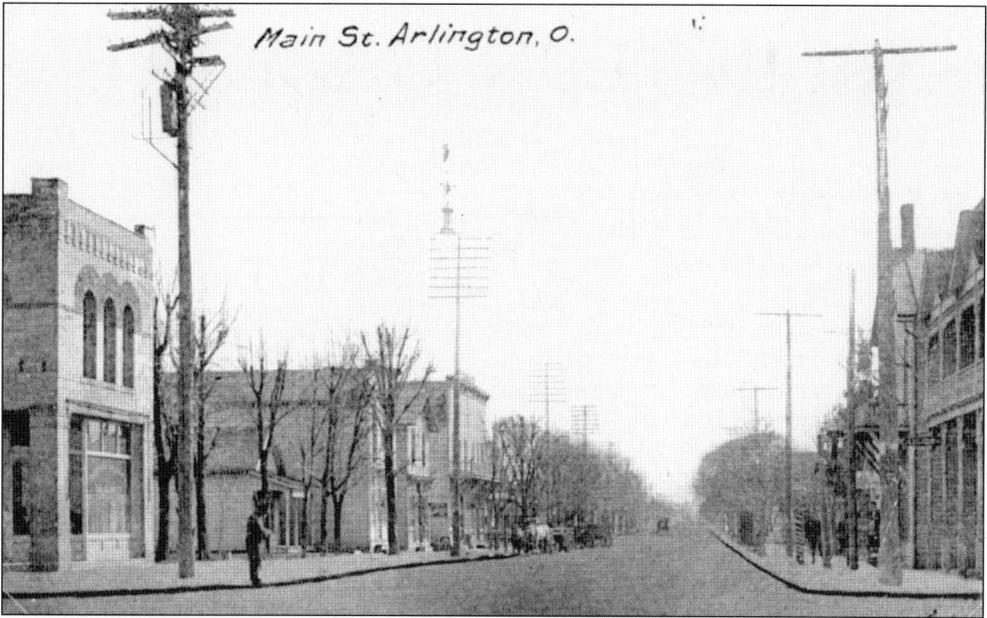

SOUTH MAIN STREET, ARLINGTON, 1911. The business district from the square looking south shows that the trees along the street were trimmed up and the leaves had not come out yet, suggesting this was a late-winter picture. The electric poles and the streetlight hanging down in the middle of the square make this an interesting street scene. (Courtesy of Paul Reusch.)

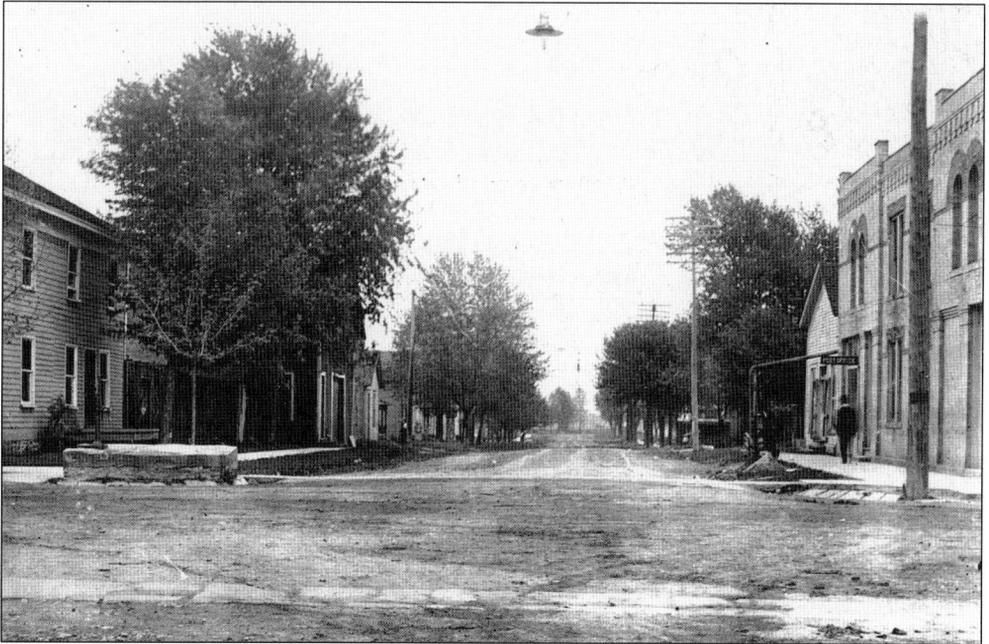

MAIN AND EAST LIBERTY STREETS, 1907. Looking from Main Street down East Liberty Street, on the left is the Pioneer Hotel and the livery stable behind it run by Percy Garlinger. On the right is the Farmers and Merchants Bank building with the post office directly behind it. Note the electric light at the intersection, a sign that Arlington had electric streetlights early. (Courtesy of Leslie Lazenby-Hunsberger.)

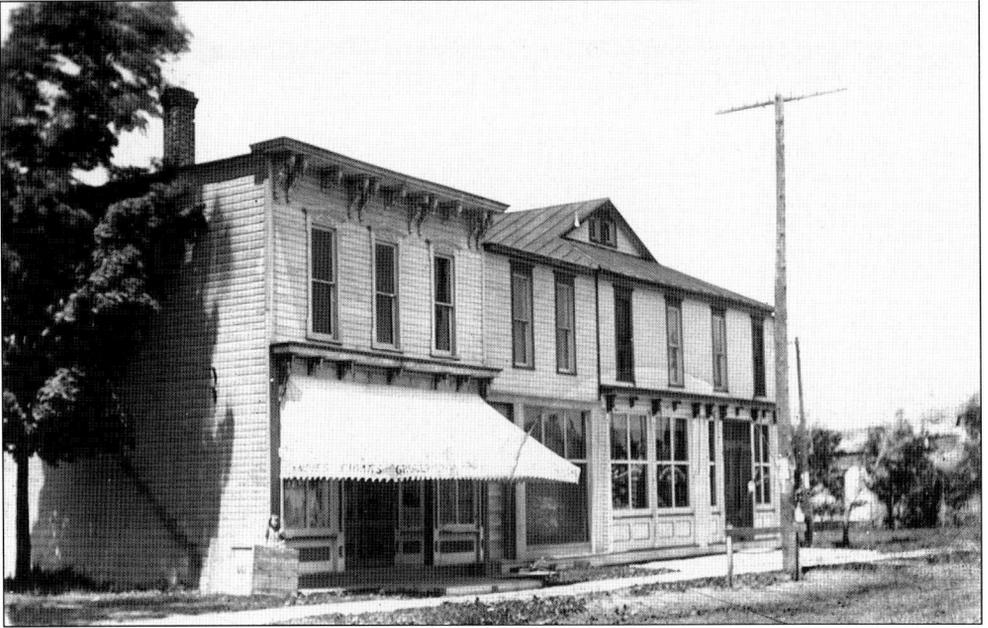

ED RETTIG'S GROCERY STORE (LEFT) AND GEORGE WERTENBERGER'S FURNITURE STORE (RIGHT), C. 1909. These businesses were located at the southwest corner of Deerfield and Main Streets in Arlington. The current occupants of these buildings are the Arlington Branch Library and McMillen Apartments. (Courtesy of Darwin Wilson.)

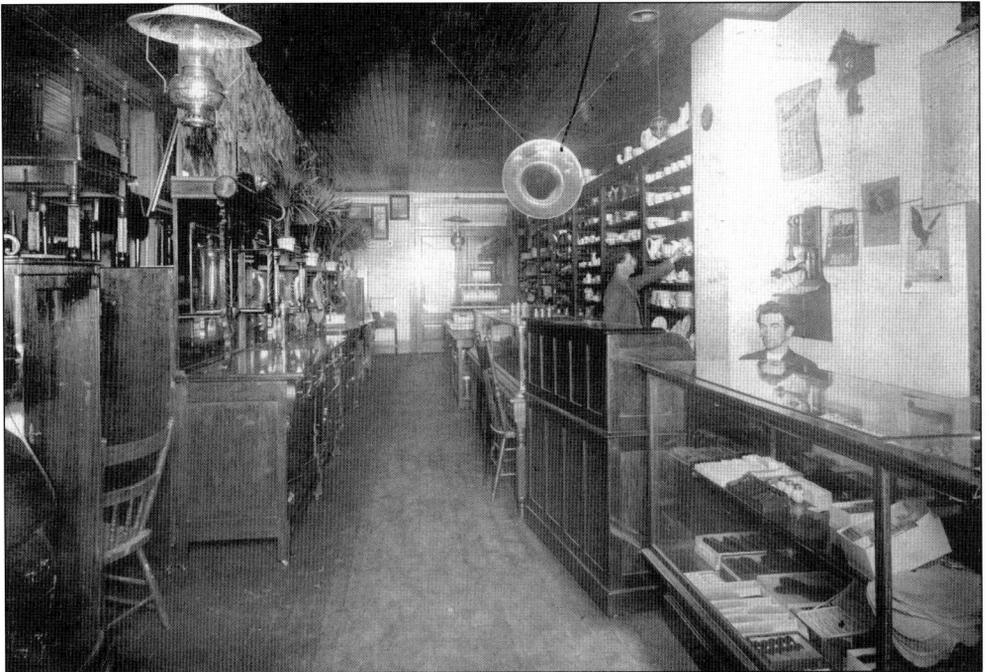

GEORGE WERTENBERGER'S FURNITURE STORE INTERIOR, 1905. A wide variety of furniture items were sold, from very large items to small pieces. George Wertenberger ran this store from 1897 to 1926, putting in 14 to 18 hours a day, six days a week. (Courtesy of Darwin Wilson.)

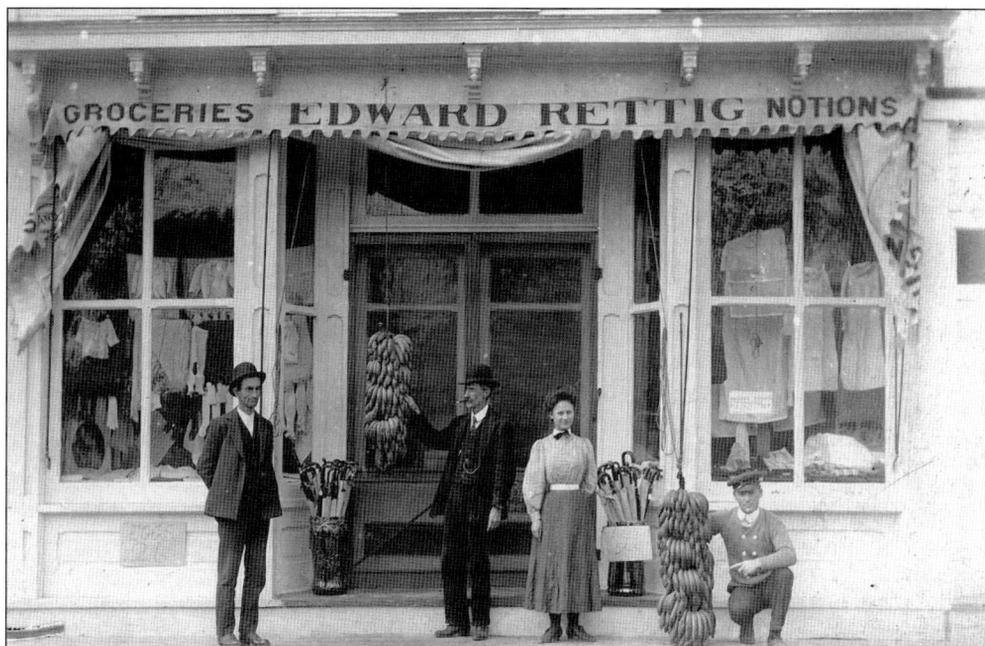

RETTIG'S GENERAL STORE, 1910. Half of this building houses the library today. The other half was torn down to make room for the parking lot. The people in the picture, from left to right, are George Wertenberger, L. E. Huston, Xanthippi (Steinman) Bibler, and Ed Rettig. Bibler used to make ladies' hats that sold in the store. (Courtesy of Darwin Wilson.)

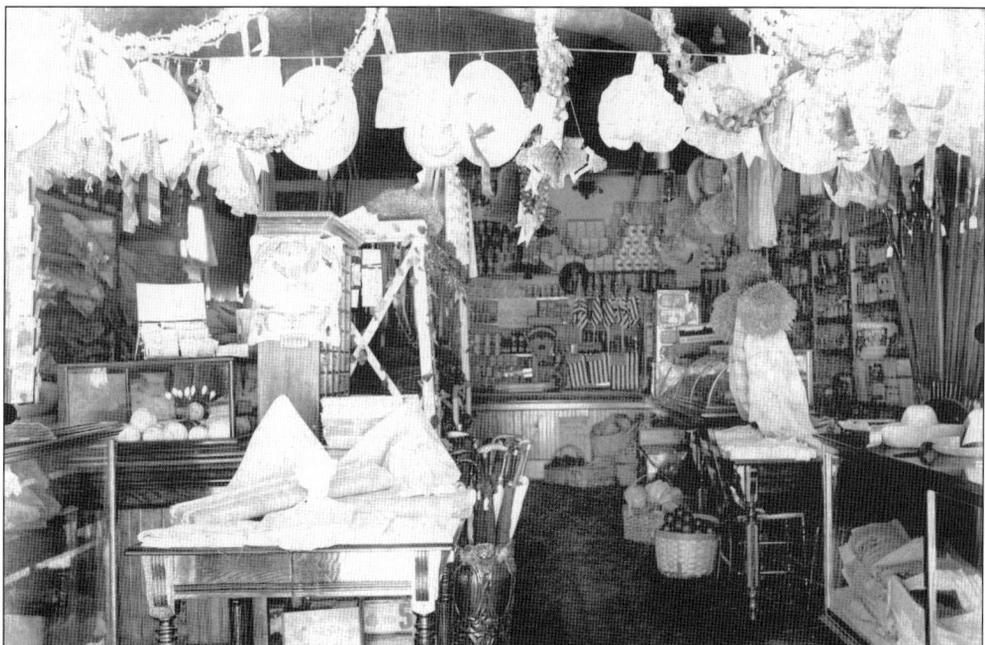

THE INTERIOR OF ED RETTIG'S STORE, C. 1909. Ed Rettig sold a wide array of goods, including hats that were made by Xanthippi (Steinman) Bibler. Rettig once told a salesman not to come back or he would shoot him. The salesman finally came back and sold Rettig some goods, but Rettig shot him in the behind with a BB gun. (Courtesy of Darwin Wilson.)

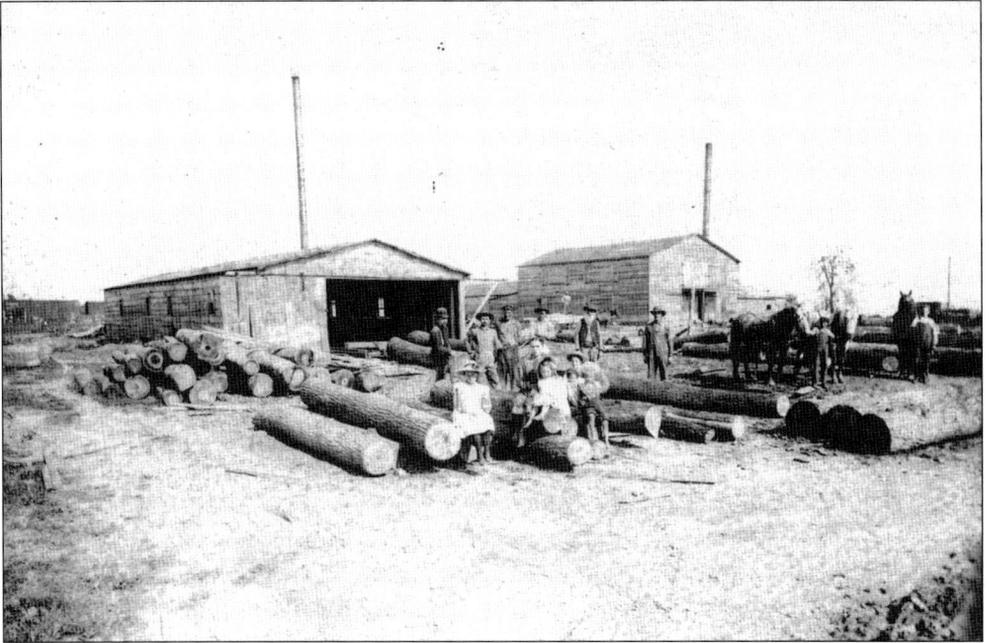

JOHN STEINMAN LUMBER COMPANY, 1907. This is an early scene from a lumberyard that opened in 1906. The sawmill on the left has many logs from area forests ready to be cut. The "big barn," as it was called, is in the background. John Steinman left the Steinman Brothers Lumber Company in Jenera to start this business in Arlington. (Courtesy of Juanita Rinehart.)

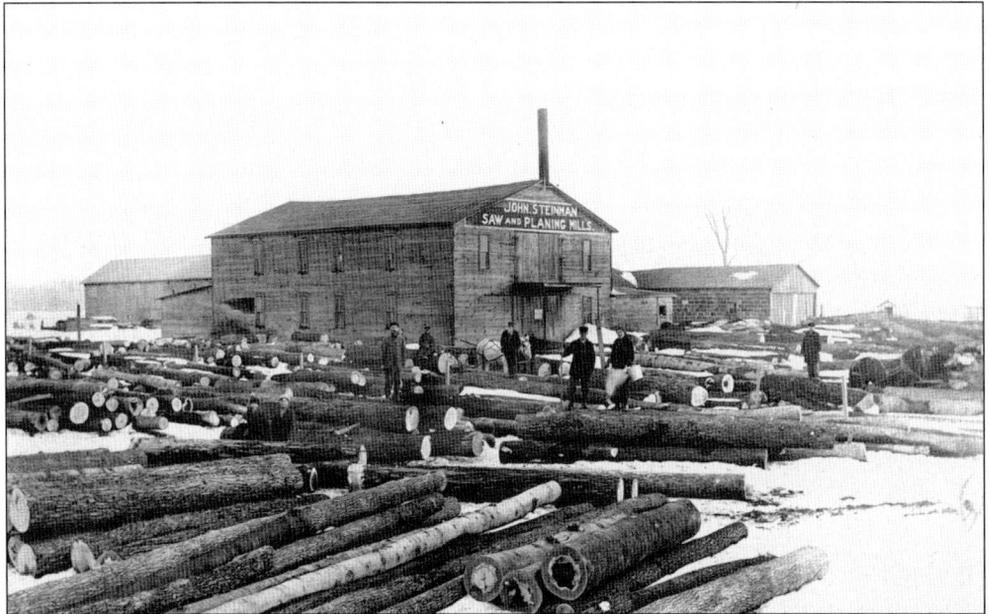

JOHN STEINMAN LUMBER COMPANY, 1912. The sign on the big barn says, "John Steinman Saw and Planing Mills" and shows more modern buildings, including a new sawmill on the right and a large lumber storage barn in the rear. The planing was done in the big barn to the left. Trees from this area produced quality lumber, and even today, sawmills still like the walnut, ash, oak, and cherry grown here. (Courtesy of Don Steinman.)

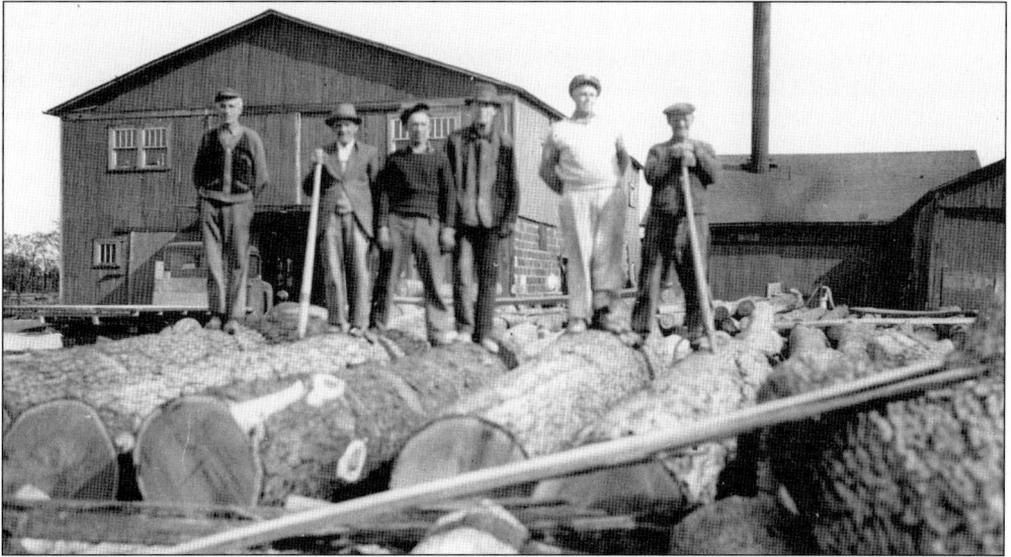

JOHN STEINMAN LUMBER COMPANY, 1920S. Pictured here from left to right are Cloyd Steinman, John Steinman, Raymond Steinman, Mack Hook, Howard "Misty" Steinman, and Bill Gossman. Logs were moved by horses or cant hooks, which some of the men are holding. The lumberyard was located by the T&OC and was on the present site of the Farmers Commission Company elevator. (Courtesy of Don Steinman.)

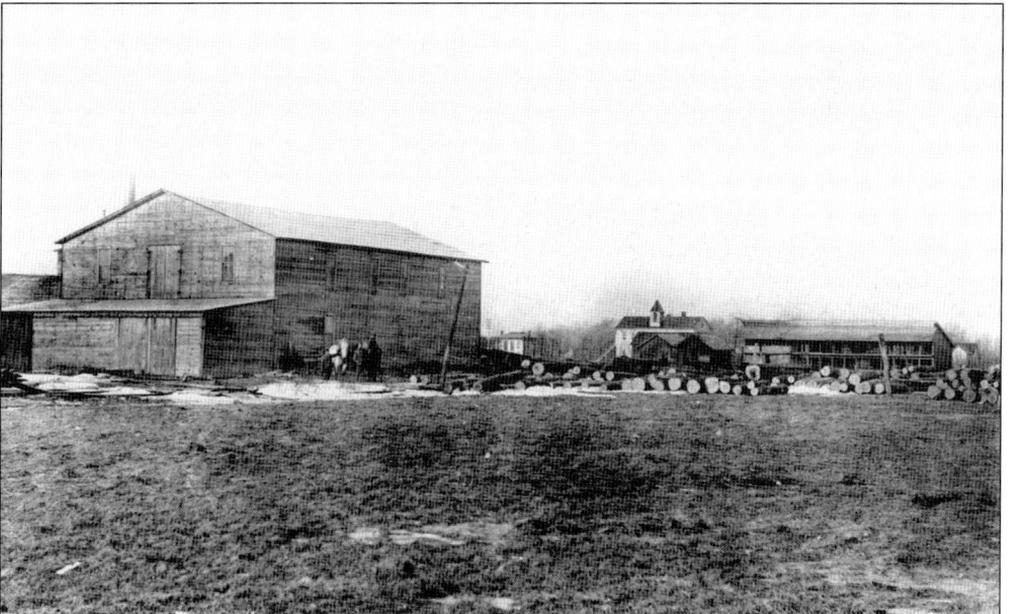

ARLINGTON TOWN SCENE, 1910–1915. This scene from the T&OC looking west shows the John Steinman Lumber Company buildings and property. Directly west of it was a pasture field. Showing predominately in the background is the wood frame, two-story Arlington School building, which was built in 1860 and served the village until 1923. (Courtesy of Don Steinman.)

Arlington, Ohio _July 10_ _1911_

M _per Grit_

BOUGHT OF John Schirmer

DEALER IN

GRAIN, SEEDS, WOOL, FLOUR, FEED AND SALT

TERMS

By 36 25/60 bus wheat @ 1.10	40.05
To Cash	15.40
" 2 bbl flour	15.60
" 1 " salt	1.35
" 1625# coal	2.84
	$ 34.79

40.05

JOHN SCHIRMER INVOICE, 1911. John Schirmer was a north end businessman located in the brick building at 526 North Main Street. In addition to selling grain, seeds, wool, flour, feed, and salt, he also sold the coal that kept Arlington houses warm in the winter. He also was in charge of keeping the dust down on the streets of Arlington by running the water wagon, much to the delight of the children. (Courtesy of Don Steinman.)

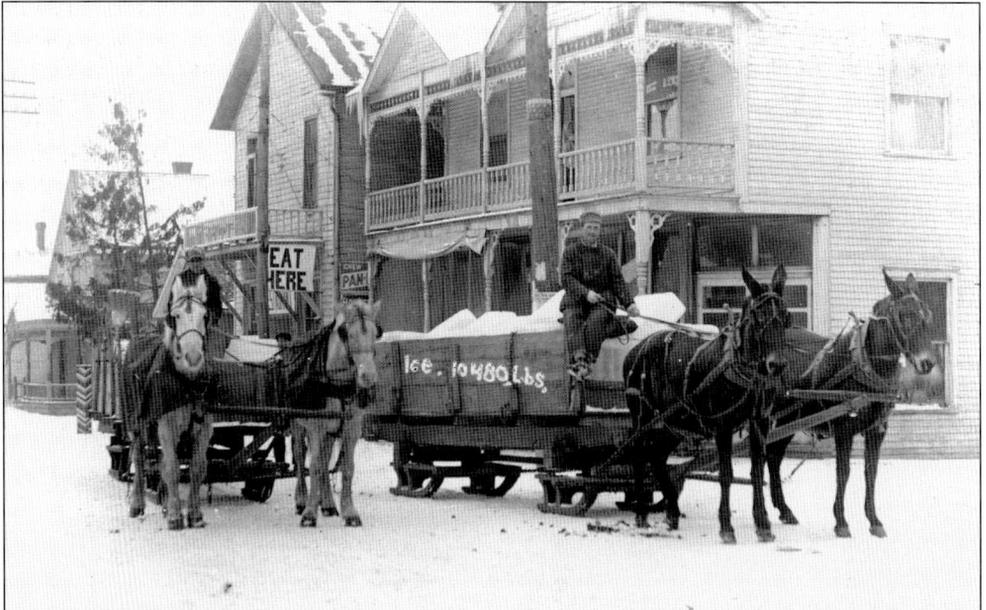

ICE WAGONS, EARLY 1900s. In the days before refrigerators, people had to use ice to keep their food cold. They cut ice from ponds, creeks, and streams during winter and brought it back to town on large sleds. They put the ice under hay and sawdust to keep it from melting. Then the ice was sold to people for their iceboxes. (Courtesy of Tom Kroske.)

THE HOTEL GAY, 1907. This was a large hotel in Arlington with many rooms that served meals in a large dining room downstairs. It started in 1895 as the Grand Central Hotel and quickly changed to the Hotel Gay when Al Gay became the owner. Other owners were G. T. Beagle and Sam Hinchey. Arlington was known for its hotels. Salesmen tried to end their day in Arlington because of the fine hotels. Both hotels sent drivers to the train station to pick up guests. Quite a rivalry existed between the hotels. The hotel closed in 1925. Pearl Misamore bought the building in 1926 and turned it into a hardware store, and Lee Gillespie bought the store and added onto it, calling the business the Arlington Hardware and Electric. (Courtesy of Helen Tombaugh.)

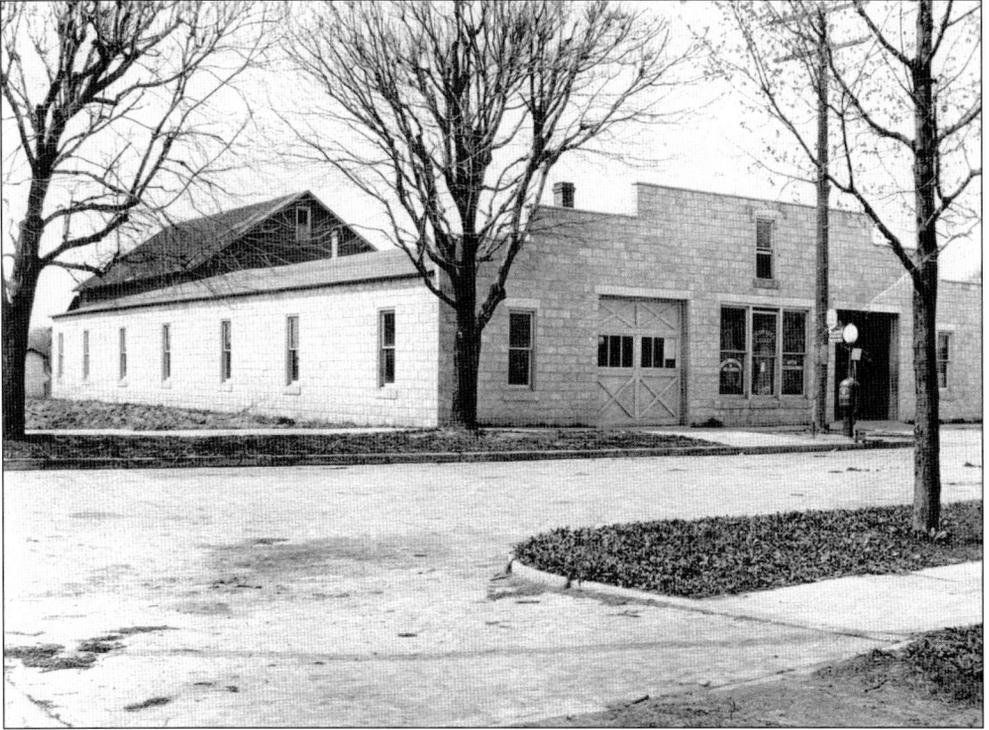

CORBIN BROTHERS GARAGE, EARLY 1900S. The address of Corbin Brothers Garage was 204 North Main Street. Later it became the Davis Poultry Company, which also sold Marathon gas and ice cream and housed Herb Price's Garage. This building was later remodeled for use as the town hall. (Courtesy of Peggy Corbin.)

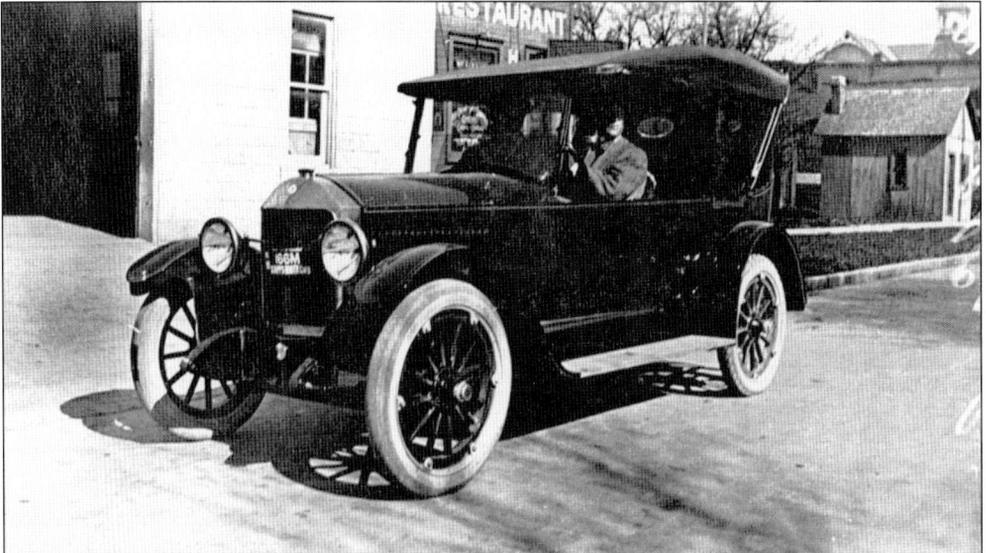

CORBIN BROTHERS GARAGE, SECOND DECADE OF THE 20TH CENTURY. Corbin Brothers Garage specialized in the repairing of early Chevrolet vehicles. Levi Hinchey's restaurant, the Blue Goose Restaurant, and the Arlington Methodist Evangelical Church bell tower can be seen in the distance. (Courtesy of Leslie Lazenby-Hunsberger.)

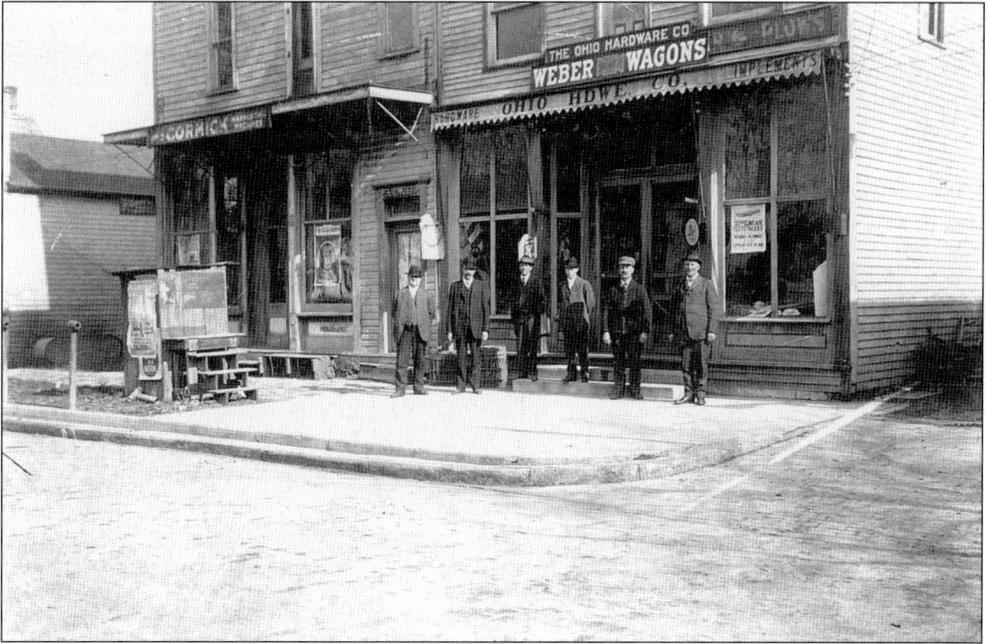

STREET SCENE, NORTH OF EAST LIBERTY, 1900S. The building on the left was last occupied by Kroske's Grocery and was razed in the 1940s. In 1947, the other building was sawed in half (front and back) and moved across Main Street and became the north section of the Arlington Hardware and Electric. The owners of the Ohio Hardware Company are standing in front of their establishment. (Courtesy of Helen Tombaugh.)

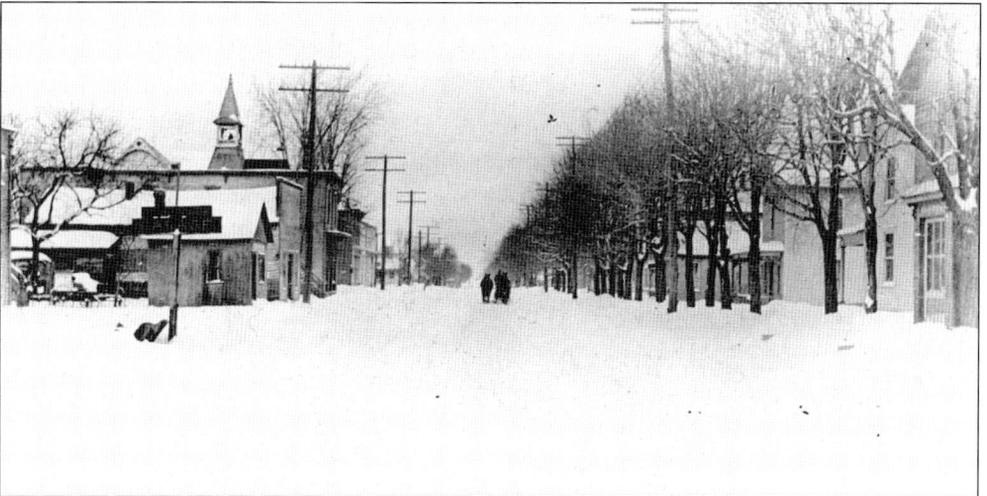

NORTH MAIN STREET, 1918. On the left, beyond the small shed, is the Joe Hinchey barbershop. The next building is the Blue Goose grocery. Both have been razed. The bell tower of the Methodist Episcopal church is in the distance. On the right of the photograph is the Fisher Shoe Store. It has been razed, but the houses to the north remain. (Courtesy of Leslie Lazenby-Hunsberger.)

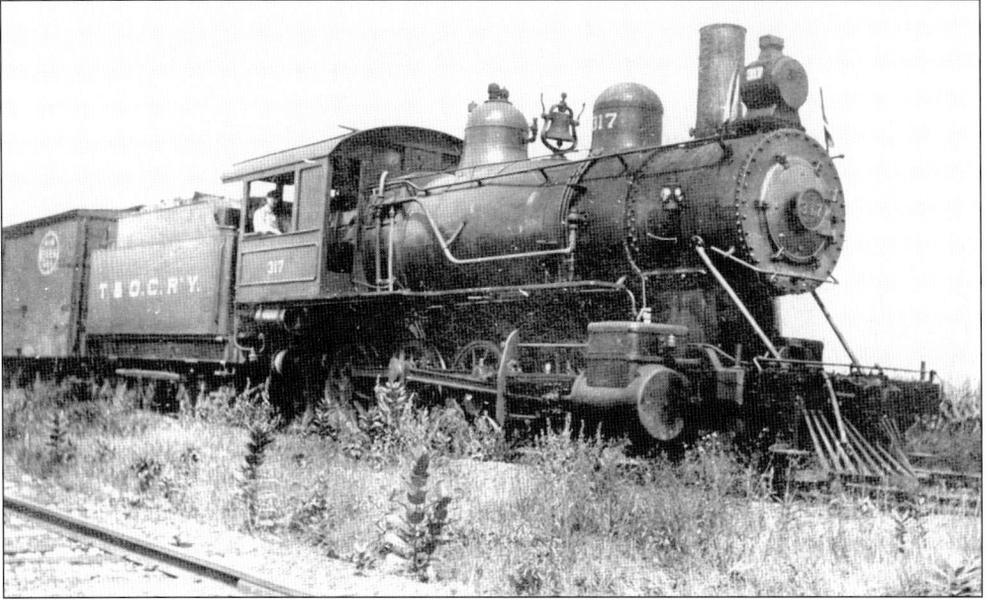

T&OC ENGINE, 1916. Engineer William Perry Rose is at the controls of the engine. He was an engineer for 10 years before his marriage. He received a gold Hamilton watch with a wood-burning engine on it for his service to the railroad. The T&OC was the north and south track through Arlington and first came through the area in 1889. (Courtesy of Bill Rose, grandson of William Perry Rose.)

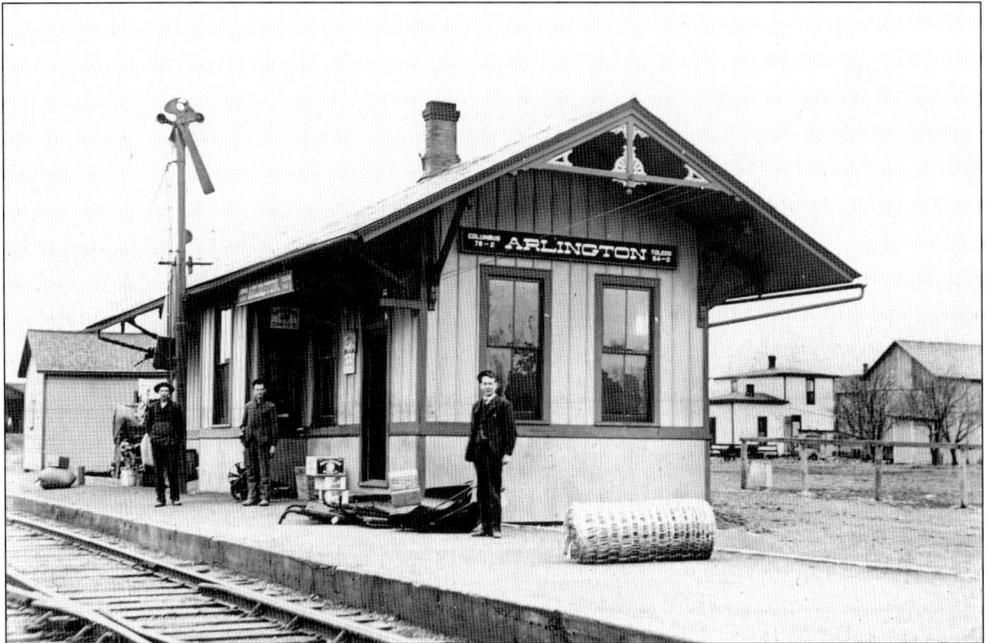

TRAIN STATION, 1920. This photograph was taken looking south toward the train station, which was built in the early 1900s. Note the hitching posts in the background. The pole on the left was used to signal instructions to the engineer. The pole was called a semaphore. Trains hauled freight and passengers. (Courtesy of Joe Schaaf.)

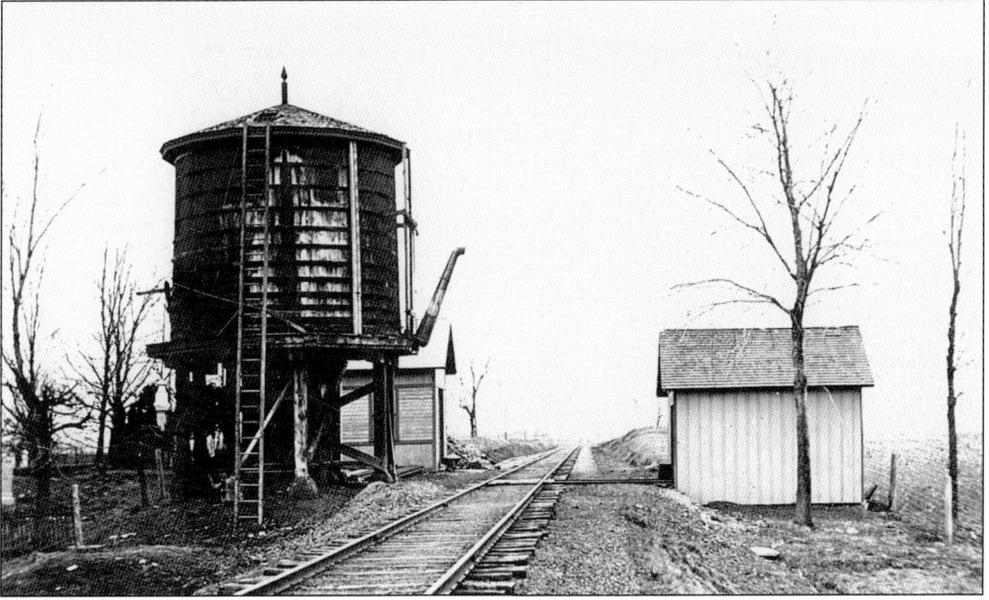

T&OC, c. 1910. This scene is along the tracks by Arlington Park. On the left is a tank that supplied water for steam trains. On the right is a small building that housed a hand pump cart that sectional track workers used. Note that on the far left are tombstones, comprising part of the early town cemetery. The graves were eventually dug up and moved to the new cemetery west of town, and the ground was used for the present-day park. (Courtesy of Don Steinman.)

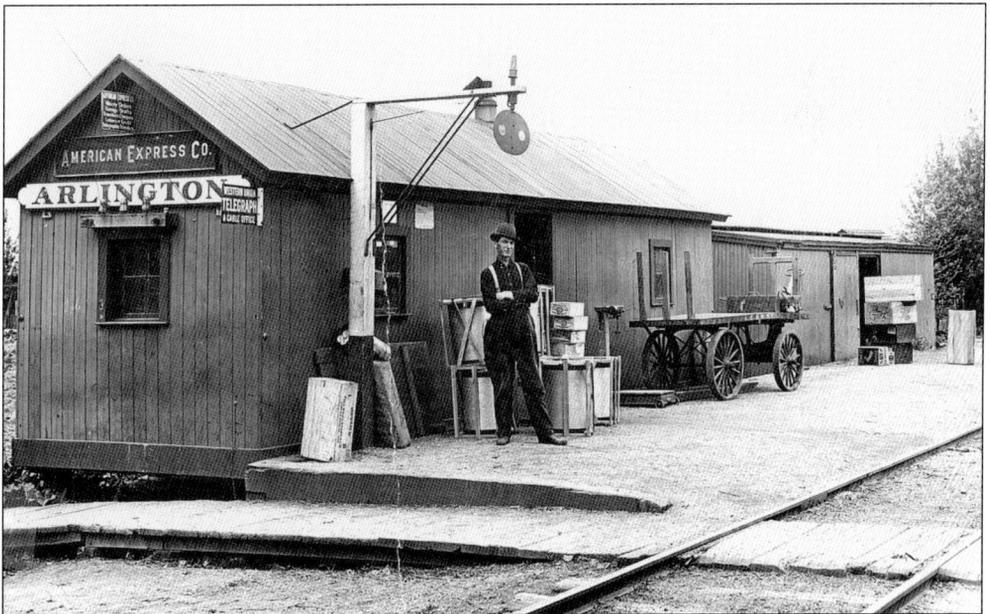

AC&Y STATION, 1907. Stationmaster Henry Groman ran this north side station, which actually was made from a boxcar. The AC&Y ran from Akron to Delphos. Just a half mile west of the station, a group of hobos camped under sycamore trees, and it was called the "Sycamore Hotel." Freight was hauled, and 43,601 passengers were carried by this line in 1921. The last train ran on January 2, 1983. (Courtesy of Leslie Lazenby-Hunsberger.)

MEMORIAL SERVICE

For The Deceased Members of Welker Post
G. A. R. No. 266,
To Be Held At The M. E. Church, Arlington, Ohio,
At 2 O'clock, P. M. Sunday, Feb. 3rd, 1907.

PROGRAM.

America	Sung by audience.
Invocation	Chaplain Vanatta.
Song	Sons of Veterans Auxiliary.
Opening Exercises	Com. Wm. Holmes.

Reading of the names of the members who have died since the organization of the Post

	By the Adjutant.

EULOGIES.

F. M. Boyle	P. A. Riegle.
John A. Woods	H. C. Vanatta.
Jeremiah Greer	J. R. Longworth.
Song	Sons of Veterans Auxiliary.
George F. Orwick	N. B. Anderson.
Levi W. Hinchey	F. N. Holmes.
John C. Smith	R. P. Smith.
Song	Sons of Veterans Auxiliary.

Volunteer eulogies on S. H Harris, Jefferson Riegle, John Cramer, Robert Dorney, John A. Wenner, Albert Harris, L. S. Lafferty, H. D. Pittsford, A. S. Murdick, Jerome Decker, Isaac Crawford, Charles Doolittle, James Cox, Alva Beagle and John Marquart.

Song	Sons of Veterans Auxiliary
Memorial Address	D. F. Beitler
	followed by D. M. Mc. Lane.

Song "Shall we meet beyond the river"
Benediction.

WELKER POST MEMORIAL SERVICE, 1907. This program was held at the Methodist Episcopal church in Arlington to honor deceased members of the GAR in the Civil War. Former Union soldiers joined GAR local posts after they were started in the 1880s. It was a chance to get together and tell old Civil War stories and renew friendships. They even held campfire get-togethers. (Courtesy of Leslie Lazenby-Hunsberger.)

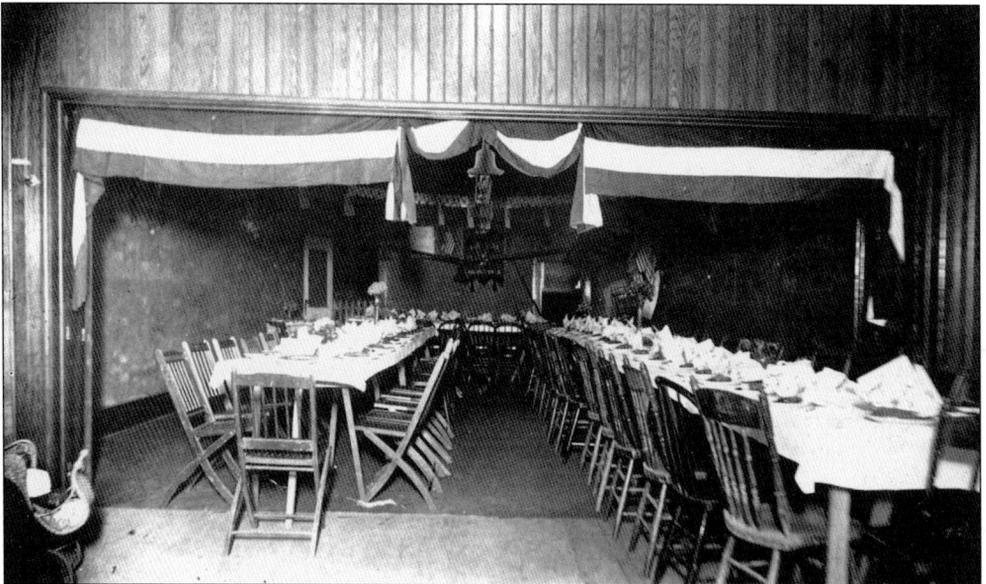

MACCABEE HALL, 1908. This hall was located on the second floor of the building at 106 North Main Street. The Maccabees, both men and women, had lodges in most of the small communities. They doctored the ill and provided relief for families in dire straits, and it also was a social organization. They had fund-raisers once or twice a year, such as an ox roast or a carnival of sorts. In this picture the hall is decorated and ready for a festive occasion. (Courtesy of Leslie Lazenby-Hunsberger.)

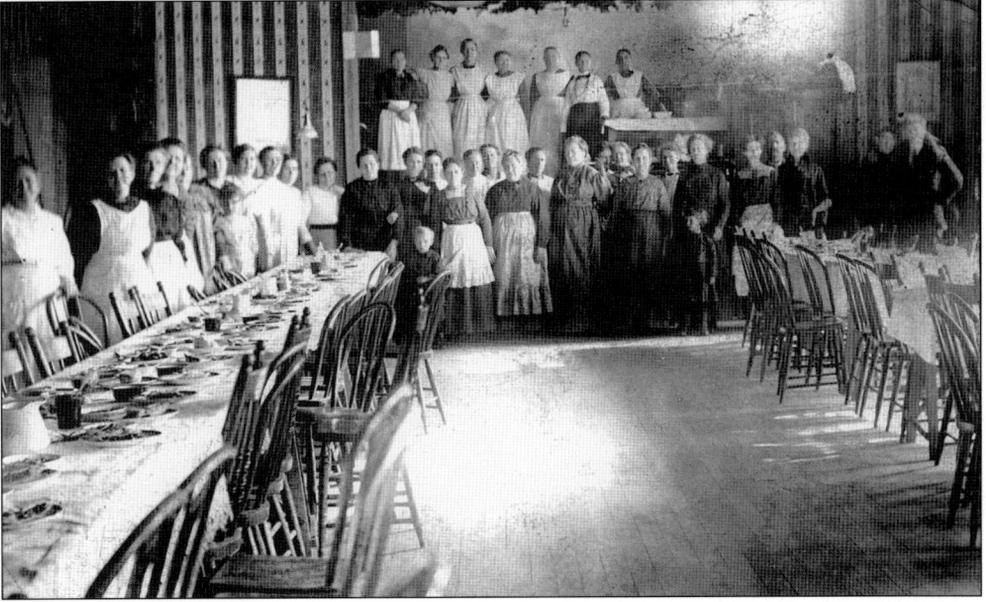

FARMERS INSTITUTE DINNER, 1914. The ladies of the Methodist Protestant church served a dinner at the Odd Fellows hall, located on the second floor of the Crates Building for the Farmers Institute. They held the Farmers Institute dinner once a year, and attendees learned new farming methods. (Courtesy of Leslie Lazenby-Hunsberger.)

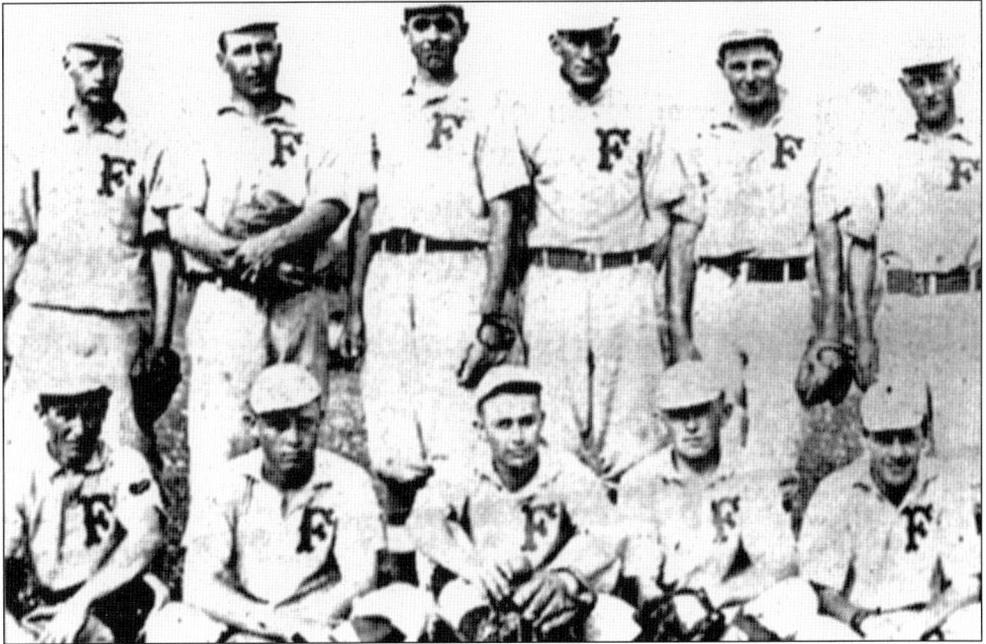

ARLINGTON FEDERAL BASEBALL TEAM, 1917. Baseball has been a popular sport in Arlington over the years. The Arlington Federal baseball team in 1917 had attractive uniforms. Members include Gale Essinger, Edgar Bame, Steve Alge, Dewey Sebastion, Theron Fink, Carl Romick, Floyd Corbin, Charles Jacob, Cleo Hite, and Elsworth Essinger. (Courtesy of Leslie Lazenby-Hunsberger.)

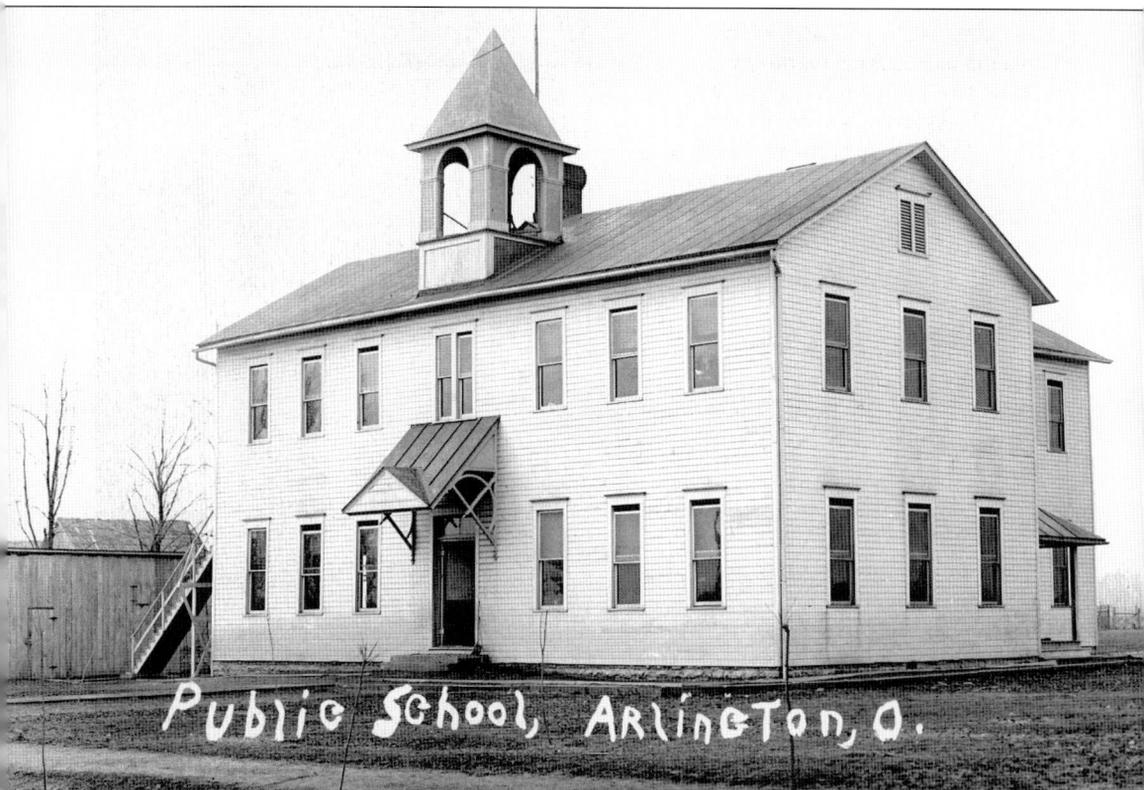

Public School, Arlington, O.

ARLINGTON PUBLIC SCHOOL, 1910. This six-room wooden school was located at 336 South Main Street on the front lawn of the current school. It was built in 1860 and served the community until mid-1923, when the new brick school building took its place. The old wood frame school had been condemned by the state. The fire escape steps on the south side were added later. It served the children of the village of Arlington for 63 years. Rural districts started coming to the new, more modern building as it offered the extra room to accommodate them. When torn down, the wood rafters were used to build a home directly across the street from the old school. (Courtesy of Peggy Corbin.)

FIRST GRADUATING CLASS, 1905.
The young lady is Amy Garlinger.
The gentlemen, from left to right, are
William A. Rauch, Edgar M. Crawford,
Grover L. Staley, and William H. Carey.
Crawford was a student, and he was also
the teacher because he passed the Boxwell
exam. (Courtesy of Tom Kroske.)

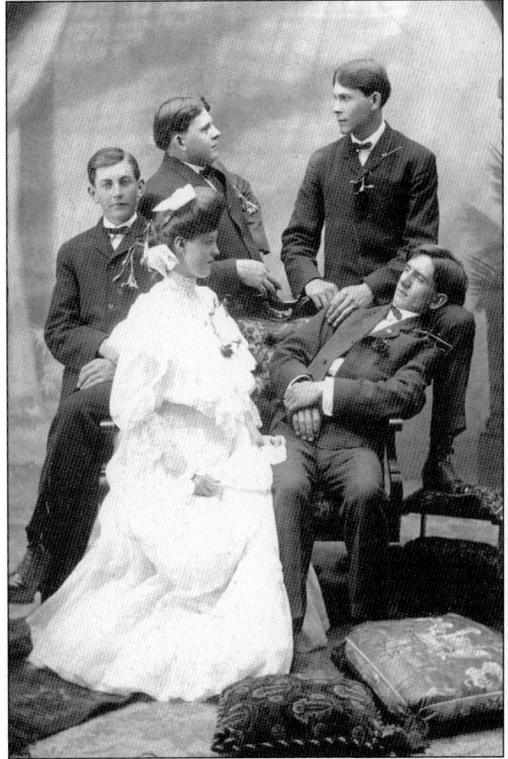

First Annual Commencement

Arlington Village Schools

Thursday Evening, May 18, 1905

===== M. P. Church =====

PROGRAM

Invocation - - -	Rev. D. Calkins
Praise Ye the Father - - -	Gounod
ORPHEUS GLEE CLUB	
Oration—"The Blight of Idleness" -	WILLIAM A. RAUCH
Oration "The Value of Decision" - -	GROVER L. STALEY
The Beetle and the Flower -	Veit
ORPHEUS GLEE CLUB	
Oration—"The Significance of an Education"	AMY S. GARLINGER
Oration—"The Power of the Minority" -	EDGAR M. CRAWFORD
The Bells of Seville -	Jude
ORPHEUS GLEE CLUB	
Oration and Valedictory—"We Build the Ladder by Which We Rise" - -	WILLIAM H. CAREY
The Drum -	Archer—Gibson
ORPHEUS GLEE CLUB	
Class Address "Life's Navy" -	Frank S. Fox
Ho, Ye Gallant Sailors -	Macy
ORPHEUS GLEE CLUB	
Presentation of Diplomas - -	Rev. W. P. Rilling
Old Folks at Home -	Foster—Melamet
ORPHEUS GLEE CLUB	
Benediction - -	Rev. G. J. Hartman

FIRST COMMENCEMENT, 1905.
The first commencement was
held at the Methodist Protestant
church on May 18, 1905. The first
graduating class had five students,
and they graduated from the
Arlington Village School. They all
participated in the commencement.
(Courtesy of Tom Kroske.)

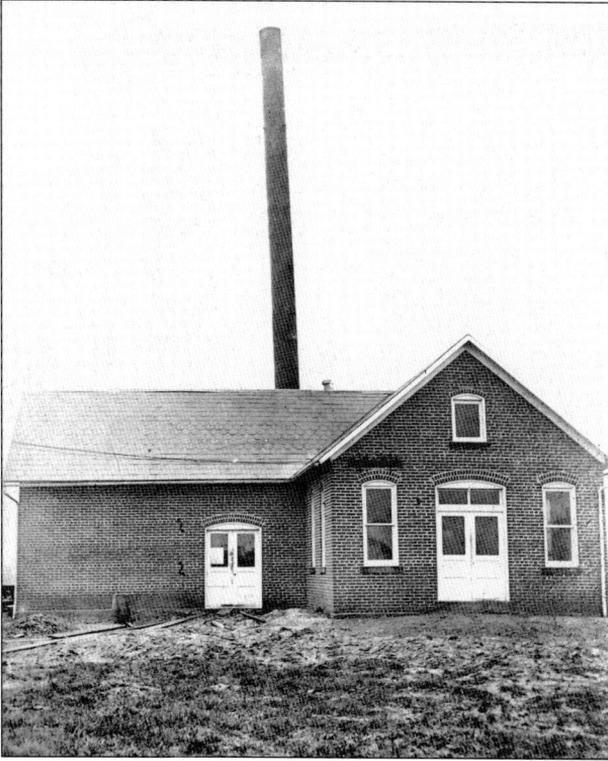

ARLINGTON ELECTRIC LIGHT PLANT, 1908. The light plant was located at the east end of Sumner Street that is now owned by the elevator. The plant did not operate during the day, and each house would only have one or two small working lightbulbs. The plant operated between dusk and 10:00 p.m. It started when the town purchased a small steam engine. Natural gas was used to produce steam to power the engine. (Courtesy of Don Steinman.)

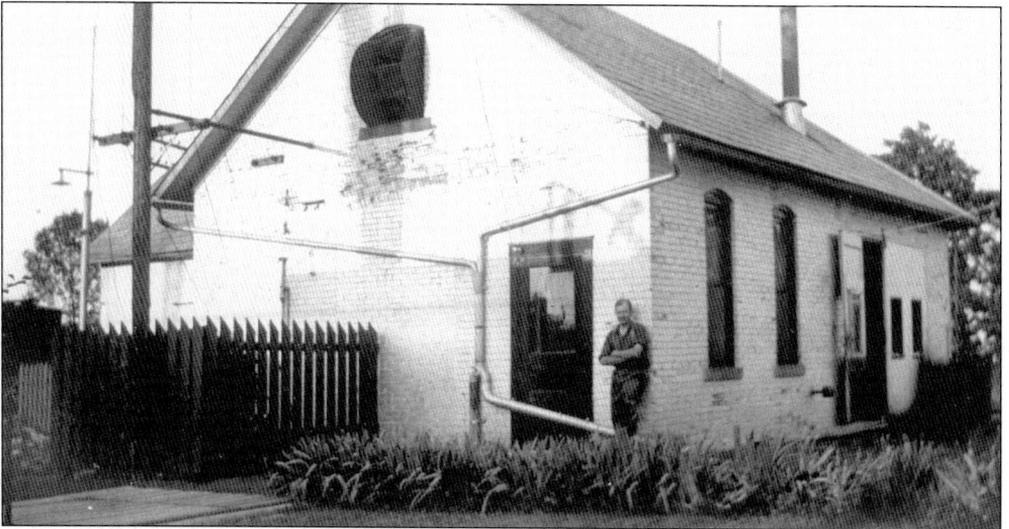

ORIGINAL ARLINGTON ELECTRIC LIGHT PLANT, 1900s. In the winter, electricity was available for two hours during the morning. The plant did not operate during daylight hours. If people wanted lights after 10:00 p.m., they had to light oil lamps. Expenses were very high, even though they did not use the plant very often. Board of Public Affairs members used their own money to pay for repairs. (Courtesy of Peggy Corbin.)

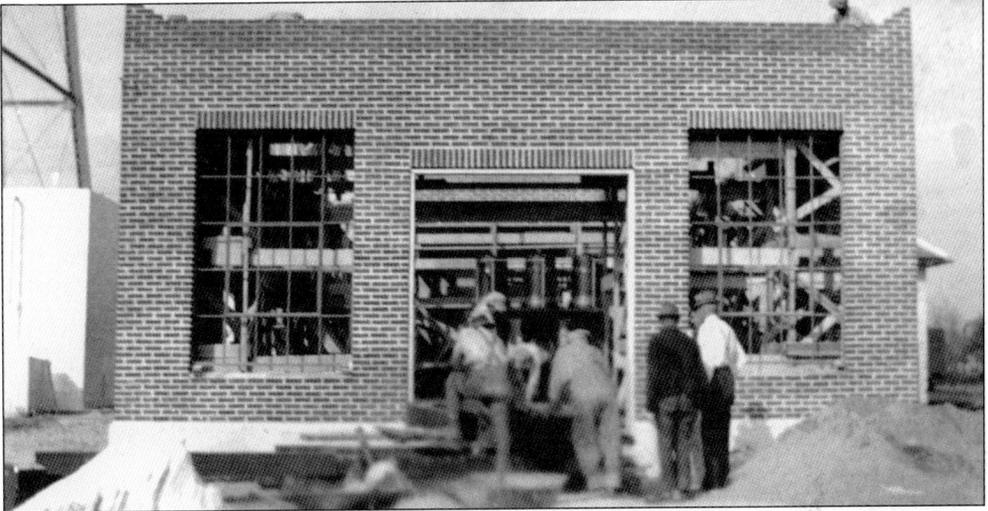

ARLINGTON ELECTRIC LIGHT PLANT. The plant was started in 1908, and four years later, a 100-horsepower engine was installed. On December 10, 1923, Arlington had 24-hour service. The light plant employed many young men who lived in Arlington. In 1923 and 1927, the plant was enlarged. (Courtesy of Peggy Corbin.)

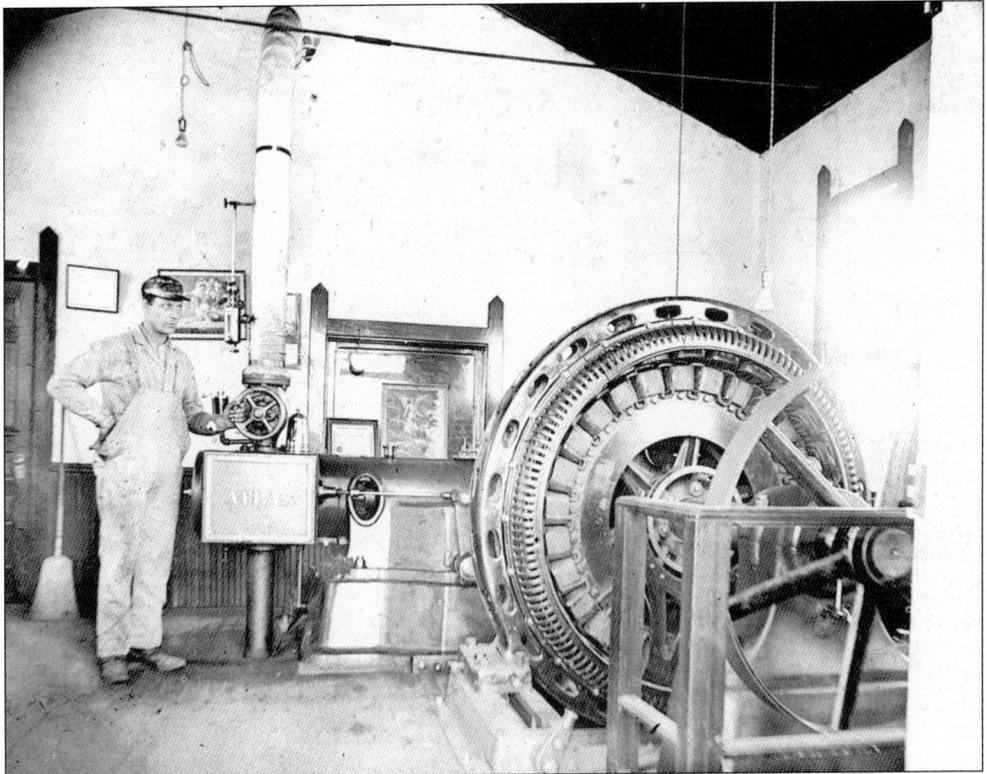

INSIDE THE ELECTRIC PLANT, 1900S. This is the dynamo and engine of the electric plant when the town manufactured its own electric power. On the left is the steam engine, which powered the dynamo pictured on the right. Steam came in from the piping to the engine. (Photograph by Beagle and Helms, courtesy of Don Steinman.)

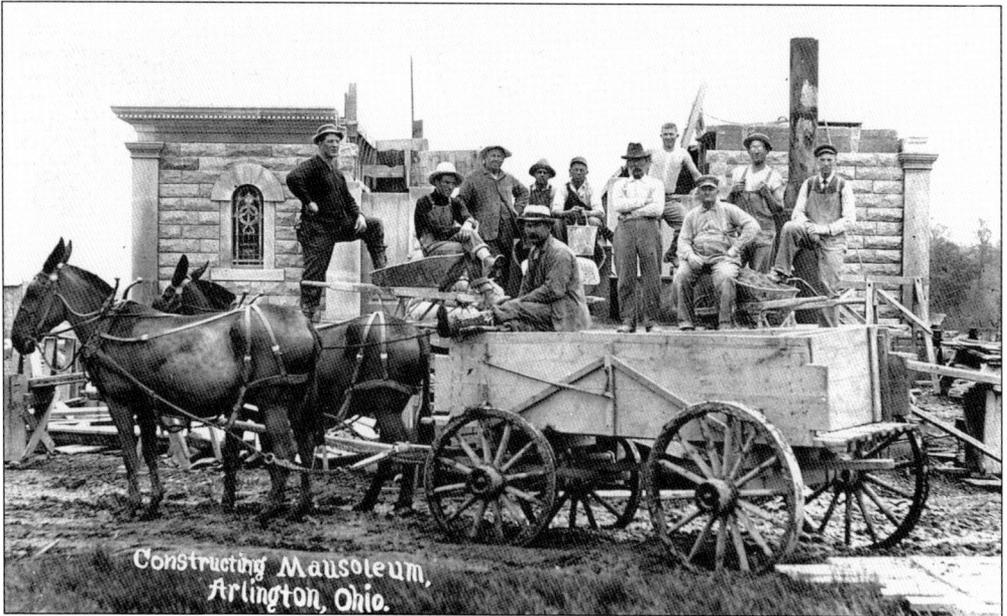

MAUSOLEUM, 1912. This is the construction team of the mausoleum; the team of mules was owned James Boyle. The mausoleum was constructed with sandstone block. It had crypts for 106 people. It was an attractive building, with double doors and stained-glass windows. (Courtesy of Leslie Lazenby-Hunsberger.)

ARLINGTON MAUSOLEUM, 1912. The mausoleum was located on State Route 103 about a half mile west of Arlington. Inside the mausoleum were crypts with doors that one could open and put caskets in to bury people instead of using a cemetery. Later when the mausoleum was destroyed, the caskets had to be taken out and put into a cemetery. (Courtesy Leslie Lazenby-Hunsberger.)

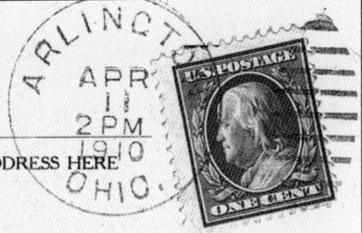

Post Card

Don't Spend One Cent

for *Wall Paper* until *you have seen our stock. New Spring Patterns now in. Stock complete.*

We can Save you Money

Julien & Davis
DRUGGISTS

ARLINGTON, OHIO

Made by Thomas & Co., Findlay, Ohio

ADDRESS HERE

James Boyle,
Arlington,
Ohio.

R. F. D. 15

JULIEN AND DAVIS POSTCARD, 1910. This drugstore also sold a lot of wallpaper. It was a successor to the Cotner Pharmacy in 1910. By 1911, the partnership dissolved with Julien acquiring the Arlington store and R. K. Davis the Findlay store. Julien traded his store for one in Elkhart, Indiana. A Mr. Modaff was the new store owner in Arlington. (Courtesy of Leslie Lazenby-Hunsberger.)

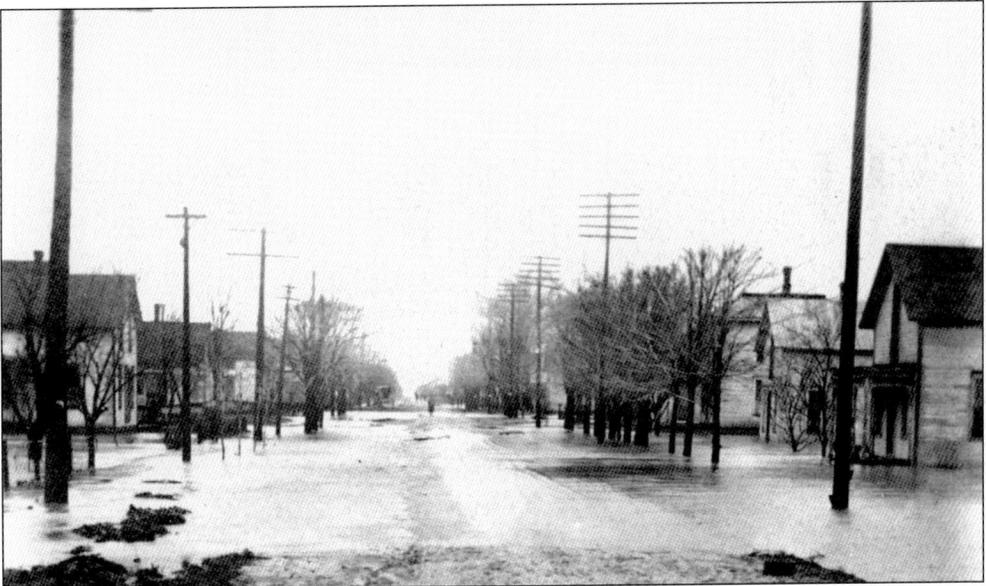

EASTER FLOOD, 1913. One of the biggest disasters in Arlington history was the Easter flood of 1913. In this picture, Main Street and the homes on each side of it are completely surrounded by water. The water receded slowly, and as one story has it, beaver dams were a problem back then and actually dammed up the water. They had to blow them up to get the water flowing. (Courtesy of Larry Hammond.)

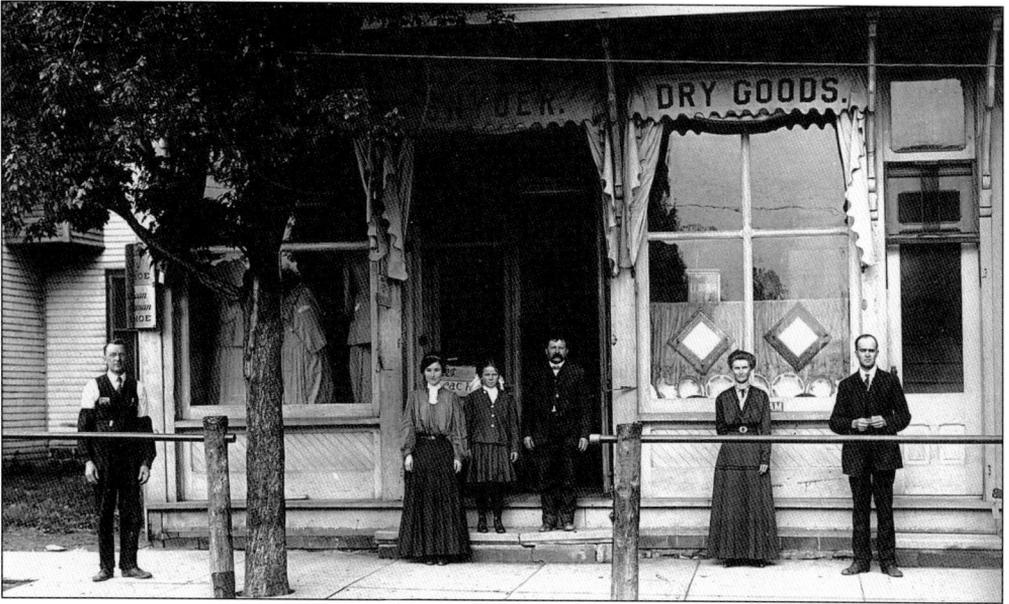

SNYDER DRY GOODS, 1910. Pictured from left to right are John Wilch, Myrtle (Snelling) Beach, an unidentified young girl, Peter Dillman, Rema Snyder, and Leonard E. "Pickle" Snyder. The store was built in the early 1900s and owned by Leonard E. Snyder. The clerk was Peter Dillman. It was located on Main Street on the south half of lot 15 in the original plat. (Courtesy of Joe Schaaf.)

ALEX SNYDER

Blacksmith & Expert Machinist

DO BLACKSMITHING, MA-CHINE & AUTOMOBILE RE-PAIRING

NORTH MAIN STREET

ALEX SNYDER ADVERTISEMENT, 1910. Alex Snyder was a local blacksmith and expert machinist who did repair work on the early automobiles. As a machinist, he could do turning and shafting, cut key sheets, make slots in cast iron, and make saw mandrels. His business was located in a barn at the rear of the southeast corner of Vail and North Main Streets. (Courtesy of Leslie Lazenby-Hunsberger.)

ROCK ISLAND BUTTER CO.

❦❦❦

Station, Rear of Crates' Store

We are Cash Buyers of Cream, Poultry and Eggs

GIVE US A TRIAL

❦❦❦

JOHN G. SCHAAF

Resident Manager

ARLINGTONIAN ADVERTISEMENT, 1910. Crates Brothers on the square bought eggs, poultry, and cream from the local farmers in addition to being a general store. Advertising was an important part of the business culture in Arlington. There was a lot of competition, and newspaper advertising was one way to get customers to one's store. (Courtesy of Leslie Lazenby-Hunsberger.)

Return in five days to
THE COTNER PHARMACY,
Arlington, Ohio.

THE COTNER PHARMACY, 1900. The Cotner Pharmacy was the third-oldest pharmacy in Arlington and was open between 1900 and 1910. The earliest pharmacy was in 1887, owned by a Dr. King. The second pharmacy was owned by Nick Stein. Except for seven years after World War II, Arlington has had a pharmacy or drugstore from 1887 to present. (Courtesy of Paul Reusch.)

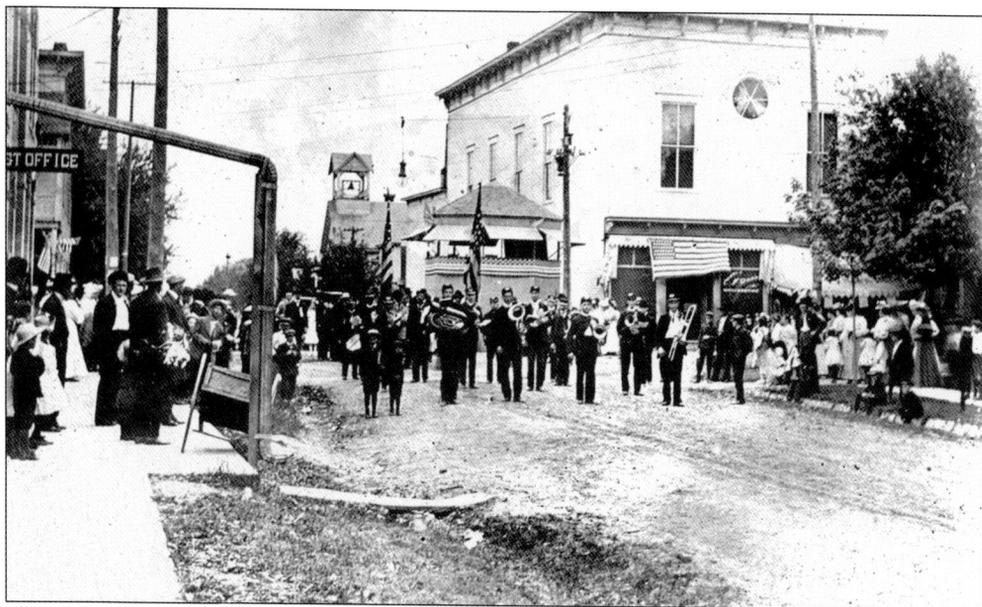

DECORATION DAY, 1907. The band is marching down East Liberty Street through the town square. On its left is the post office located at the rear of the Farmers and Merchants Bank. Behind is a bandstand on the Crates Brothers store. The bell tower in the background is atop the town hall and was used to signal fires. (Courtesy of Leslie Lazenby-Hunsberger.)

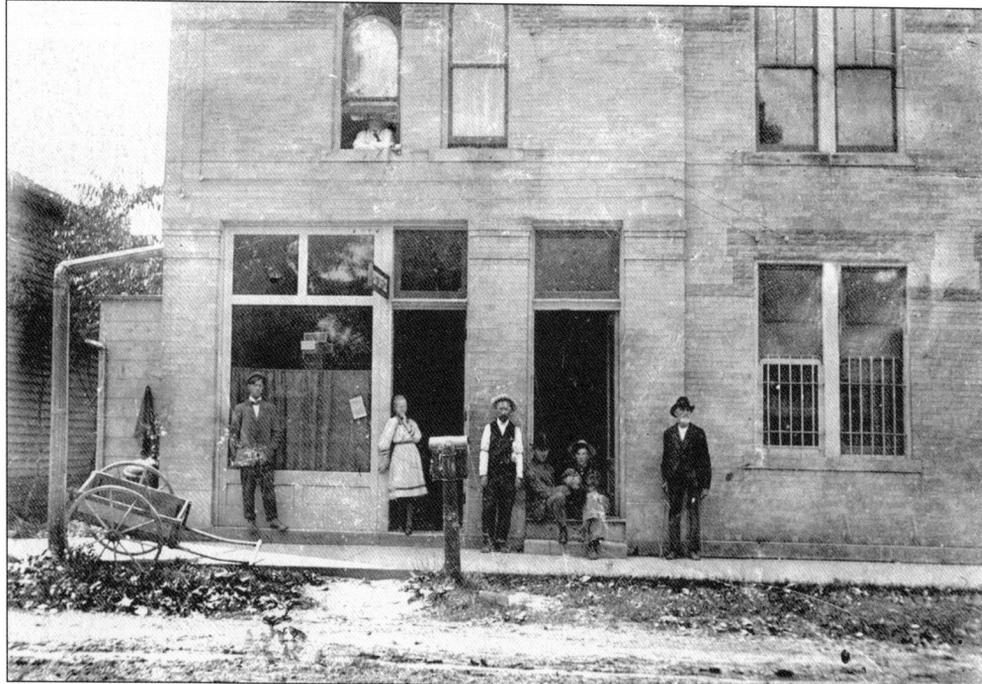

POST OFFICE, BEFORE 1908. The post office was located on East Liberty Street in the back of the Farmers and Merchants Bank. Note the mail cart in front of the office. Trains delivered mail to Arlington. Above the post office (where a man is looking out the window) was a dentist office. Mail was not delivered, creating daily visits to the post office. (Courtesy of Don Steinman.)

THE HOOP MILL, EARLY 1900S. This company had about 35 employees and was important to the early growth of Arlington. The mill was owned by J. M. Peel and Brother Company. It made many wooden barrel hoops that held wooden barrels together. They were made from elm logs. (Courtesy of Leslie Lazenby-Hunsberger.)

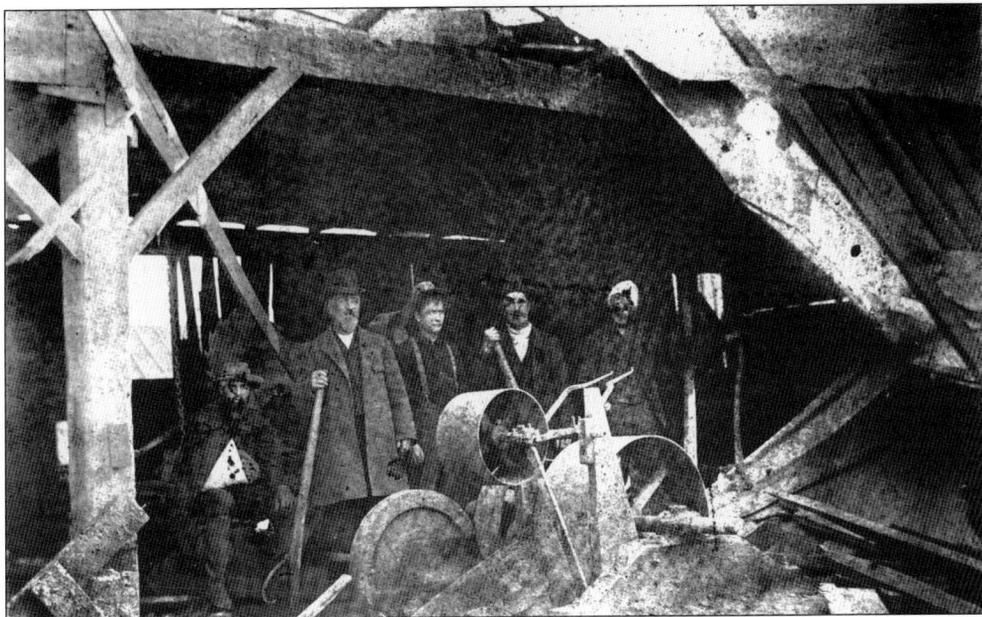

HOOP MILL, 1920. In the early 1900s, the hoop mill was built. It was located at the east end of Mill Street at the intersection of the AC&Y and the T&OC railroad. The hoops were made of elm because it could be bent. Logs were cut into lengths of about seven feet and then sawed into planks about one and a half inches thick. In 1917, the owners moved the business to Arkansas because the elm tree supply was depleted. (Courtesy of Joe Schaaf.)

"The Crystal Queen"

An Operetta in Three Acts
BY THE ARLINGTON HIGH SCHOOL
SATURDAY EVENING, FEBRUARY 22, 1913

CAST OF CHARACTERS

—— MORTALS ——

Cissie Rose Bud..............Gresham Trovinger
Millie, the Milk MaidGoldie Sampson
First School Girl........................Ival Smith
The Prince of Slumberland.................Jay Vail
Johnny Stout.......................Guy Anderson
Tommy Thin.......................Ivan Steinman
Policeman X Y Z....................Godfrey Crates
First School Boy.....................Olan Gobrecht

—— IMMORTALS ——

The Crystal Queen....................Carrie Russell
Spirit of Fire.........................Inez Tombaugh
Spirit of Water......................Bernice Hauman
Spirit of Earth.......................Cleo Steinman
Spirit of Air..........................Alyce Orwick
First Fairy..............................Hazel Russell
Other Fairies— Argyle Russell, Lydia Crates,
 Lorena Pugh, Fairy Hartman, Gwenolyn
 Kroske, Hazel Wilch, Edna Marquart,
 Celia Bowman, Edna Crates and Grace
 Hosafros.
Wooden Soldiers— Harlin Orwick, Truman
 Donaldson, Fred Romick, Roy Burnham,
 Manuel Boyer, Glen Snyder, Edison Hus-
 ton, Esrom Bailey, Dallas Waltermire and
 Bert Gilmer.

—— INSTRUMENTAL ——

Piano Accompanist.........................Gail Foltz
Violin and Cornet...Orville Adler & Roi Bailey
Piano Duet...........Cora Riegle & Eva Farmer
Overtures and Selections
............Arlington Independent Orchestra

—— RECITATIONS ——

Argyle Russell Mabel Hartman
 Ina Hartman

Dr. A. S. Butler
Dentist

Permanently located in the rooms
over the Farmers' & Merchants'
Bank, Arlington, Ohio.
Open every day and evening ex-
cept Saturday evening and Sunday

Phone 145

Let The

Farmers AND Merchants
BANK CO.

Take care of your Finan-
cial Business.

Farmers & Merchants Bank

-:- The Place To Buy -:-

DRUGS
is at

Modaff's Pharmacy

MOTTO: "The Golden Rule"

H. T. Dally
Funeral Director

We Do Business Regardless
Of Distance

PHONE .:. .:: 101

PLAYBILL FOR THE ARLINGTON SCHOOL OPERETTA, 1913. This four-page playbill is for a three-act operetta called *The Crystal Queen*. It was performed by Arlington school students. This would have been in the old six-room frame school that stood in front of the present school building. Forty-two students took part in the operetta. (Courtesy of Juanita Rinehart.)

Chorus, "The hour grows late"...........................
Piano Duet, "Dames of Seville," Schubert
.......................Eva Farmer and Cora Riegle
Recitation, "When our dreams come true"
..Ina Hartman

SCENE III

Chorus, "Market Day"..........................
Song, "The Poppy and the Butterfly"
.............................Goldie Sampson
Song and Chorus, "Under the Apple tree bough"
.......................................Ival Smith
Trio, "Laugh and drive dull care away"
 Guy Anderson, Godfrey Crates, & Ivan Stein-
 man.
Recitation, "Behold in me".............Carrie Russell
Song, "Back to the dear old home"
.........................Gresham Trovinger
Finale, "Homeland of the Free"...Patriotic Chorus
 Company and Orchestra
Music.............................Orchestra

The Snyder Co.

**The people that Pay
More for Produce &
Sell Goods Cheaper
than Competitors**
PHONE 3

Hotel Gay

The Place to Stay When in
Arlington.

Best Meals in the State.
New Furniture and Warm
Rooms.

Sam Hinchey, Prop.

OHIO HAY & GRAIN CO.

Pays Highest Prices For
Hay and Grain

L. R. Woodward
Phone 141 ARLINGTON, O.

PLAYBILL FOR OPERETTA, PAGE 3. This operetta was one of the events of the school year. The community businesses showed support for the school, with 22 merchants placing advertisements on the playbill, as the examples on this page indicate. There is also a nice picture from the Good Hope steeple of what is currently the residence at 226 South Main Street. (Courtesy of Juanita Rinehart.)

ARLINGTON
"The Best Little Town in North-western Ohio"

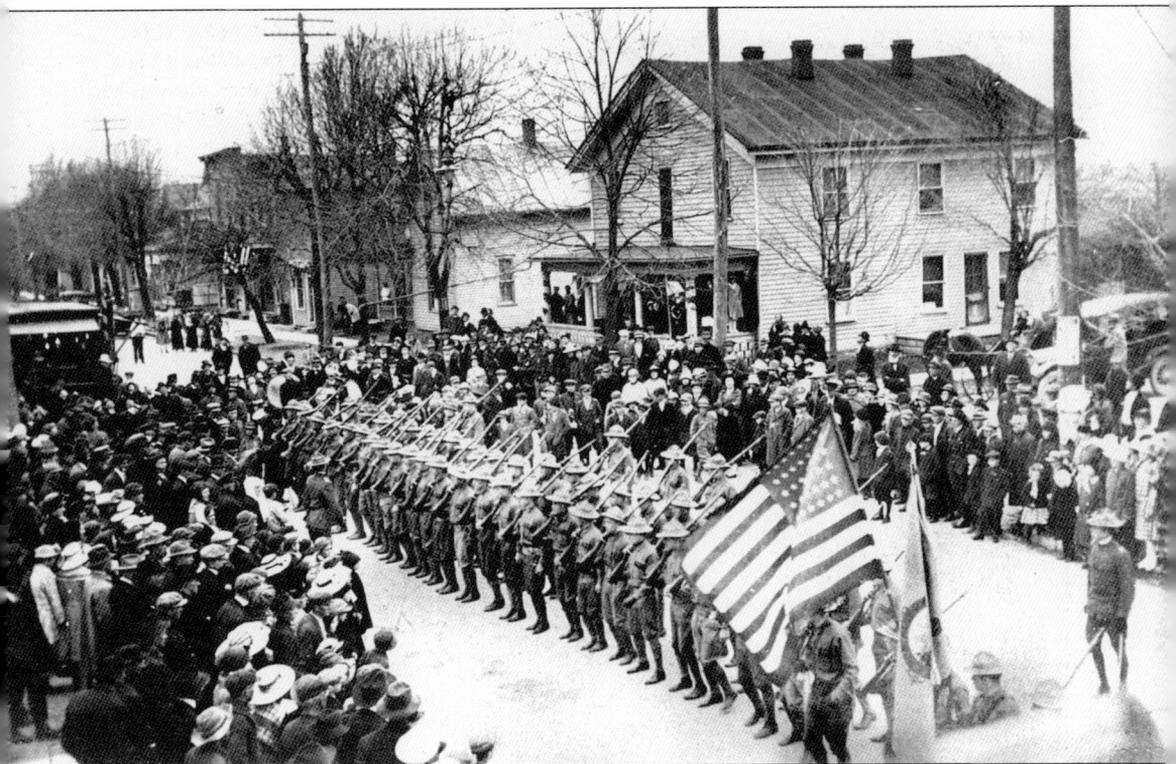

DECORATION DAY CELEBRATION, 1917. Huge crowds watch on a Saturday afternoon as the cadets from Ohio Northern University performed a flag raising and did several military drills. Local children provided music. The Civil War veterans unfurled the big 18-foot-by-28-foot flag that floated 60 feet in the air. The old Pioneer House provides a background setting with four chimneys. The Pioneer House was eventually moved to Cumberland Avenue, and its previous location became the home of Corbin Brothers' new garage. The home of Orville and Celia Johnson is shown north of the Pioneer House. (Courtesy of Leslie Lazenby-Hunsberger.)

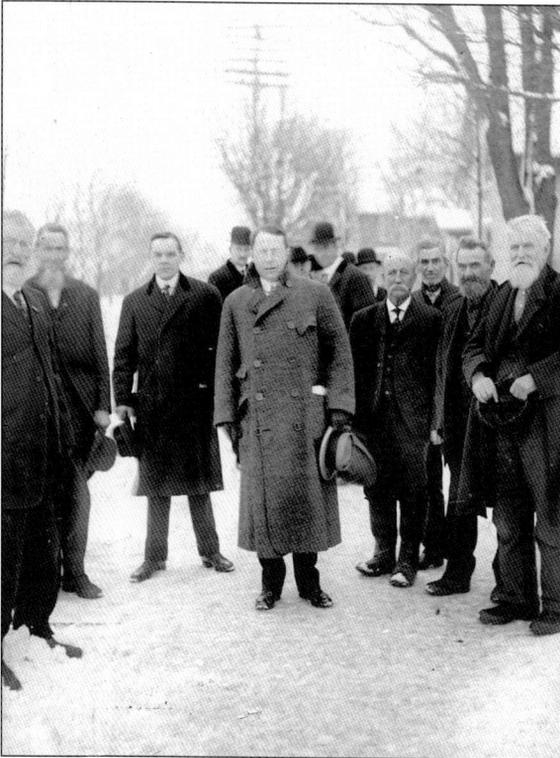

GOV. JAMES COX VISITS ARLINGTON, C. 1914. Incumbent James Cox stopped by Arlington while campaigning for reelection of governor of Ohio. He is pictured with several Arlington Civil War veterans. Veterans shown in this picture are Joseph Longworth, Henry VanAtta, John Isenbarger, Tom Anderson, Joe Garman, Nathaniel Bonaparte Anderson, and C. R. Wagner. Cox lost the election but became governor again in 1917. (Courtesy of Peggy Rinehart.)

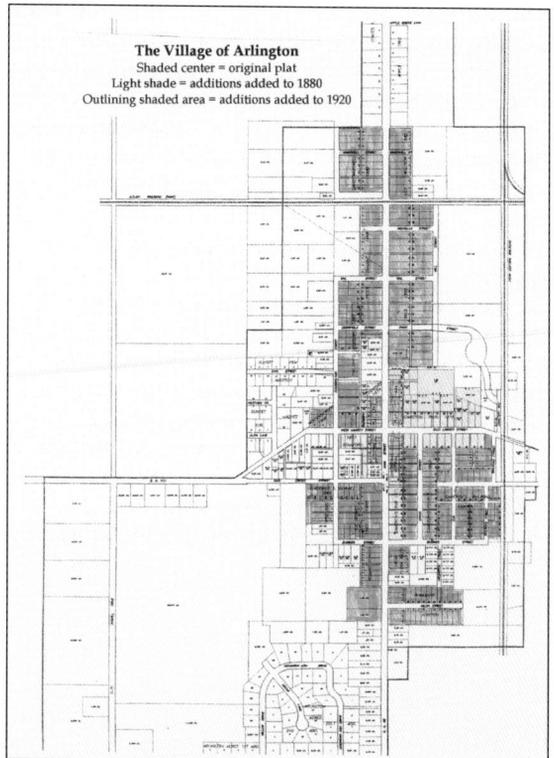

The Village of Arlington
Shaded center = original plat
Light shade = additions added to 1880
Outlining shaded area = additions added to 1920

MODERN PLAT MAP OF ARLINGTON, 1990. During the boom years, 17 new additions by Peter Traucht, George Dorney, Robert Dorney, Wallen Cameron, Flora Wilch, Susan Wertenberger, and Oscar Wise were added to the village. The town spread toward the railroads. The total shaded area shows the size of the town by 1914. During the high times that followed, no new additions were recorded. (Courtesy of Deb Anderson.)

Three

HIGH TIMES
1921–1950

The early 1920s was a period of change for Arlington. Veterans coming back from World War I found jobs, and Arlington prospered. Roads were paved, and railroad tracks were improved. A modern school was built, consolidating the town and rural schools. There was a spirit of pride and an anticipation of better living conditions ahead. By 1928, economic conditions were in a downturn, and on October 29, 1929, the stock market crashed. Arlington as well as the whole country was headed for 10 years of tough economic times.

In 1935, the town of Arlington, with less than 1,000 people, had seven gasoline stations, six grocery and meat stores, and four restaurants. It had three each of the following: churches, barbers, hardware stores, doctors, appliance stores, and grain elevators. Also, two each of the following: music instructors, hay and straw buyers, veterinarians, blacksmith shops, insurance agents, poolrooms, and banks, one of which was run from a home. It also had a general store, shoe repair shop, ladies' millinery shop, beauty shop, piano tuner, livery stable, horse racing track, lumber company, well driller, bakery, bulk fuel plant, tailor, men's shop, seller of fire extinguishers and alarms, concrete tile and block plant, tin shop, drugstore, funeral home, greenhouse, dentist, telephone company, newspaper, watch and jewelry store, auctioneer, hatchery, and tourist cabins, as well as several plumbers and carpenters. A lawyer was the only business Arlington appeared not to have. People lived, worked, and spent their money in Arlington.

In the 1940s, Arlington sent many men to World War II. In 1942, Arlington became the first village in the county to have a lit football field. From 1945 to 1950, Arlington football teams were undefeated in 44 straight games. In 1945, the town started an annual homecoming parade and festival that would last 50 years and become one of the most attended events in the area.

In tough economic times, the town bonded together, provided jobs and support for each other, lived, loved, and laughed with each other, and truly lived "the high times."

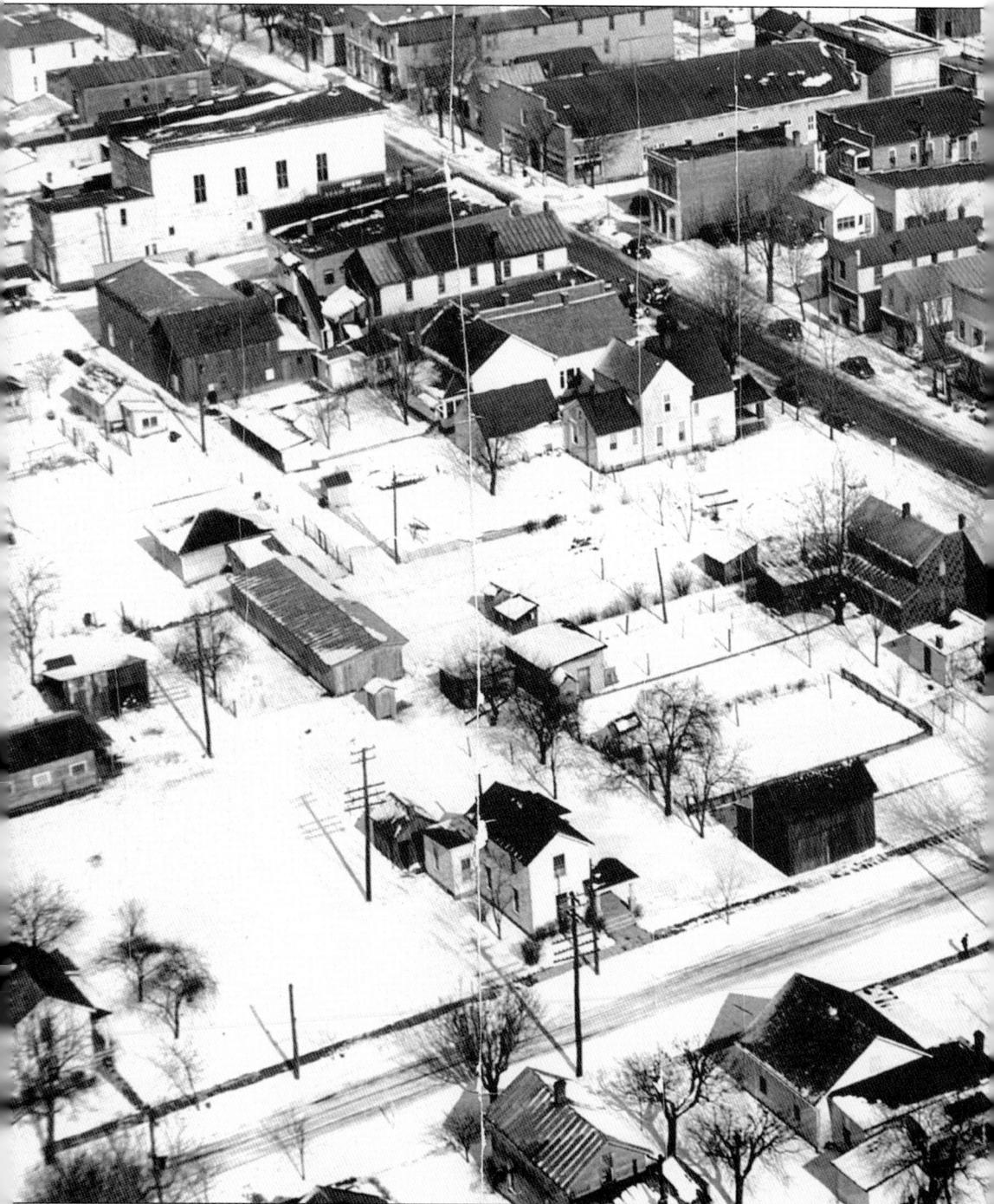

AERIAL PHOTOGRAPH OF ARLINGTON, 1920s. This photograph shows the area of the 16 original lots of the village of Arlington. Main Street runs from the upper left corner. The large building (east side of the street) is the Ohio Hardware Company. It was located on the south half of lot 10. Because of the location of the first railroad through the village, the business district had developed farther north along Main Street and then moved south with time. Part of the building

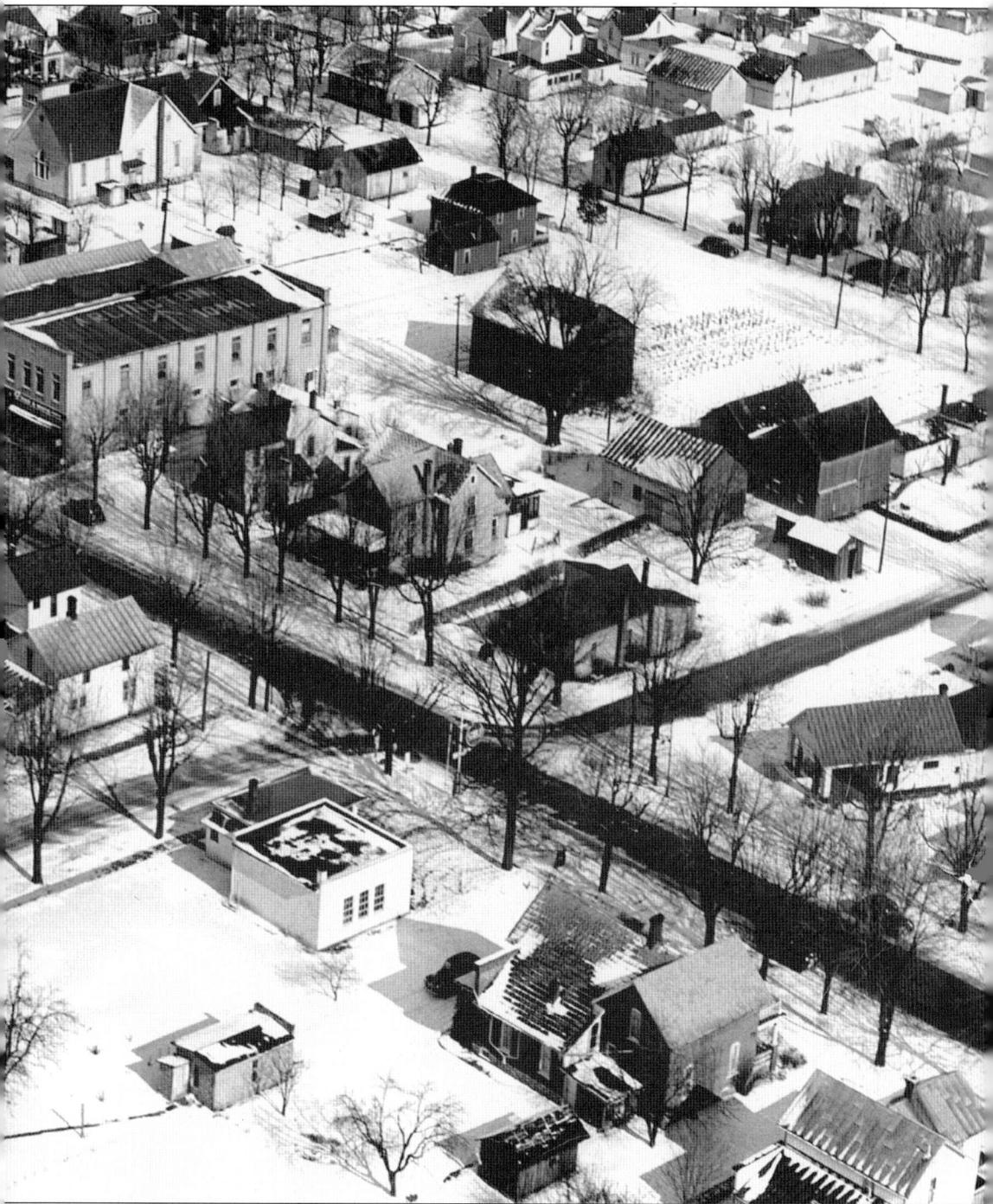

located on the north half of lot 10 had been moved in from that northern business area. The other part was moved to East Liberty Street just east of the Corbin Brothers building. Many of the buildings in this photograph have been razed or moved to other locations. (Courtesy of Mildred Fink.)

Publick Sale

At my residence on Railroad street close to
T. & O. C. Elevator, on

Tuesday, Dec. 30, '24

At One O'clock in the Afternoon

As it would take too much space to mention all
articles, I will name a few:

Bedsteads and Bed Clothing, two heating Stoves,
one cook stove, tables, cheers, one old cubberd that
Noha used in the ark, dishes, cooking utensils of all
kinds, one sewing mashine, about 8o cans of fruit,
8 gallon of sour krout, the good old Dutch kind, some
potatoes, grape butter, green tomato pickles and lots
of articles too numers to mention.

If the weather should be bad, everything will take
place in the house where it is warm and dry.

Sale to Commence Promptly at 1 P. M.

COL. GEO. W. CORBIN, Auctioneer

SEYMOUR HARRIS

Terms: Cash on Day of Sale

PUBLIC SALE, DECEMBER 30, 1924. Seymour Harris sold all his belongings at a public sale on Railroad Street, and Col. George W. Corbin was the auctioneer. Yes, the sign maker could not spell *public* right. Harris was the son of Spencer Harris, a Civil War veteran. Sales in small towns always draw big crowds of interested people. Many come just to talk and enjoy themselves. (Courtesy of Tom Kroske.)

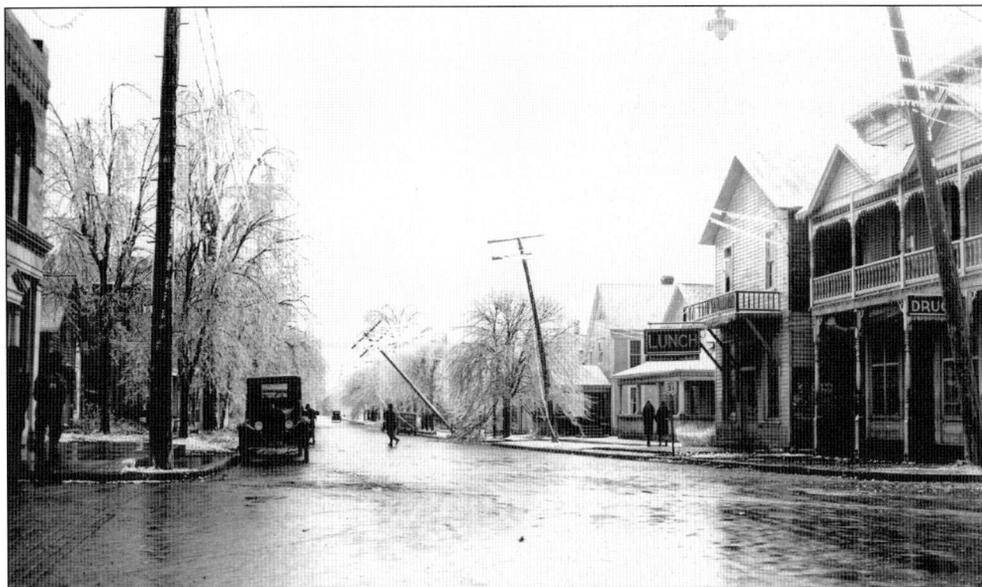

ICE STORM, MARCH 29, 1928. A severe ice storm hit Arlington on Thursday, March 29, 1928, and continued through most of Friday. Many trees and tree limbs came down across electric and telephone wires, causing problems in the town. Telephone poles toppled over in some instances. Liberty Street was almost impassable. (Courtesy of Don Steinman.)

KU KLUX KLAN UNIFORM. By 1924, there were more Ku Klux Klan (KKK) members in Ohio than any other state. This picture is of the only known remaining Arlington KKK uniform. The uniforms were designed to look ghostly. The KKK was a result of local men not wanting outside workers laying railroad track and brick roads to stay here and take their jobs and marry local women. (Courtesy of Don Steinman.)

KKK UNIFORMS, 1920s. The KKK furnished only the headband, and local women made the uniform. The headbands were numbered starting at 1. The only remaining Arlington uniform shows headband 136, meaning that most of the able-bodied men in 1924 Arlington were members. Memberships cost $10, and regular meetings were held. (Courtesy of Don Steinman.)

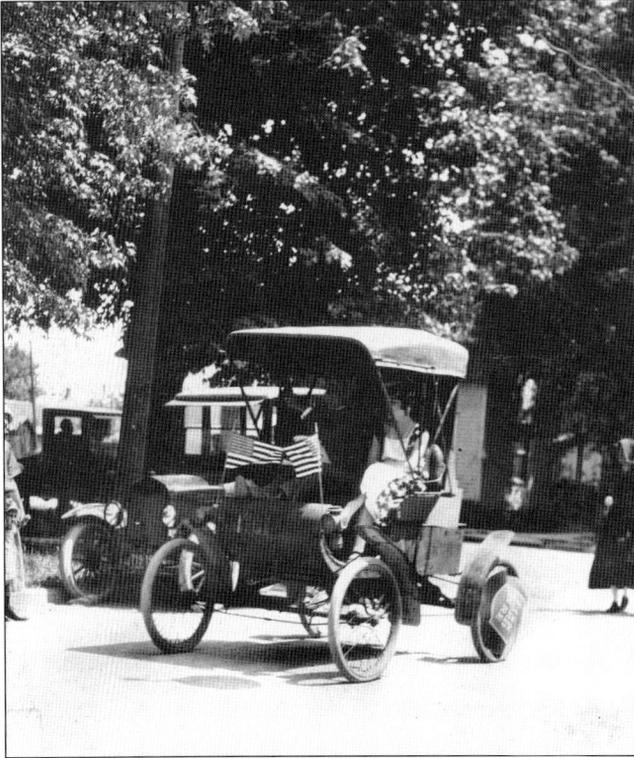

FOURTH OF JULY HOMECOMING PARADE. A 1901 automobile is pictured in this 1924 Main Street parade. A basket dinner was held at noon, followed by the parade. There was a baseball game, horse races, and an evening address by Prof. Ray Huff. The day ended with music by a Findlay band under the direction of Arlington's own Ira Vail. (Courtesy of Leslie Lazenby-Hunsberger.)

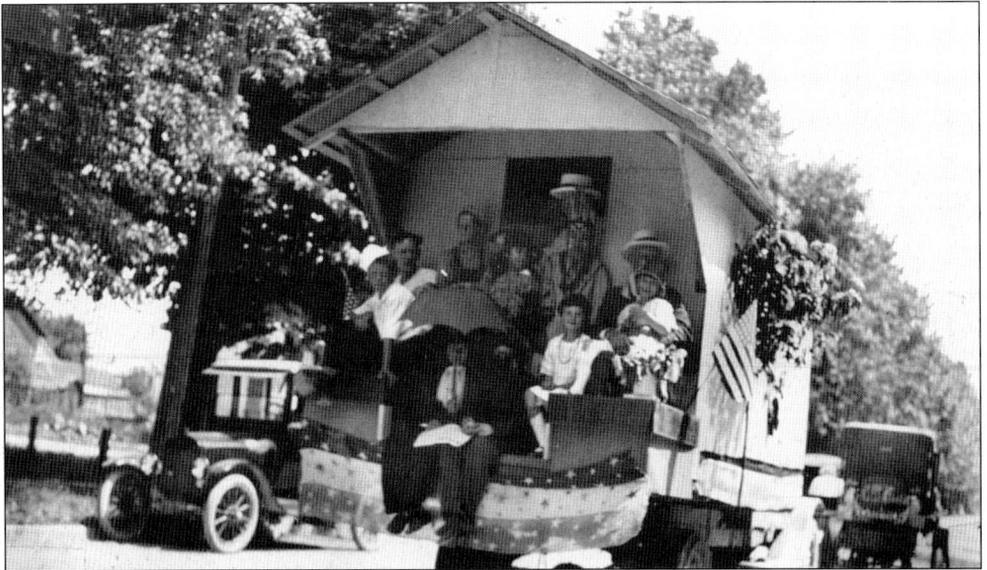

HOMECOMING PARADE, JULY 4, 1924. Independence Day was always a time for fun, fireworks, basket dinners at noon, baseball games, horse races, music, and a good parade. This parade group appears to be having a good time with what looks to be a building on wheels. It was decorated with flags of course. Independence Day was a day everyone looked forward to. (Courtesy of Leslie Lazenby-Hunsberger.)

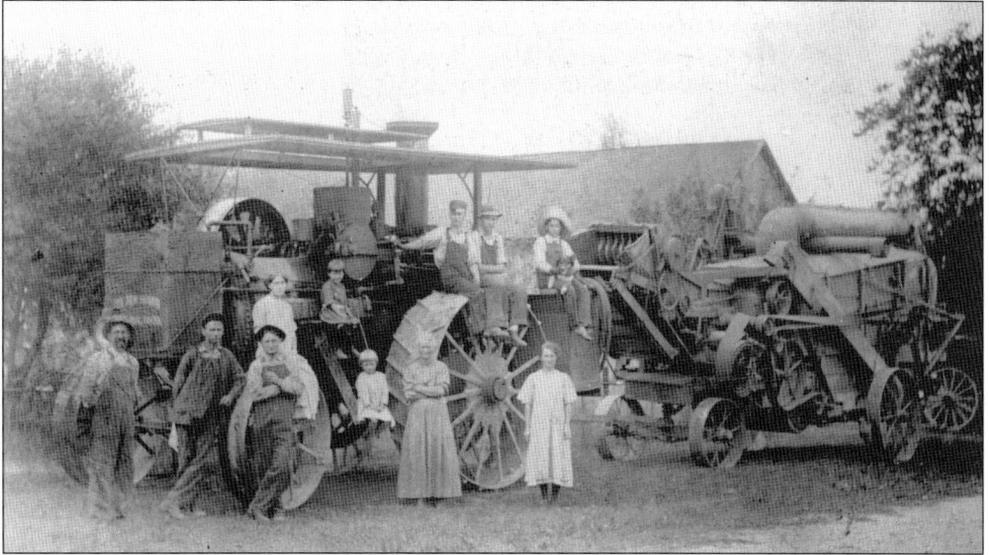

HARVESTING CROPS IN THE 1920S AND 1930S. Harvesting was done with a thrashing machine. Neighbors worked together to get in the crops by forming a "thrashing ring." This particular machine was owned by Adam Pifer, who was called "Thrasmachine Adam." He and his crew worked for many different farmers. On thrashing day, there was a large number of men for the women to feed. (Courtesy of Joe Schaaf.)

JUDY HAD A LITTLE LAMB, C. 1943. Farm families always had a lot of pet animals, and Judy Garlinger Best had a pet lamb that had to be bottle fed. The lamb followed her everywhere she went. One of the great benefits of farm living is having animals. (Courtesy of Judy Garlinger Best and Alice Fay.)

EARLY SCHOOL BUS. When the new school was built in Arlington in 1923, many of the one-room schools in the area closed. Their rural students needed to be transported into the village for school. This is a 1934 photograph of an early school bus. The driver and some pupils are pictured here. (Courtesy of Darwin Wilson.)

ARLINGTON HI-CRIER, OCTOBER 22, 1937. This is issue No. 1 of the Arlington High School publication the *Arlington Hi-Crier*. This was a very professional publication that covered all the news of the school and had many advertisements from community businesses. If one wanted to know what was going on, one needed to read this publication. (Courtesy of Don Steinman.)

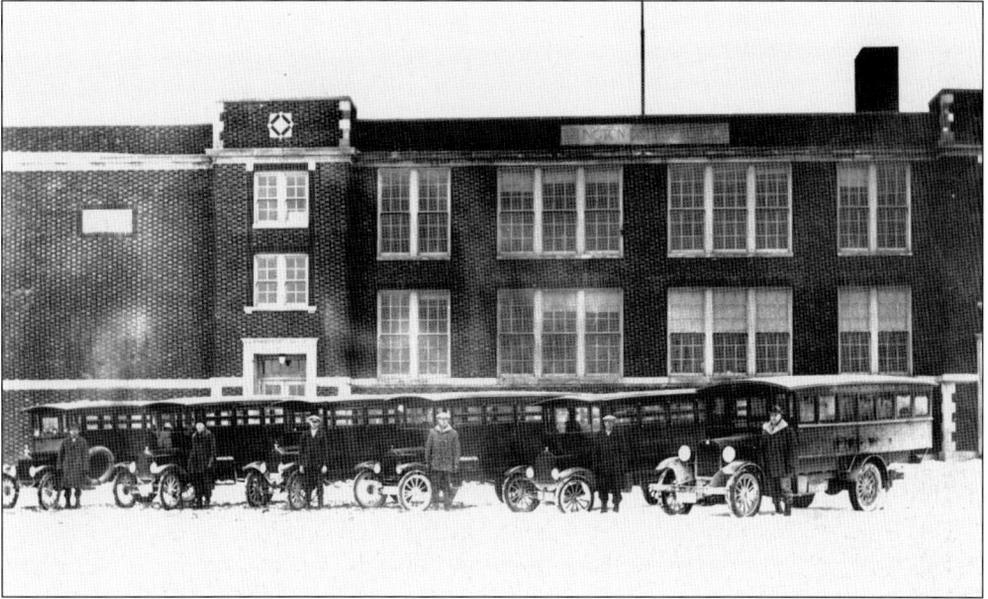

ARLINGTON DISTRICT SCHOOL, 1923. The new school was larger and was built on land behind the old wood frame school. The lower floor had four classrooms, restrooms, a gymnasium, a stage, and locker rooms. The first floor had six classrooms and overlooked the gymnasium. The top floor had four more classrooms, the offices, a library, and a study hall. The bus drivers pictured are, from left to right, Cloyce Lanning, unidentified, Clarence Lanning, Andy Glick, Ed Wilch, and Frank Beach. (Courtesy of Arlington School.)

SCHOOL BUS, 1938. The first school buses to carry rural pupils for the new school in Arlington were not owned by the school. These buses were owned and operated by private individuals. Some individuals owned more than one bus and hired drivers for the other buses. This 1937 Chevrolet school bus was owned and operated by Rufus Wilson. (Courtesy of Darwin Wilson.)

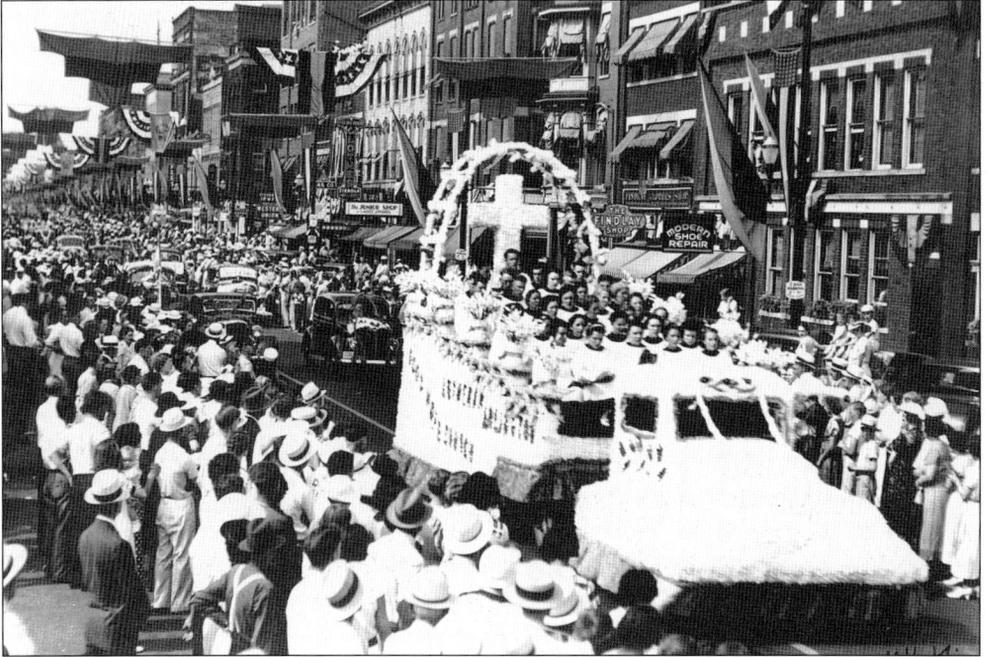

ARLINGTON CHURCH FLOAT IN ANNIVERSARY PARADE, 1937. The Arlington Good Hope Lutheran Church choir rides the float in the 1937 parade in Findlay, celebrating the 50th anniversary of the discovery of natural gas in Findlay and Hancock County. Note the large crowd that attended the celebration. (Courtesy of Cleva Collar.)

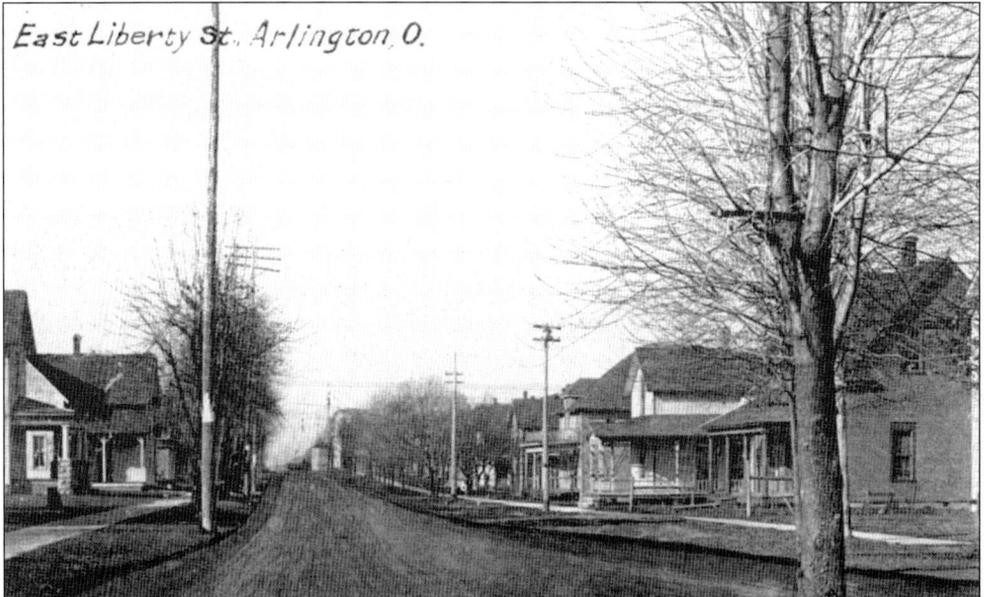

East Liberty St. Arlington, O.

EAST LIBERTY STREET, 1930s. This view looking west from the railroad is one of the older residential streets in Arlington. State Route 103 did not run straight into Arlington until 1931 and instead curved northwest one mile east of town and crossed the railroad track and connected at East Liberty Street. The town council eventually closed the crossing after several deadly accidents. (Courtesy of Leslie Lazenby-Hunsberger.)

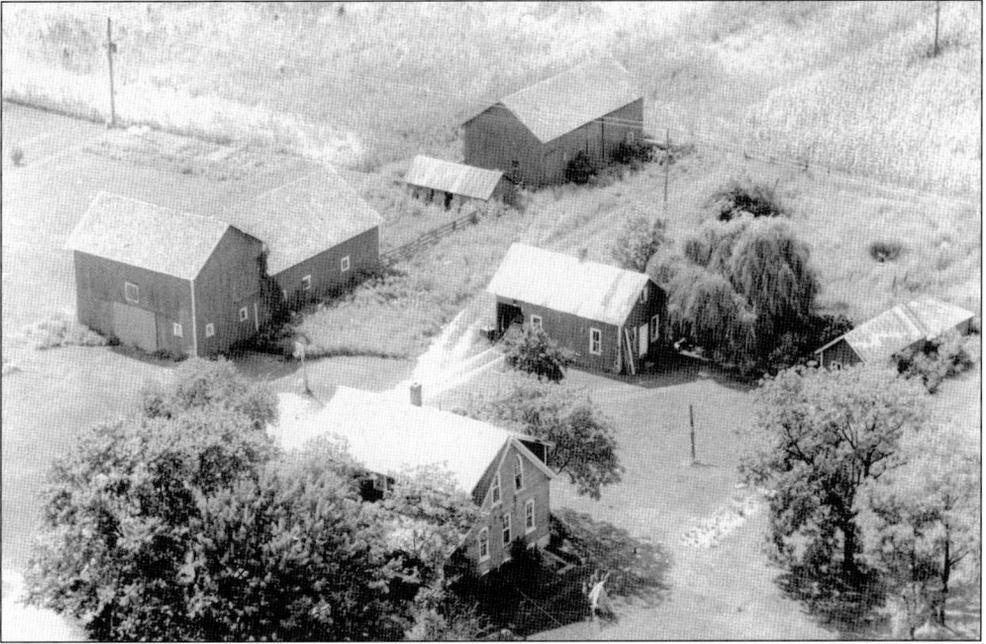

FARM NEAR EDGE OF TOWN, 1940S. Towns grew, and Arlington was no different. This was a rural farm at one time and now is part of Arlington. Only the brick home on South Main Street, currently owned by J. J. and Phyllis Solt, remains. The remainder of the farm has been developed. (Courtesy of J. J. and Phyllis Solt.)

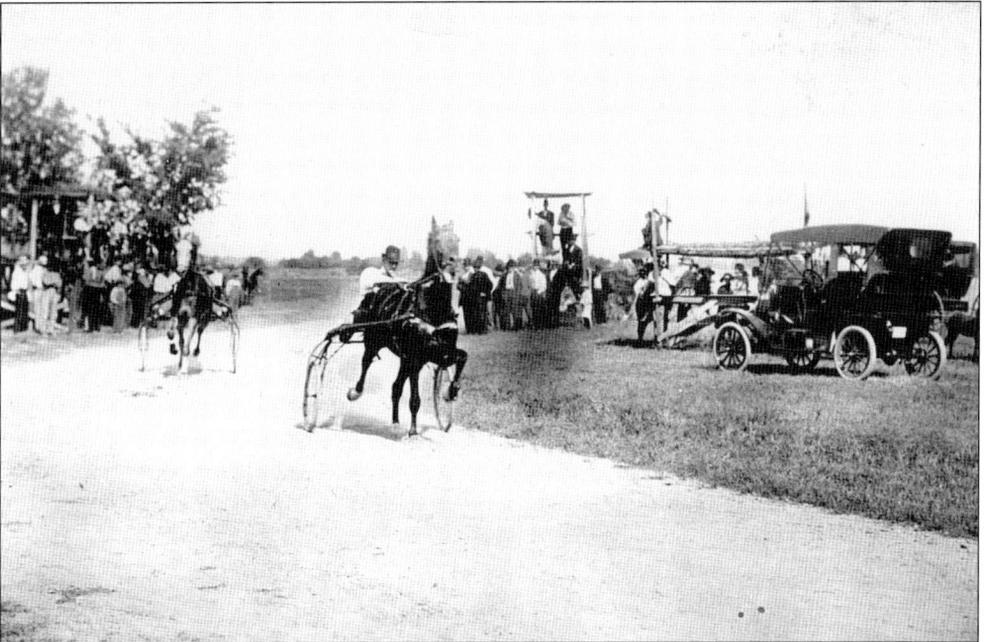

OLD RACETRACK, 1920S. On the old Solt farm south of Arlington was a popular harness horse racing track. Many people watched the races and enjoyed the activities here. Children sitting in the schoolhouse upper floors could watch the horses work out every day. This once rural area is now filled with homes. (Courtesy of J. J. and Phyllis Solt.)

HOUDESHELL'S TAVERN, 1942. Known as the Nugget Restaurant in Arlington, this building was moved south of town in 1934 by Daniel Houdeshell. It has been a tavern, restaurant, gasoline station, and beauty salon. The bar in the tavern was one of the oldest in the area. For many years, the field to the north was used for ball games, circuses, and other traveling shows. (Courtesy of Fern Marohn.)

NORTH MAIN STREET, 1941. On the east side looking south, beginning on the left is Kroske's Grocery. The diamond-shaped sign is a Coca-Cola sign, and the vehicle is a bakery delivery truck. The upper floor of the next building was occupied by the John Waxler family and the lower floor a business room. Next are the Dutch Boy Restaurant, Orville Johnson home, and Corbin Brothers Chevrolet. Pictured are Dale Kroske with Tom Kroske on the sled. (Courtesy of Tom Kroske.)

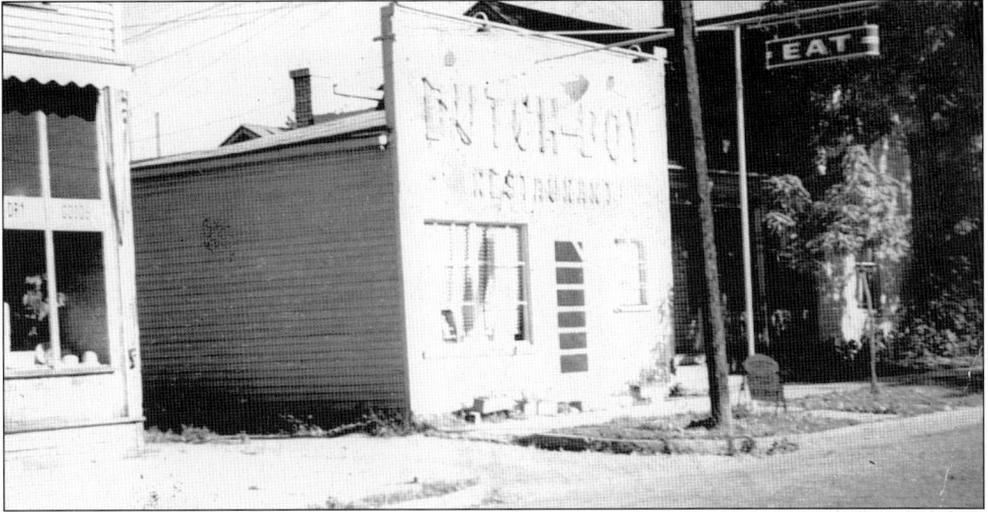

DUTCH BOY RESTAURANT. Opened in 1937 by Orville and Celia Johnson, this is a 1942 photograph of the Dutch Boy Restaurant. It was a favorite hangout of the teenagers (especially the booth under the window on the right). Celia made the best pies, and the chocolate sundaes had a cherry on the top. The building was razed around 2000. (Courtesy of Fern Marohn.)

1936

RETTIG

YOU ARE LEARNING FAST!
THE MORE YOU BUY, THE MORE YOU SAVE
WHEN YOU BUY IT HERE

More Wheaties, large box	only	10c
Post Toasties, large box	only	9c
Extra Quality Macaroni, 2 lbs.	only	13c
Lassen's Perfection Flour, 24½ lbs.	only	88c
Trumpet Coffee, (24c value)	only	17c
O. R. Coffee (Fancy Santos)	only	15c
Very Best Peas, good flavor	only	8c
Choice Hand Picked Navy Beans, 3 lbs	only	10c
Renz's Large Loaf Bread, 1½ lb-	only	10c
Extra Sweet Large Prunes, 2 lbs.	only	15c
Pure Cane Sugar, 5 lbs.	only	25c
Medium Size Ivory Soap	only	5c

We Pay Cash and We Thank You for Your Produce

E. P. RETTIG NORTH MAIN STREET

E. P. RETTIG STORE ADVERTISEMENT, 1936. How prices have gone up since 1936! In this advertisement from Ed Rettig's store, bread was only 10¢ a loaf and five pounds of sugar was 25¢. Rettig had to be sharp on his prices as there were five other stores in town in 1936 competing for the grocery business. (Courtesy of Darwin Wilson.)

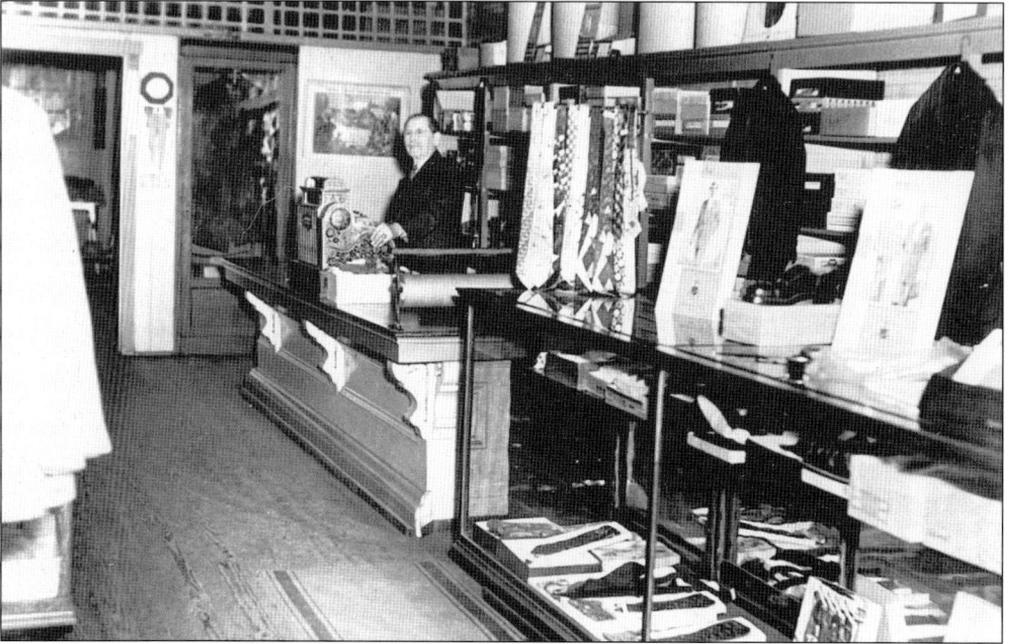

THE INTERIOR OF HERMAN MAROHN'S MEN'S SHOP, 1942. Herman Marohn is behind the counter ready to sell customers a wide variety of items, including ready-made and tailor-made suits, vests, white and colored shirts, ties, hats, and coats. He also sold and made farmers' clothing and did pressing. (Courtesy of Fern Marohn.)

HERMAN MAROHN'S MEN'S SHOP, 1942. Marohn came to Arlington from Germany in 1894 and had men's clothing shops at various locations in town. The location shown is on the east side of North Main Street, original lot 9, which later housed the *Arlingtonian* newspaper. Marohn clothed the men of Arlington for 59 years, retiring in 1953. (Courtesy of Fern Marohn.)

EARLY AUTOMOBILE REPAIR. Automobiles always need repairs. In this 1920 photograph, Gerald Corbin of Corbin Brothers Garage has just finished working on George Wertenberger's automobile. Notice the license plate location over the hood at the base of the windshield. The Corbin brothers were in the automobile business in Arlington for over 50 years. (Courtesy of Leslie Lazenby-Hunsberger.)

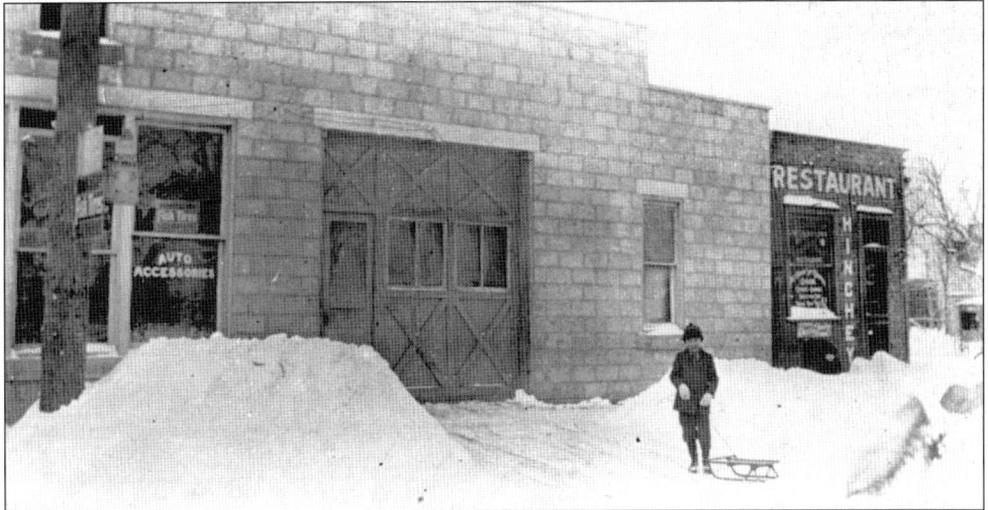

ORIGINAL CORBIN BROTHERS GARAGE. The Corbin brothers, Floyd and Gerald, began their automobile repair garage in this cement block building located on the west side of Main Street, north of the square. In addition to repairs, they bought and sold automobiles. Immediately north of the garage was Hinchey's Restaurant, operated by Sam Hinchey. These two buildings are shown in a 1920 photograph. (Courtesy of Leslie Lazenby-Hunsberger.)

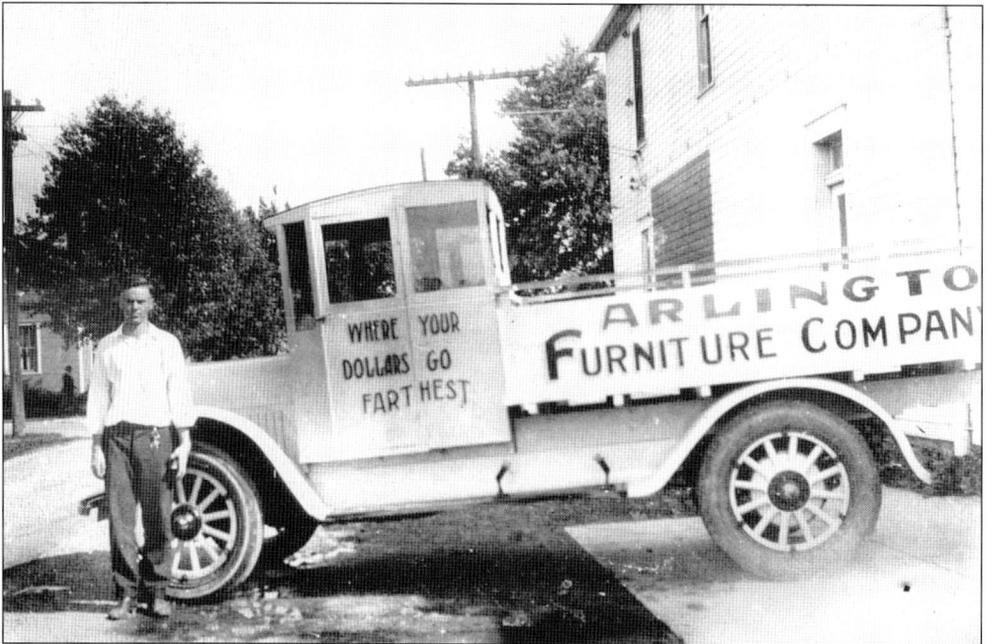

ARLINGTON FURNITURE COMPANY'S DELIVERY TRUCK, 1926. Driver Harvey Traucht, brother of Harlow Traucht, stands beside the Arlington Furniture Company delivery truck. This company was jointly owned by George W. Trout and Company of Findlay and Carr and Hicks of Fostoria. They purchased the business from George Wertenberger in May 1926. (Courtesy of Don Steinman.)

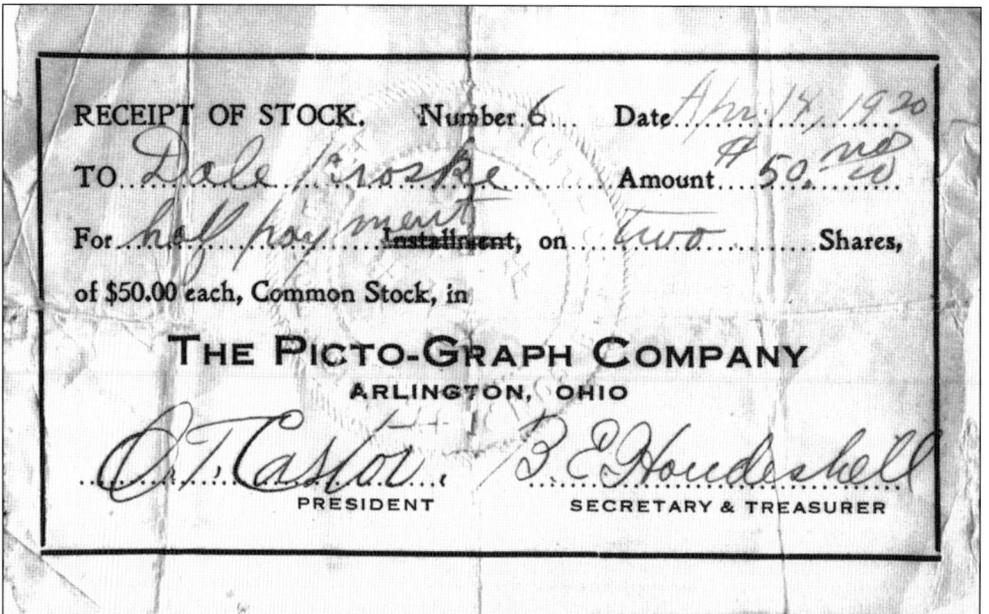

THE PICTO-GRAPH COMPANY, 1920. The Picto-Graph Company was an Arlington business established on April 16, 1915, and was still selling stock for $50 in 1920. O. T. Castor was the president and B. E. Houdeshell the secretary and treasurer. They developed over 100 rolls of film a day using soup bowls in the basement of a local business. (Courtesy of Tom Kroske.)

KUM-ON-INN RESTAURANT, EARLY 1940s.
Standing outside this popular restaurant, three
doors south of the square on the west side, are Don
Steinman (left), Charles "Red" Lafferty (right), and
Duane Traucht (kneeling). This restaurant was
famous for good food and homemade pies. For many
years, it was open 24 hours a day. Many good times
were had here. (Courtesy of Don Steinman.)

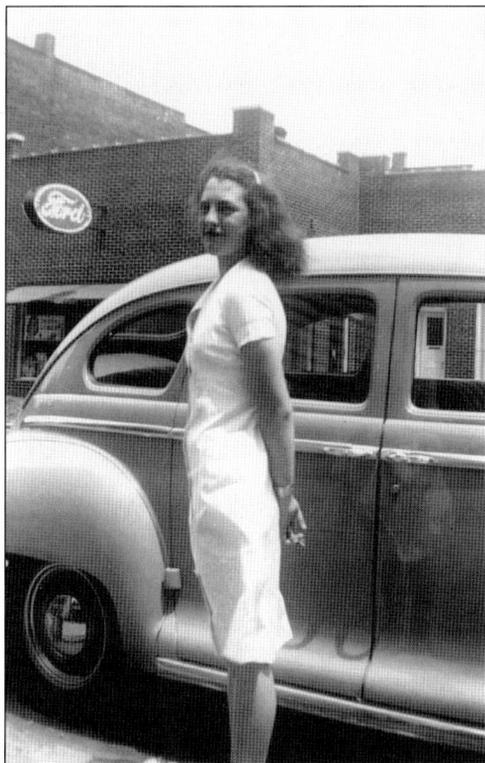

WAITRESS MARILYN MILLER LAZENBY,
c. 1945. Marilyn Miller Lazenby was a
waitress at the Kum-On-Inn Restaurant
and was wearing her waitress uniform
when this picture was taken. She was
getting into her car parked in front of the
restaurant. Over the years, many Arlington
people were employed by this somewhat
famous restaurant with a very catchy name.
(Courtesy of Marilyn Miller Lazenby.)

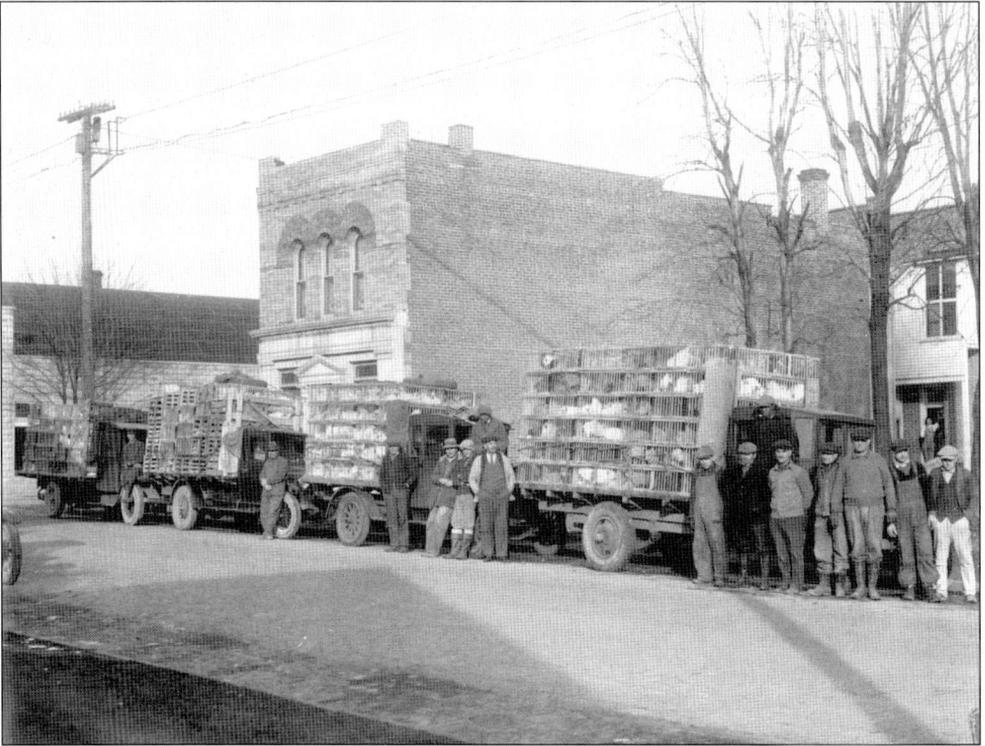

BOOMING CHICKEN BUSINESS, 1920S. Four truckloads of chickens line Main Street in Arlington. Chickens were a big business in town, both for the locals who raised them and as a business for those shipping them to larger areas such as Cleveland. Some of the men pictured are Marvin and Jim Line, Lester and Roth Schaaf, Carl and Earl Davis, Fred Rothlesberger, and Edson Smith. (Courtesy of Dave Davis.)

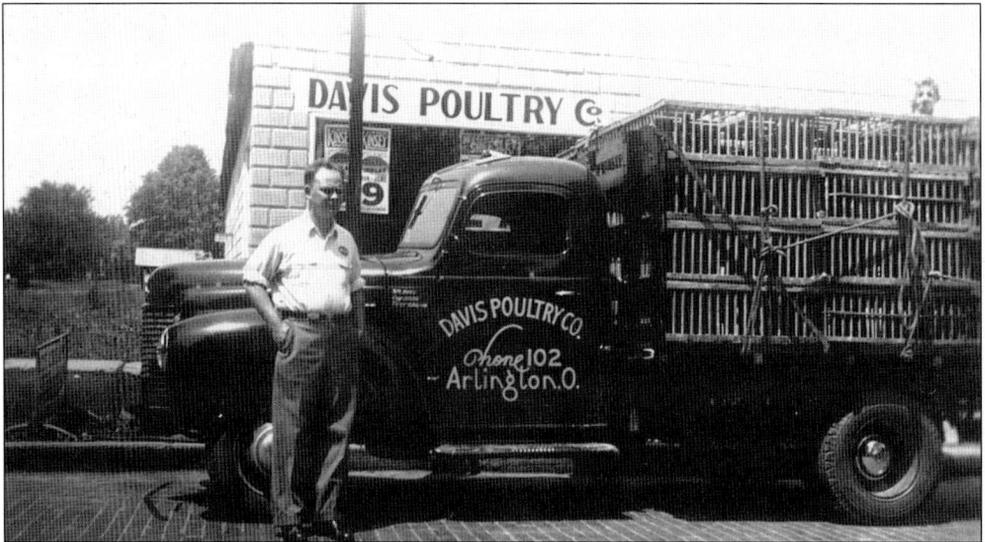

DAVIS POULTRY COMPANY. In front of the Main Street business, Raymond Davis is pictured by one of the delivery trucks used by the firm to do business over a wide area of Ohio. Note that the street is paved with bricks in this early-1940s photograph. (Courtesy of Dave Davis.)

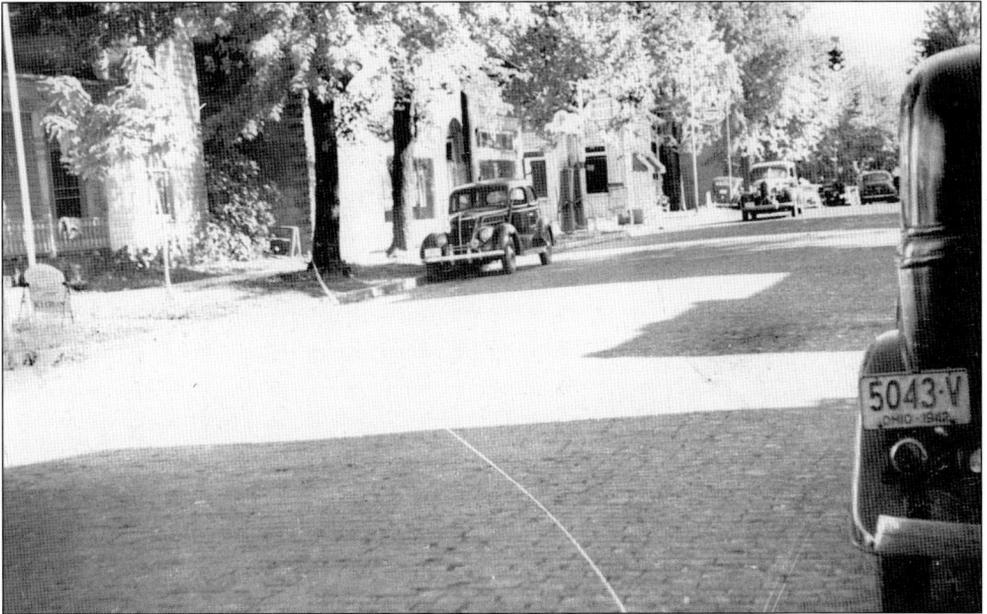

ARLINGTON'S BRICK MAIN STREET. By the early 1920s, World War I veterans were still unemployed. Government projects were created to build a system of brick roads to replace the dirt ones. Arlington's brick Main Street is a result of this project. The bricks weighed 10 pounds each, and the workers could lay only a quarter mile a day. The bricks are still under the asphalt on Main Street. (Courtesy of Fern Marohn.)

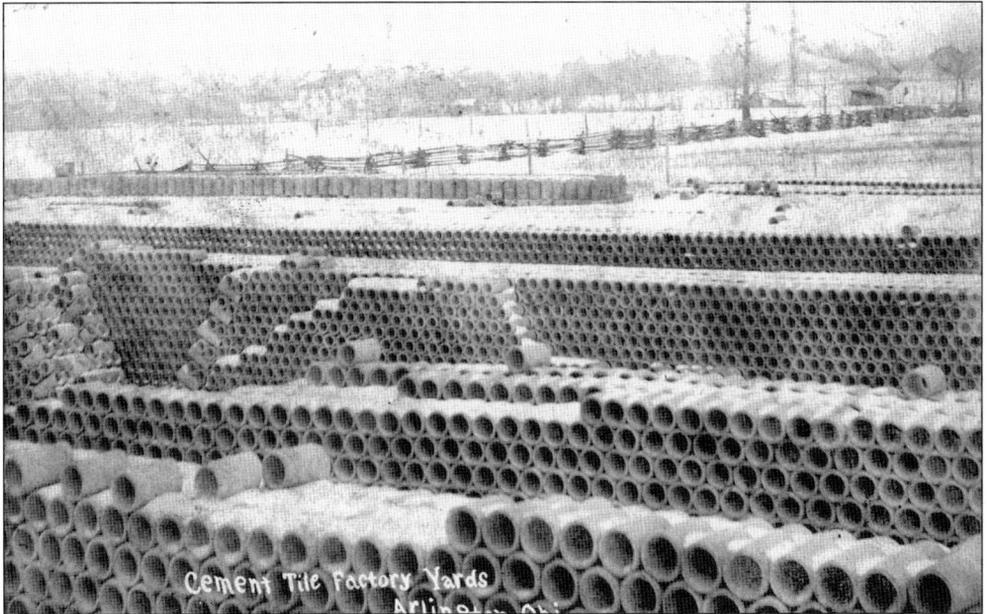

CEMENT BLOCK AND TILE FACTORY, C. 1915. For 38 years, from 1910 to 1948, this locally owned business supplied cement tile to local farmers and building blocks to local people and contractors. It was located on the east side of town, just east of the railroad tracks across from the water tower. The walls of at least two houses in Arlington were constructed of blocks from this plant. (Courtesy of Don Steinman.)

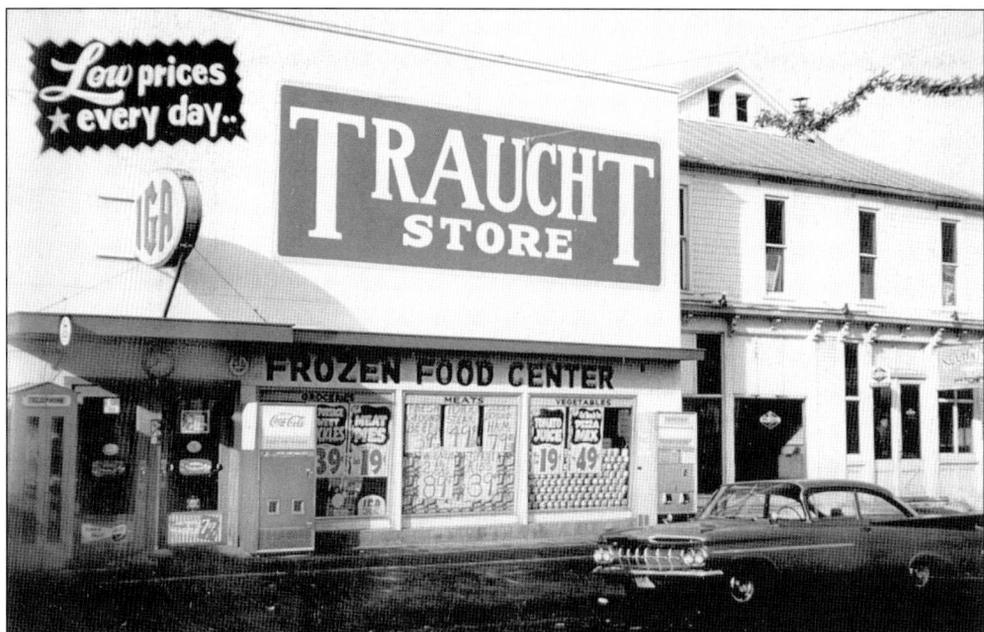

TRAUCHT STORE, 1960. In 1938, Harlow and Eva Traucht bought an existing grocery store. They named it Traucht Store, but it was always called Harlow's. There were many innovations, such as frozen-food lockers and the first cash register to give out coin change automatically. Who can forget the $2 bills people got with their change! The Traughts moved to their new facility in January 1969. (Courtesy of Leslie Lazenby-Hunsberger.)

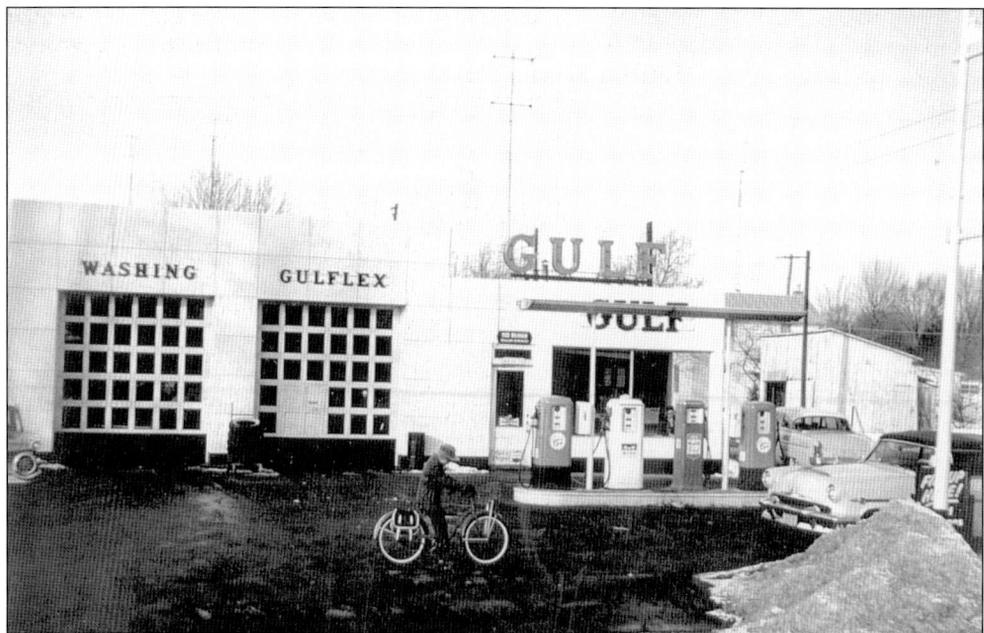

BRANAN'S GULF SERVICE, C. 1950. One of the more popular hangouts for both young and old men was Branan's Gulf, located at the corner of Main and Main Cross Streets. In 1956, a popular young entertainer named Elvis Presley stopped in, but no one knew him. Even after singing "Heart Break Hotel," they still did not know him! (Courtesy of Karen Landolt.)

BIBLE FELLOWSHIP CHURCH, 1950s. The Bible Fellowship Church was started in 1942 and used this building from 1944 to 1973. It is located on the southwest corner of West Liberty Street and Cumberland Avenue. The building has an interesting history, starting as the English Lutheran church and then converted into a home, back to a church in 1944, and then to an apartment complex in 1974. (Courtesy of Arlene Remaley Suter.)

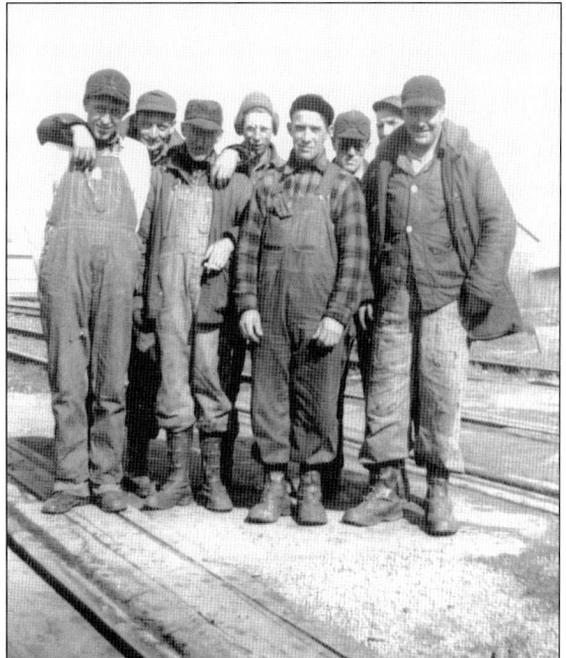

NEW YORK CENTRAL RAILROAD GANG, SEPTEMBER 3, 1943. Pictured are regular and seasonal workers of the New York Central Railroad: from left to right, (first row) Sidney Businger, Purd Cramer, Kenneth Businger, and Willis Riegle; (second row) Donald Gossman, Luther Businger, Lester Schaaf, and Wood Hindall. These workers did numerous railroad-related jobs such as mowing and track replacement repairs on the line from Findlay to Kenton. (Courtesy of Mabel Businger.)

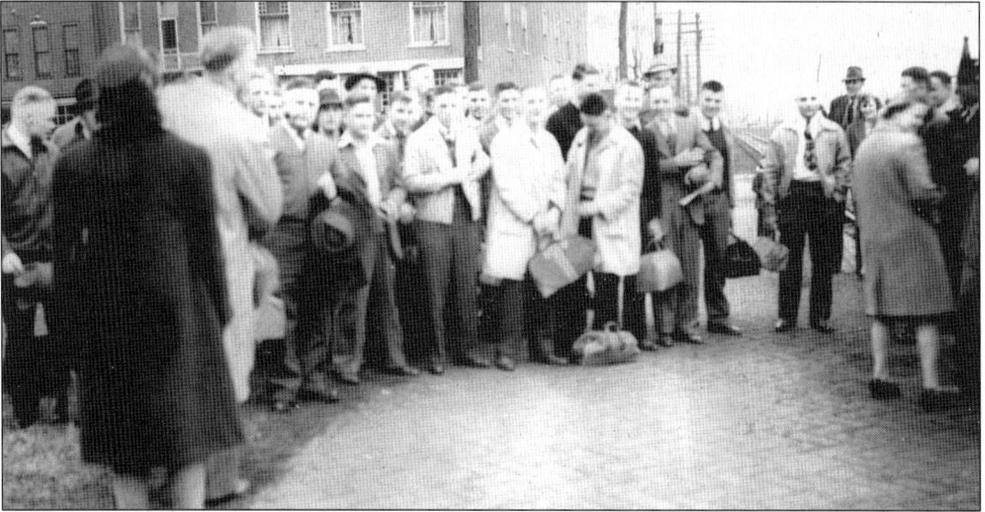

LEAVING FOR SERVICE IN WORLD WAR II, EARLY 1940s. The families are sending off inductees and enlistees to service in World War II. They departed from the AC&Y station at the north end of Arlington. They are on the north side of the tracks with John Schirmer's store and coal business building, now Morrow's Laundromat, in the background. (Courtesy of Peggy Rinehart.)

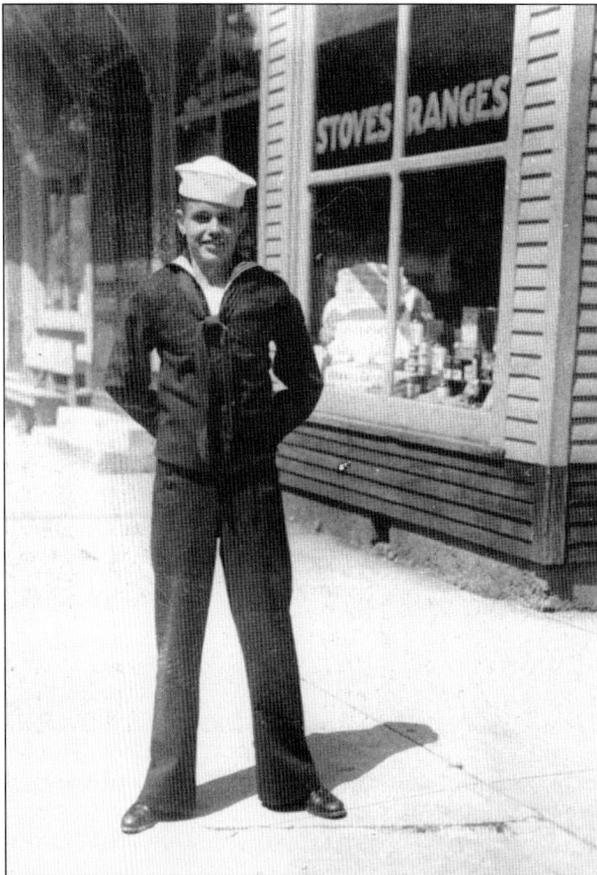

TOM GROHOSKE IN FRONT OF DECKER'S TIRE STORE, EARLY 1940s. Tom Grohoske was the son of Leonard Sr. and Ruth Grohoske. Home on leave, he is seen in front of Decker's Tire Store, on the east side of South Main Street. Owner Don Decker sold tires and did recapping. He also sold small appliances, stoves, ranges, and radios. (Courtesy of Peggy Rinehart.)

FRONT WINDOW OF MORRISON'S DRUG STORE, EARLY 1940s. As Arlingtonians went to the post office, they would stop and look at pictures of World War II service people in the front window of Morrison's Drug Store. There were many pictures of servicemen, and servicewomen were Dortha Wilch, Dorothy Beach, and Jane Ellen Newman. Morrison's Drug Store would later become Stella's. (Courtesy of Peggy Rinehart.)

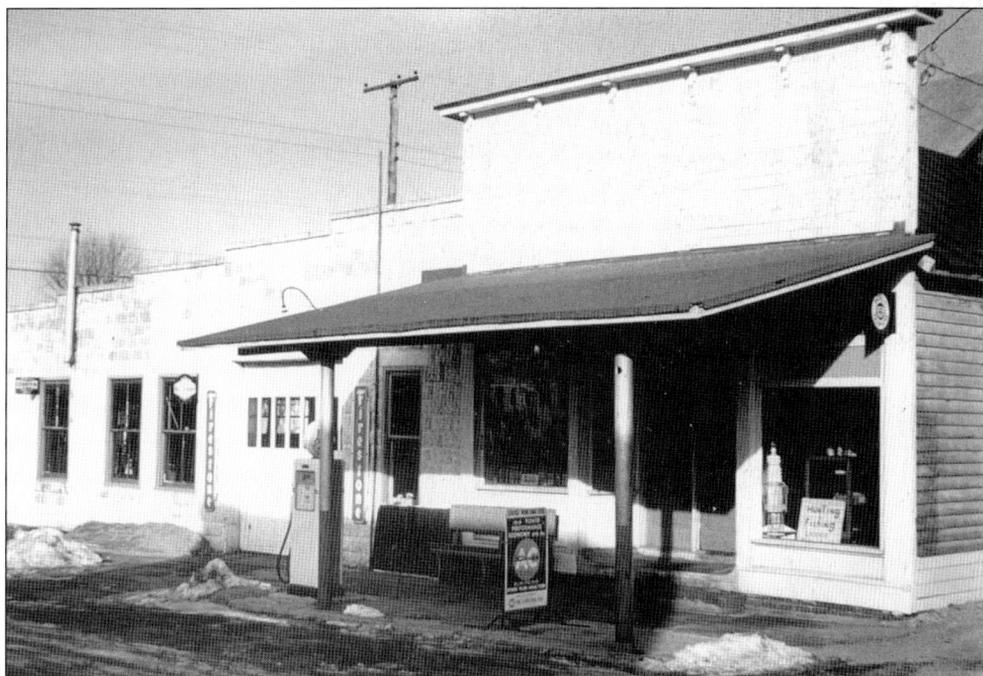

SNYDER GARAGE, EARLY 1960s. Located on the north side of West Liberty Street, this business was owned by Leonard Snyder and then his son Don. They sold gas, worked on cars and electrical appliances, and had metal-working lathes. They also sold driver's licenses, automobile plates, hunting and fishing licenses, and fishing equipment. In 1947, they were a Plymouth and DeSoto car dealership. (Courtesy of Marie Boyle.)

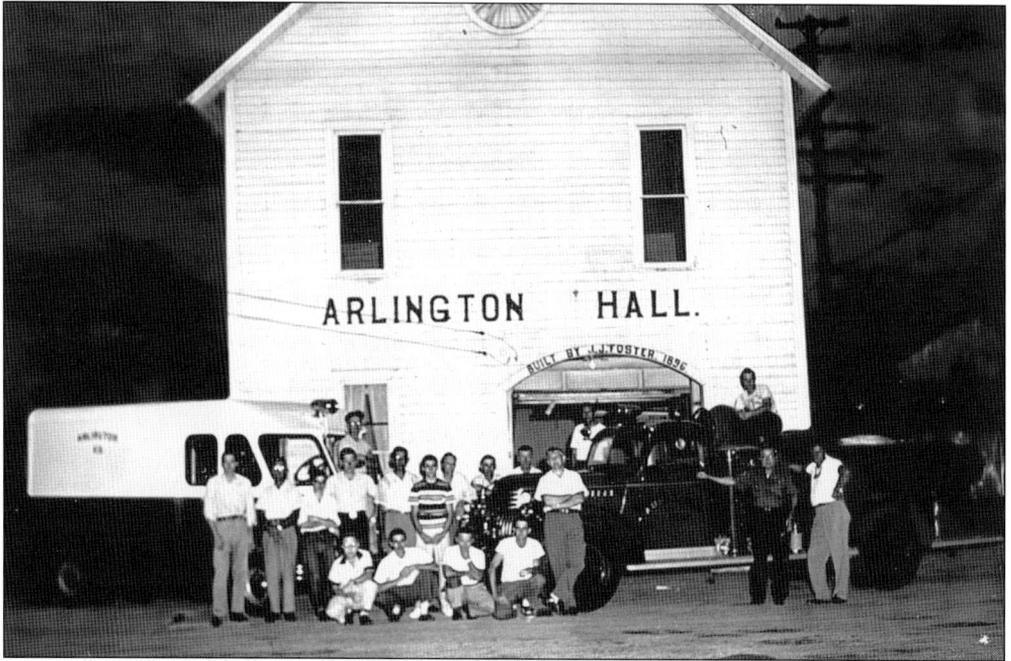

ORIGINAL TOWN HALL, WEST LIBERTY STREET, 1956. Members of the Arlington Volunteer Fire Department are pictured with their trucks in front of the old town hall. This building housed fire equipment, the town council met downstairs, and the jail was in the rear. The Boy Scouts met upstairs. (Courtesy of Greg Snyder.)

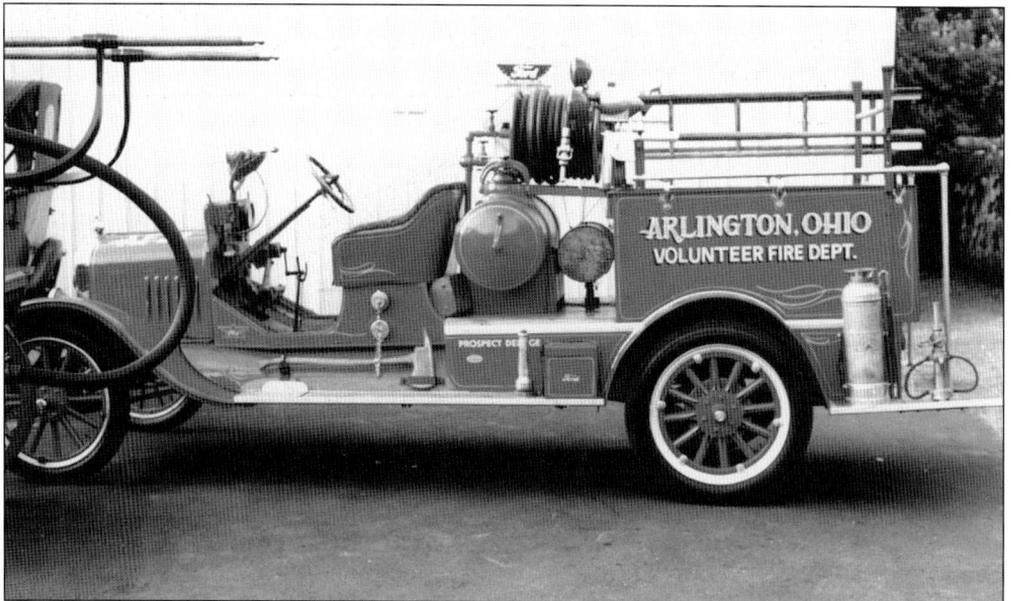

ARLINGTON'S FIRST MOTORIZED FIRE ENGINE. This is a 2002 photograph of the completely restored 1923 Ford Model T fire engine. As a fire engine, the engine had features such as an electric starter, a generator, a battery, and a water pump. It replaced the hand pumper purchased in 1897. It is on display in the Michigan Firehouse Museum in Ypsilanti. (Courtesy of Tom Kroske.)

No PU 76

(NO DUPLICATES ISSUED) $ **1** **25c** FEE

STATE OF OHIO

DIVISION OF CONSERVATION AND NATURAL RESOURCES

RESIDENT

HUNTING AND TRAPPING LICENSE

I Certify that.... *A. E. Kroske* .

applied for a Resident Hunting and Trapping License, subscribing to an oath that he is a citizen of the United States and a resident of Ohio. He has paid the fee of ONE DOLLAR required by law and is, therefore, authorized to kill game within said state until August 31, 1947, subject to all the provisions and penalties of the laws of Ohio and the orders of the Conservation Commission regulating the hunting and killing of wild birds and animals.

DESCRIPTION OF LICENSEE

Residence *Arlington* .

Occupation.... *Retired* Height. *5-8*

Age.. *71*Color hair. *gray* ...Color eyes... *blue* ...Weight. *125*

Issued at.... *Arlington* .

(City)

.. *A. E. Kroske* this. *10*.. day of. *Sept* .. 19 *46*. Hour *9 a. m.*

(Signature of Licensee) (Clerk or Authorized Agent) *N. B.*

HUNTING AND TRAPPING LICENSE, 1946. In the 1930s, 1940s, and early 1950s, the area was a hunter's paradise. The area was teeming with pheasants and rabbits. One was allowed to shoot two pheasants in the morning and two pheasants in the afternoon. If hunters had good dogs, they reached their limit quickly. The area was filled with hunters from miles away during the hunting season. (Courtesy of Tom Kroske.)

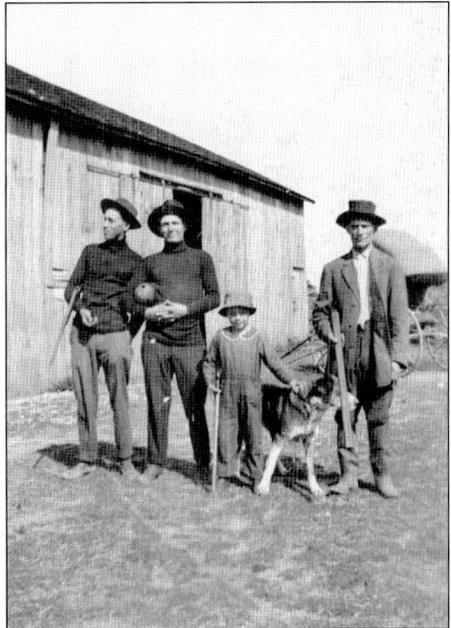

A HUNTING WE WILL GO, 1920–1930. Hunting clothes on and guns ready, from left to right, Ivan Steinman, Joe McBride, J. R. Longworth and his dog, and Philip Longworth get ready for another hunting season. The Arlington area was known around this part of the state as an area with plenty of game to shoot. (Courtesy of Juanita Rinehart.)

WEST LIBERTY STREET, 1947. This picture shows the north side of the street facing east. On the right, fronting on Main Street is the building housing the newspaper office and the office of Dr. John Solt, D.V.M. On the left, with the gasoline pump under the awning, is Snyder's De Soto Plymouth dealership. New automobiles are pictured in front of the building. (Courtesy of Greg Snyder.)

WEST LIBERTY STREET, 1947. Looking toward the north side of West Liberty Street, on the left is the blacksmith shop of brothers Pard and Tommy Bowman. Pard kept their money in his pocket, in a leather bag with drawstrings. The white building is the town hall (site of the current post office), and a new automobile is located in front of the Snyder's De Soto Plymouth dealership. (Courtesy of Greg Snyder.)

Four

THE GREAT MIGRATION
1951–1980

The use of tractors and improved farm machinery meant fewer people were needed on the farm, and men returning home from World War II began seeking and finding jobs in the world outside Arlington. Arlington still had many family-owned businesses in the early 1950s. It supported two car dealers, two elevators, two doctors, two hardware stores, multiple gas stations, restaurants, grocery stores, and clothing stores, and a jewelry store, weekly newspaper, furniture store, pharmacy, appliance store, beauty shop, and barbershops, but an exodus was beginning. The automobile and cheap gasoline were making it easy to travel to bigger towns for entertainment, work, or supplies.

Local utilities, like the light plant that supplied electricity and the telephone company, ceased to operate, and services from large companies were obtained. The Farmers and Merchants Bank that began with a group of local investors sold out to Mid-American Bank. The railroad that dropped off mail six times per day was no longer used for deliveries.

The town did grow bigger with 17 new plat additions to it and better with the following improvements. Land south of the school used as the town dump was filled in and additional classrooms added. Both the Methodist church and the Lutheran church were added on, and the Bible Fellowship congregation built a new church. Old structures on lots 14 and 15 of the original plat were torn down, making space for the car dealership of Earl Grimes. In 1977, the town began to work on a wastewater treatment plant, and by 1979, villagers were connecting to it and demolishing their septic tanks.

The townspeople were still very community oriented and each year hosted a homecoming that featured a parade, rides, food, bingo, and a chance to work and play together. During the summer in the 1950s, the town sponsored a weekly outdoor movie on the wall of the town hall. Community members also volunteered their time and money to construct a swimming pool at the park. At Christmastime there was a town party inside the Corbin Brothers Chevrolet building featuring a piñata filled with candy. Life was good as an Arlingtonian.

BUILDING THE NEW SWIMMING POOL. Beginning in 1945, the homecomings were started again to raise money for a swimming pool. It took six years to raise enough money, and in 1952, construction began. Many people did volunteer work on the pool, and in 1953, it was opened to the public. This 1952 photograph shows the pool and bathhouse under construction. (Courtesy of Tom Kroske.)

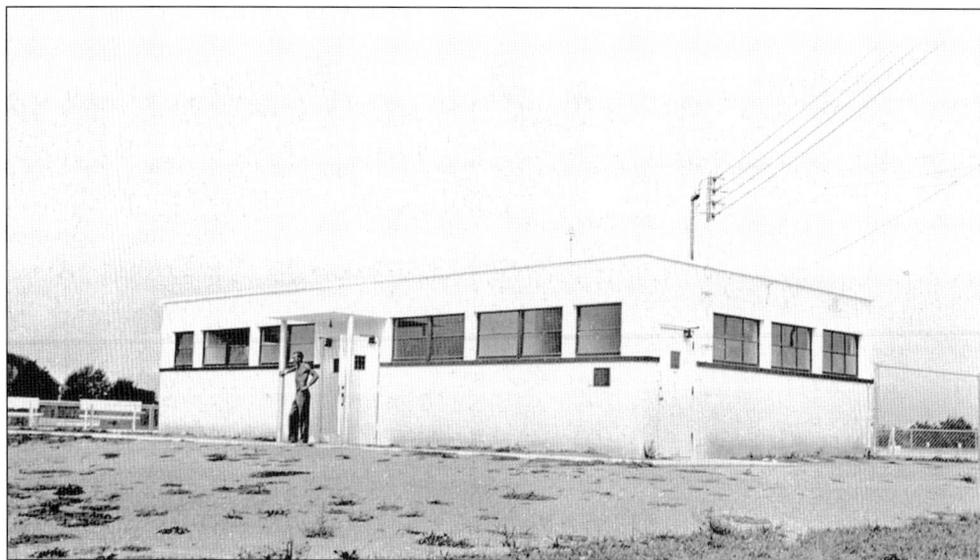

SWIMMING POOL BATHHOUSE. This 1953 photograph shows the new bathhouse for the swimming pool. The building contained an entry room for collecting admissions, concessions, and baskets for clothing. There were dressing rooms on either side with toilet facilities, changing stalls, and showers. On each side, accessible from the outside, were public restrooms. (Courtesy of Leslie Lazenby-Hunsberger.)

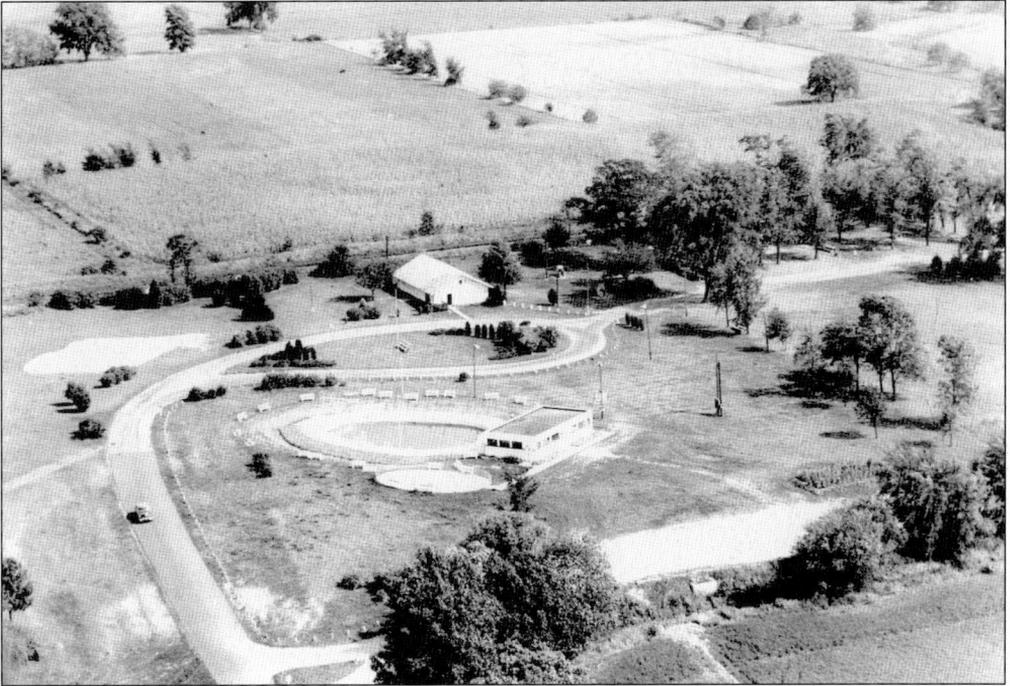

AERIAL VIEW OF ARLINGTON PARK, 1955. The park was started with 11 acres in 1938 and gradually added on to. It became an Ohio state park highway rest area in the early 1940s. The state turned the park back over to the town in 1952 so that the swimming pool could be built as the state wanted no part of swimming pool upkeep. (Courtesy of Don Steinman.)

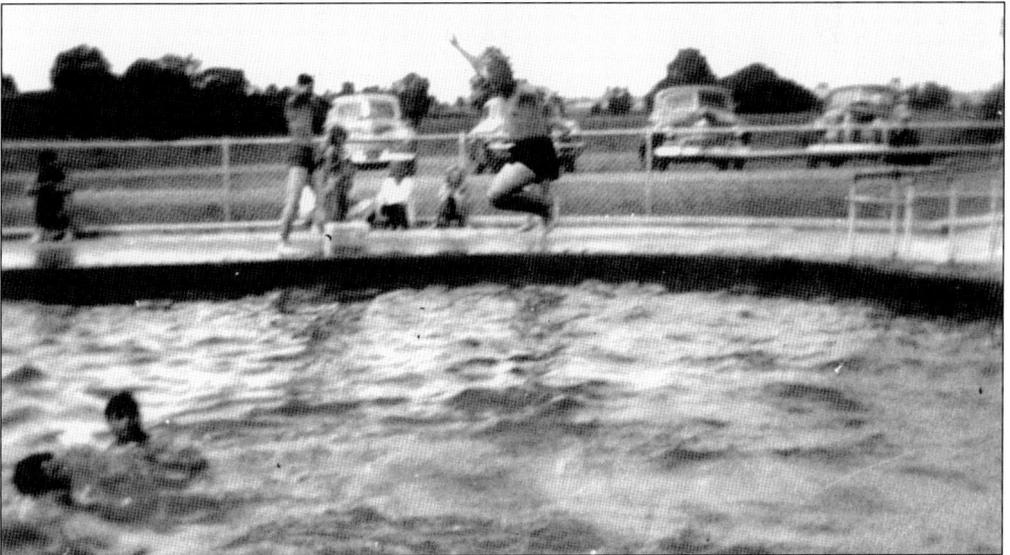

THE FIRST SWIMMERS. This 1953 photograph shows some of the first swimmers enjoying the new swimming pool. Pictured in the water on the left is Stanley Woodward, and next to him is Bob Crosser. Jumping from the diving board is John (J. J.) Solt. The fence surrounding the pool was inside a "moat" to make it low enough for people to see over but too high to climb. (Photograph by Tom Kroske.)

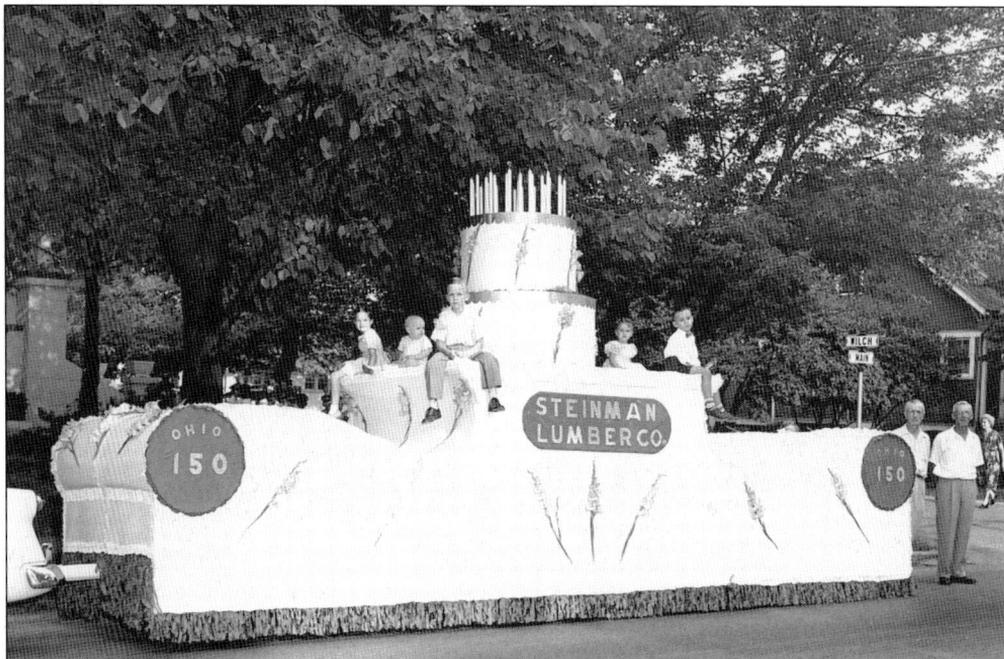

HOMECOMING FLOAT, 1953. Arlington's homecomings lasted from 1945 to 1995 and always contained numerous floats such as this John Steinman Lumber Company entry in 1953 with a cake on top celebrating the 150th birthday of the state of Ohio. The big barns of the lumber company housed many float builders, and this was an enjoyable time when families, organizations, and businesses got together to build float entries. (Courtesy of Don Steinman.)

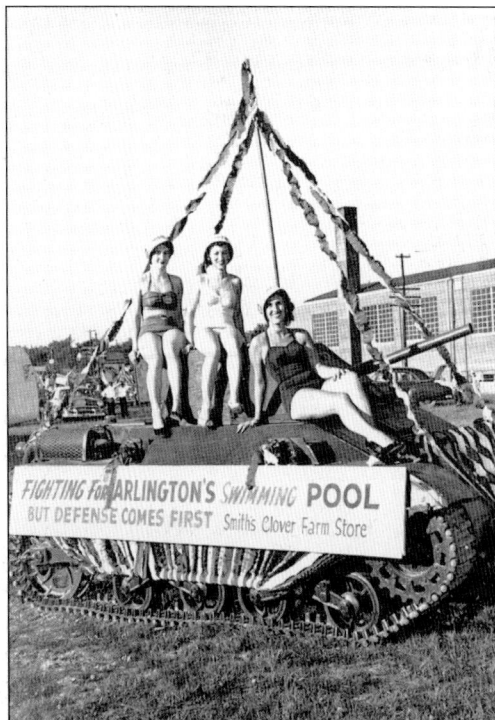

SMITH'S CLOVER FARM HOMECOMING FLOAT, 1953. Clem Smith's float in the 1953 homecoming parade was rather unusual. A local farmer had bought an army tank for use around the farm. Smith bought the body, engine, and tracks and made the gun from a carpet tube. On the float are, from left to right, Marilyn Miller Lazenby, Margaret Miller Sadler, and Evelyn Hauman. (Courtesy of Leslie Lazenby-Hunsberger.)

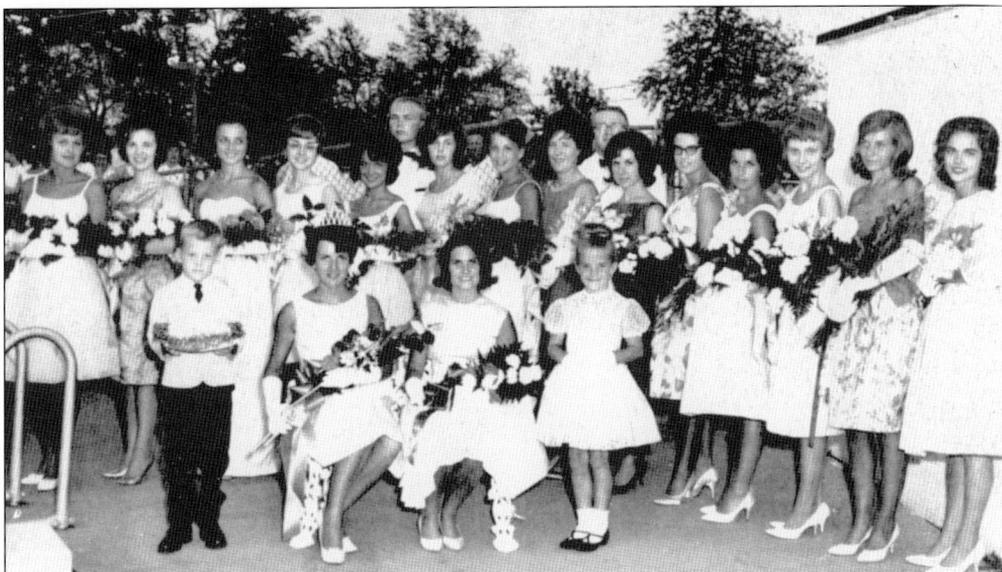

HOMECOMING QUEEN CONTESTANTS, 1963. Sixteen queen contestants along with ushers and crown bearers are pictured at the swimming pool. The contestants were sponsored by local businesses. Each contestant was taken for a stroll around the swimming pool, and then one girl was chosen queen for the annual homecoming. The queen contestants rode in convertibles in the parade. (Courtesy of Don Steinman.)

GRAND PRIZE—1951 DE LUXE FORD CAR

HOMECOMING
AND FESTIVAL

ARLINGTON, OHIO

TWO BIG NIGHTS
AUGUST 23 & 24, 1951

No. 3007

Sponsored by ARLINGTON SWIMMING POOL ASSN.

Benefit of Swimming Pool Fund

Donation 50c You Need Not be Present to Win

HOMECOMING GRAND PRIZE, 1951. The annual homecoming grand prize was a new car for the first 20 years. It was always given away at 10:30 on the second night. The first car given away was a Ford, provided by Arlington Ford Sales. The winning ticket was owned by Corbin Brothers Chevrolet. The Ford dealer bought the car back from the Chevy dealer. (Courtesy of Tom Kroske.)

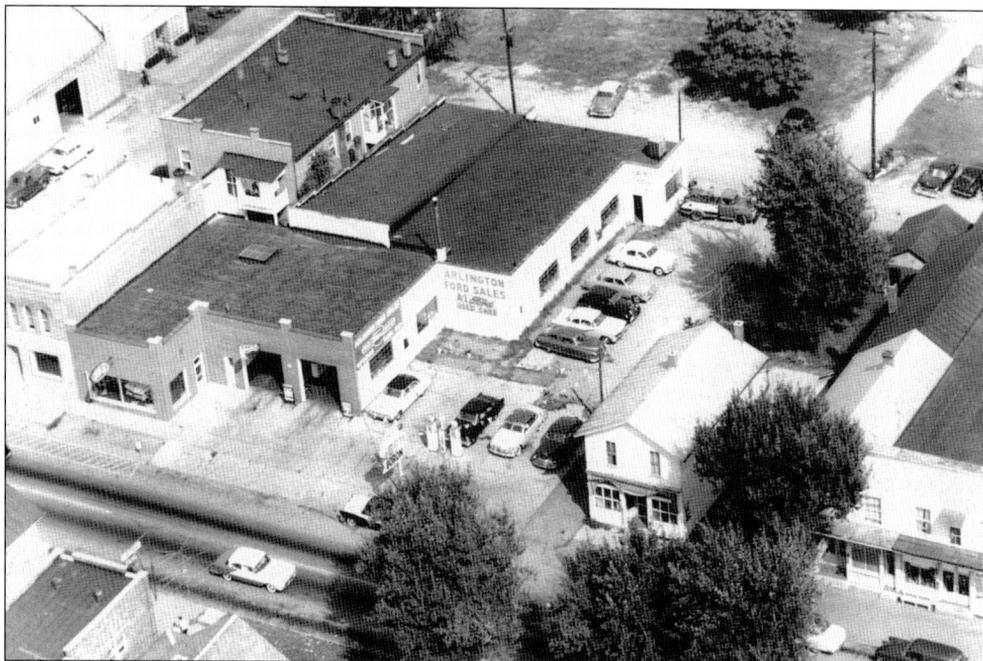

AERIAL PHOTOGRAPH, 1950s. Along East Liberty Street at the top left corner are Corbin Brothers Chevrolet and the Dally Funeral Home. Across the street is the Dorney Building. From left to right on South Main Street are the Farmers and Merchants Bank (white roof), Arlington Ford Sales, Weber's Barber Shop, S and S Electric and Photo Shop, and Hartman Hardware. Most of these buildings had apartments. (Courtesy of Mildred Fink.)

CORBIN BROTHERS CHEVROLET. This is a 1964 photograph of the building built by Floyd and Gerald Corbin on the northeast corner of Main and Liberty Streets in 1923. The building has no supporting walls in the interior. Several wooden trusses span the 65-foot width to support the roof. Floyd got the idea from hangars he worked in as an airplane mechanic during World War I. (Courtesy of Peggy Corbin.)

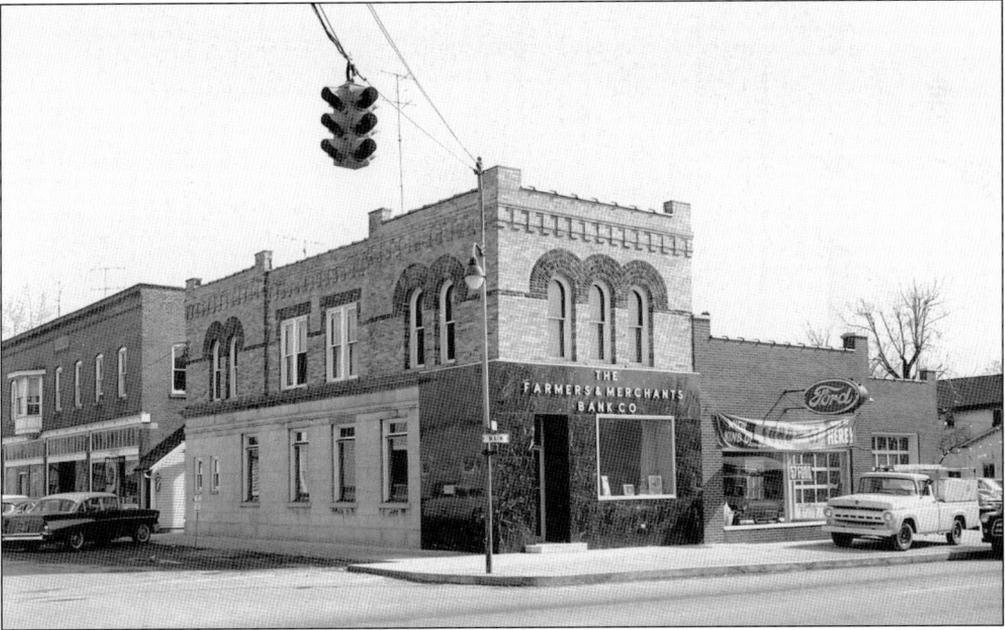

FARMERS AND MERCHANTS BANK REMODELED. This 1957 picture shows the bank after remodeling was completed in 1924. New marble stone was placed on the exterior, and the door was moved to a Main Street entrance. A new five-ton vault and safety-deposit boxes were installed along with marble floors and new windows. The bank was at the same location for 66 years. (Courtesy of Leslie Lazenby-Hunsberger.)

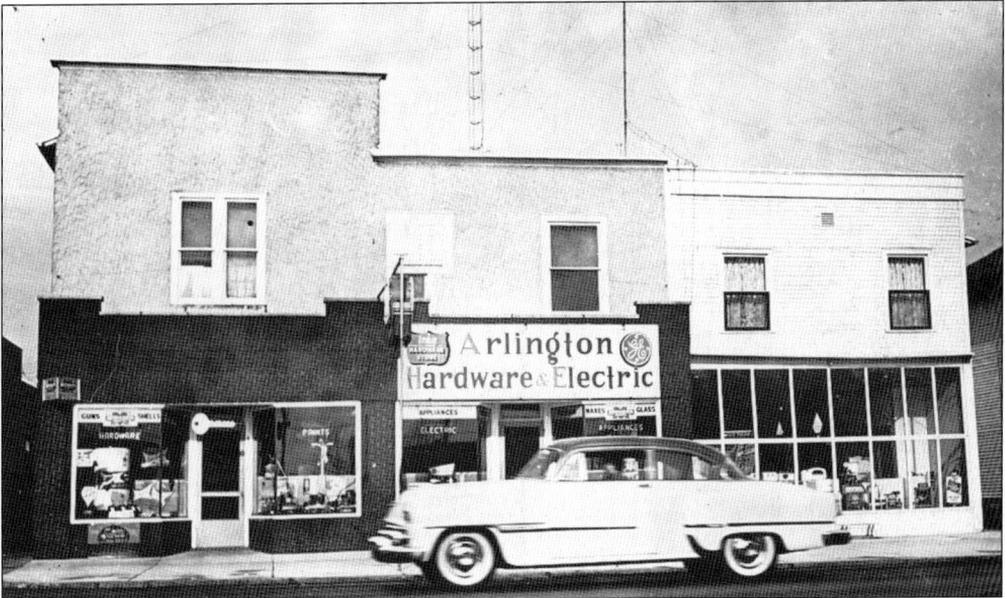

ARLINGTON HARDWARE AND ELECTRIC, 1953. Lee and Cleo Gillespie bought the brick-faced left two-thirds of the building from Pearl Misamore and Leonard Snyder in 1945. It was the former Hotel Gay. In 1949, they enlarged the store by moving the old Ohio Hardware building from across the street to complete an appliance showroom in the north one-third of the building. (Courtesy of Lee Gillespie.)

ESSINGER'S APPAREL SHOP AND THE CLOVER FARM STORES, EARLY 1960S. Alma and Catherine Essinger worked in dry goods at the Spot Market. Paul Reamsnyder discontinued the dry goods and gave the inventory to Alma and Catherine to start an apparel shop. Bus and Nell Beach owned the Clover Farm Stores to the north. The businesses were on the west side of North Main Street. (Courtesy of Leslie Lazenby-Hunsberger.)

STELLA'S RESTAURANT AND SODA GRILL, LATE 1950S. Stella Bibler bought this business in 1945 and ran it until 1982. It had a long soda fountain–type bar with two booths in the back and a big rack of comic books. It also sold drugstore-type items. One could get fountain drinks, sodas, coffee, sandwiches, french fries, milk shakes, and eventually regular dinners. (Courtesy of Leslie Lazenby-Hunsberger.)

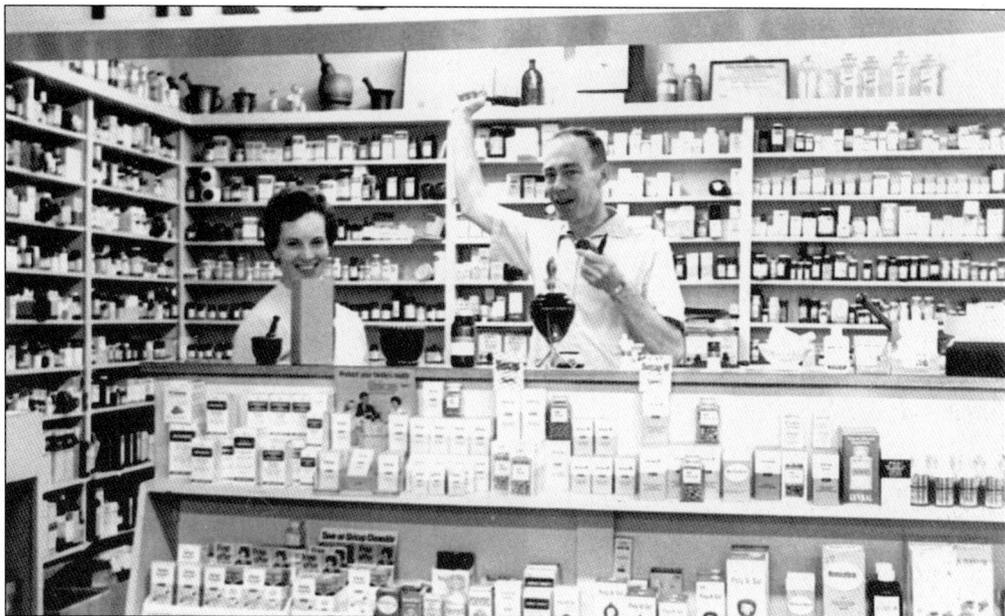

INSIDE MCDEVITT PHARMACY, 1960S. Dorothy Waxler and Earl McDevitt are shown working in the prescription section of the McDevitt Pharmacy. The pharmacy was located in the brick building at 106 South Main Street, which is currently the home of the Arlington Pharmacy. Waxler still works there. In addition to prescriptions, the pharmacy also had a soda grill and sold a wide variety of items. (Courtesy of Dorothy Waxler.)

DOCTOR'S OFFICE, 1960. The brick doctor's office shown at the left in this picture was built in 1846 by Dr. Belizer Beach. It was the first brick home in Arlington and was called the Stanford House. The bricks came from the Soloman Watkins farm. Drs. Harold Treece, Reid Burson, and Mark Penn practiced here. It was torn down in 1987 for a bank drive-through. (Courtesy of Karen Landolt.)

DALLY FUNERAL HOME AND POST OFFICE, EARLY 1960S. On the left is the Dally Funeral Home. This building was part of a building cut in half from the Houdeshell Block and moved to this location. The block building on the right was built by Jim Bob Dally as a casket showroom, and in 1951, it became the post office. (Courtesy of Leslie Lazenby-Hunsberger.)

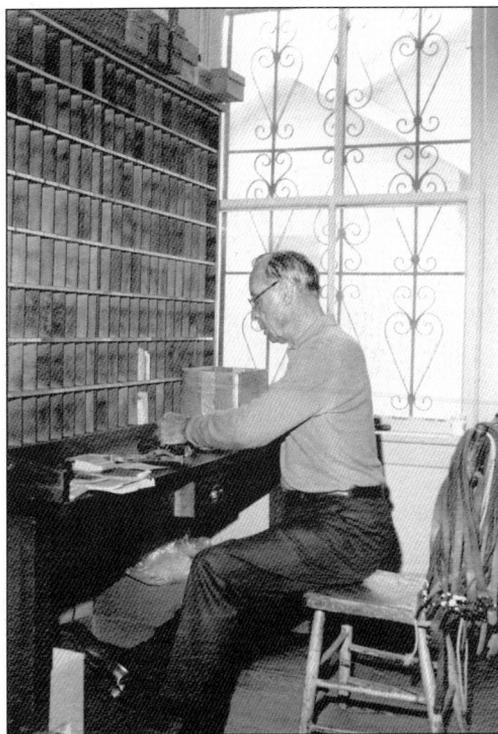

INSIDE THE POST OFFICE AT 114 EAST LIBERTY STREET, 1950S–1960S. Rural delivery mail carrier Clarence Moore is shown in the back of the post office sorting mail before making his rural deliveries. The post office was a community meeting place. The town people had boxes with combination locks, and people needed to remember their combinations. Today people just have to remember to take their keys. (Courtesy of Jim Hindall.)

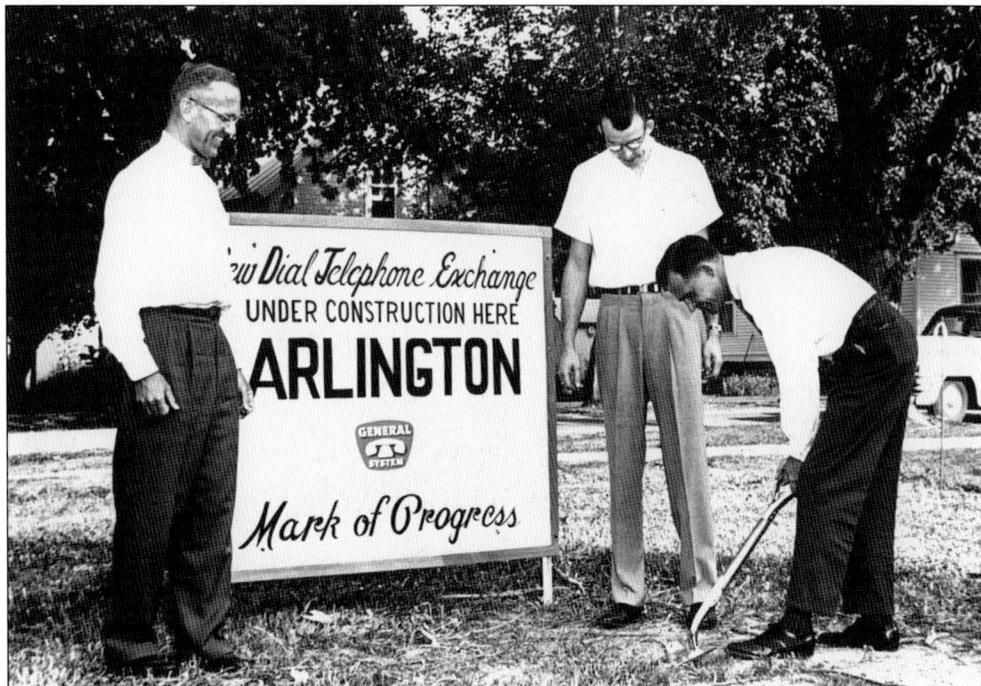

SITE OF A MODERN TELEPHONE OFFICE. Plans for a modern dial telephone system and building were divulged on this sign in 1968 by the General Telephone Company. A representative of General Telephone (left), along with Keith Corbin (center) and Mayor Raymond Carey, marks the spot with a sign on Union Street. This would eventually spell the end of the telephone operator. (Courtesy of Leslie Lazenby-Hunsberger.)

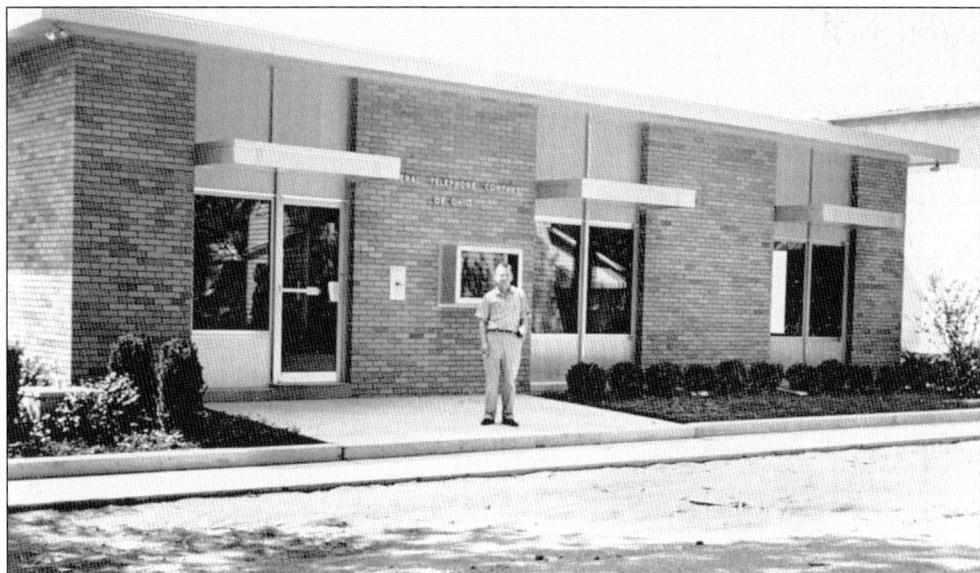

NEW GENERAL TELEPHONE COMPANY OFFICE BUILDING, 1969. Many Arlington women lost jobs as telephone operators because of this direct dialing system. Prior to automation, the operator manually connected a wire from the caller's telephone number to the person being called. The operator then rang the party being called. (Courtesy of Leslie Lazenby-Hunsberger.)

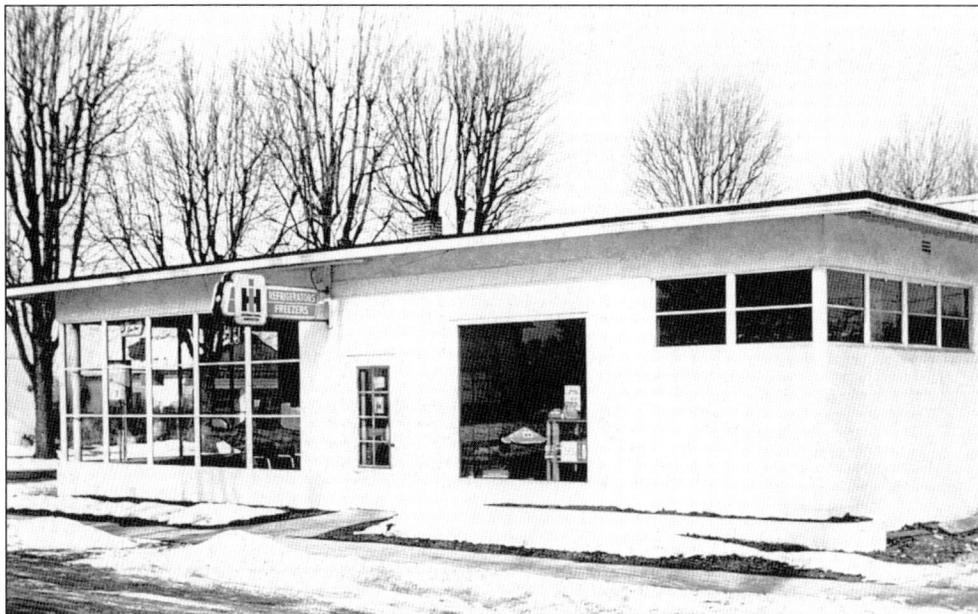

BAME'S INTERNATIONAL TRACTOR DEALERSHIP, 1960s. J. G. "Stub" Bame started an International Harvester dealership in Arlington in 1937. He built this cement block building at the northeast corner of Cumberland and West Liberty Streets in 1950, the only building that has ever been on this property. It was a modern dealership with a nice showroom. Bame's International went out of business in 1963. (Courtesy of Leslie Lazenby-Hunsberger.)

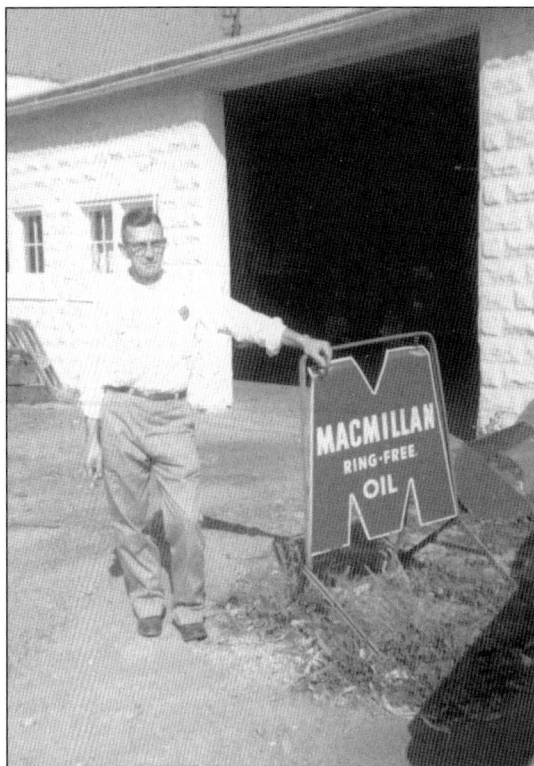

EVERETT SMITH IN FRONT OF SMITH FARM IMPLEMENT, NOVEMBER 1964. Owner Everett Smith stands in front of his Allis-Chalmers dealership in the block building on the alley just northeast of the square. Smith owned the last Allis-Chalmers dealership in Arlington. Previous owners were Oscar Wolford trading as Wolford Implement Sales and Merritt Gehrisch as Gehrisch Implement Sales. (Courtesy of Dan Smith.)

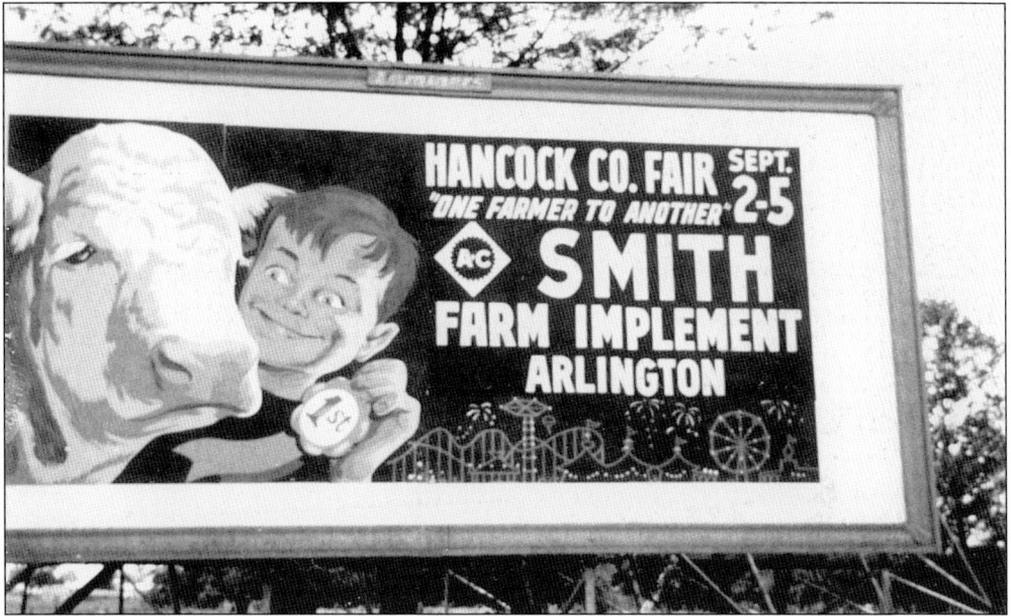

BILLBOARD ADVERTISING HANCOCK COUNTY FAIR, 1963. The fair is always a special time for rural Arlington people, and this advertisement from Smith Farm Implement reminds all farmers that the Hancock County Fair is September 2–5. Smith Farm Implement was the local Allis-Chalmers dealer in Arlington, and the sign was on U.S. Route 68 on the way to Findlay. (Courtesy of Dan Smith.)

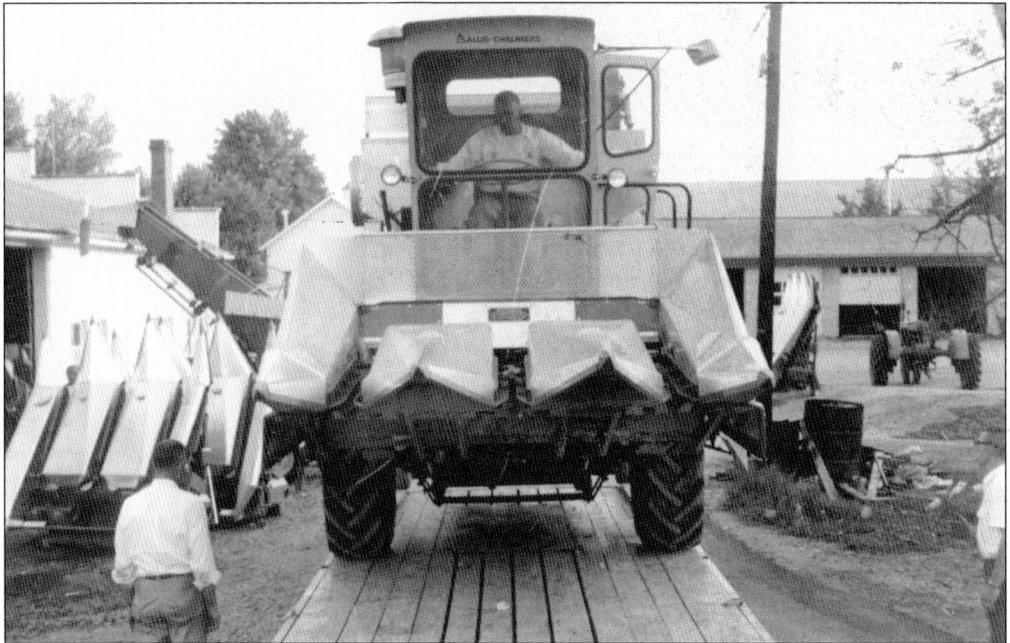

SMITH FARM IMPLEMENT, 1966. Employees of Smith Farm Implement are shown loading an Allis-Chalmers gleaner combine with a three-row corn head onto an equipment trailer. Allis-Chalmers was the most popular line of farm equipment in the Arlington area. There were Allis-Chalmers dealers in Arlington for 50 years, from 1936 to 1986. (Courtesy of Dan Smith.)

WEST LIBERTY STREET, LOOKING EAST, 1955. An interesting street scene shows cars parked to the left along the side of the old Crates Building, much as horses had years earlier. On the right are cars parked at Stella's and also the Hinchey Barber Shop. The Farmers and Merchants Bank building is in the distance. A race car from Snyder's Garage is coming down the street. (Courtesy of Greg Snyder.)

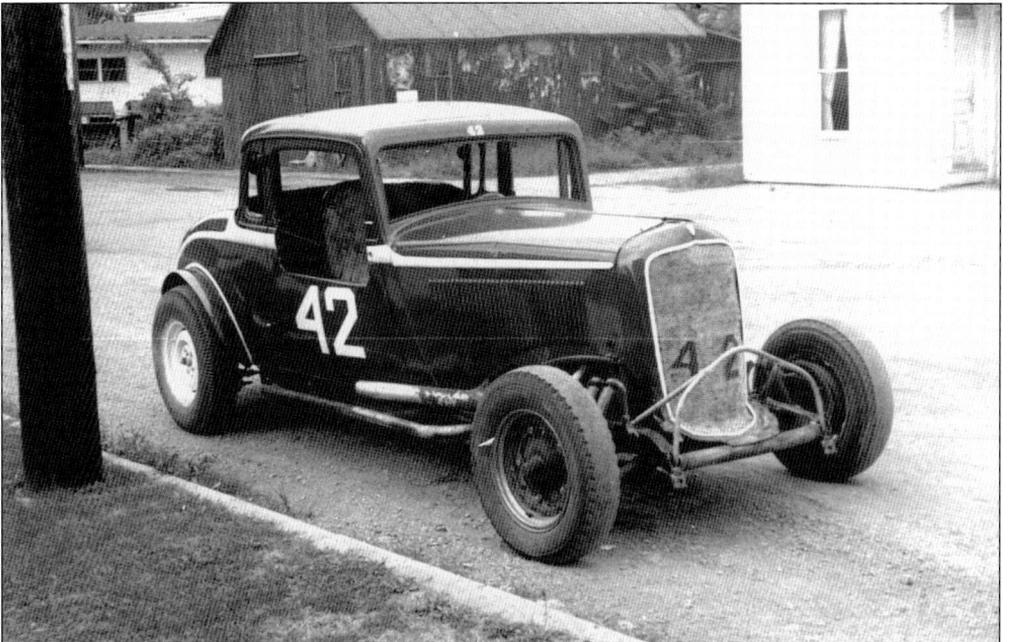

DIRT TRACK RACE CAR, 1955. Built in Snyder's Garage by Don Snyder and others, this race car was driven by Emerson Deyer. It raced at Millstream Motor Speedway west of Findlay and New Bremen Speedway in New Bremen. It was one of the better "second heat" cars. It was powered by a six-cylinder Dodge truck engine with dual carburetors. (Courtesy of Greg Snyder.)

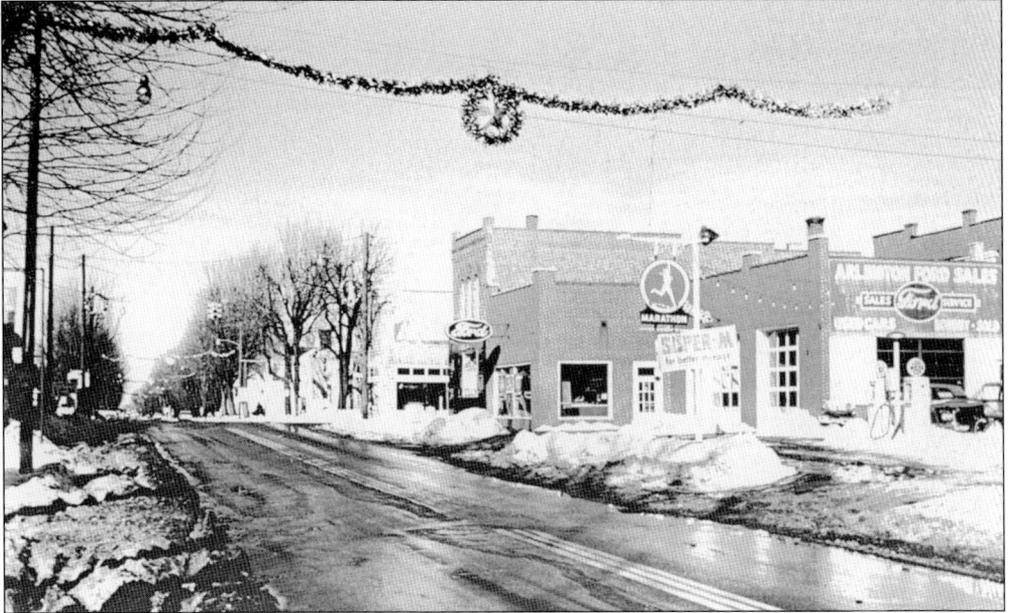

CHRISTMAS LIGHTS ALONG MAIN STREET. Christmas lights were installed each year by the volunteer fire department. To hold the lights there were wires stretched across the street throughout the business district. First there were just lights. This 1960s photograph shows decorations and lights. As buildings were razed, the wires came down, and now lit decorations are placed on poles on each side of the street. (Courtesy of Leslie Lazenby-Hunsberger.)

JACK HINDALL'S ROTARY RIG, 1970S. From 1950 to 1987, Jack Hindall operated a well-drilling business. Well depths ranged from 30 to 550 feet in depth, taking from a day to a week to drill. He averaged 80 wells per year and did some blast hole drilling for Blanchard Station and Pifers stone quarries. Once his derrick fell when one of the four jacks supporting it went down in the sand. (Courtesy of Lois Hindall.)

ARLINGTON GARDEN CLUB TREE PLANTING, EARLY 1960S. State Route 68 through Arlington was designated the Johnny Appleseed Highway. The women of the Arlington Garden Club planted crab apple trees along both sides of the highway. Mable Corbin, Susan Corbin, Ruth Bailey, and Celia Johnson are among the group pictured planting trees. Very few of these trees are left today, succumbing to insects, diseases, and development. (Courtesy of Celia Johnson.)

JOHNNY APPLESEED RESTAURANT AND BOWLING LANES, EARLY 1960S. One of the most popular Arlington businesses of all time, the Johnny Appleseed Restaurant and Bowling Lanes served Arlington from 1957 until fire destroyed it in December 1976. Known for good food and enjoyable times, it was also a source of employment for many Arlington people. Harry Richards was the manager for many years. (Courtesy of Leslie Lazenby-Hunsberger.)

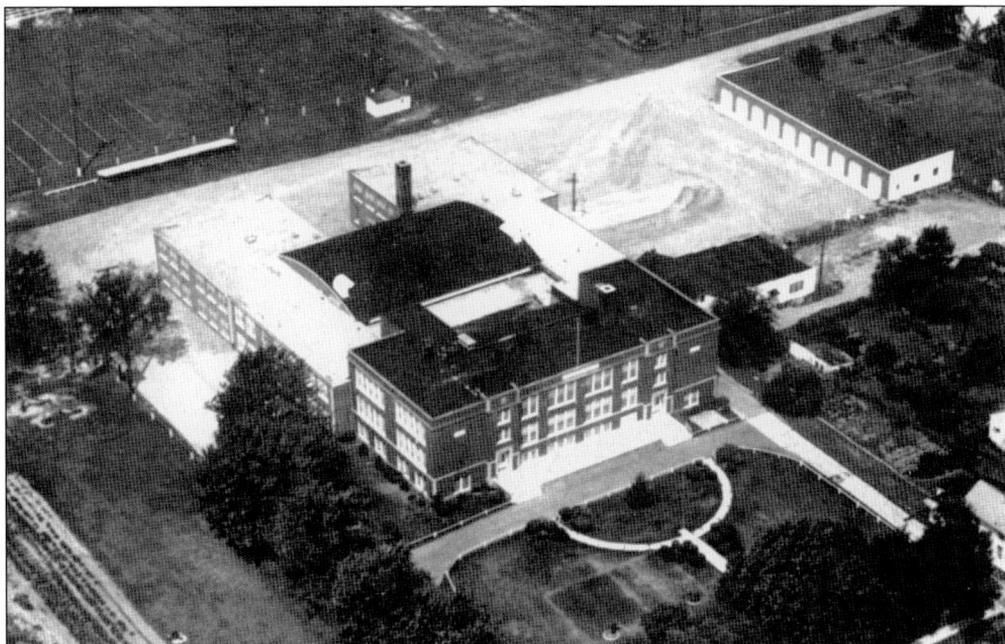

AERIAL VIEW OF ARLINGTON SCHOOL, 1953. Taken shortly after the first addition was made to the original 1924 building, this picture shows two new wings added on to the north and south. Looking closely at the yard in front of the building, one can see an outline of the foundation of the 1860 school building that the 1924 building replaced. (Courtesy of Don Steinman.)

ARLINGTON HIGH SCHOOL BAND, SUMMER 1962. The band marches in the sesquicentennial celebration in Findlay on South Main Street, led by band director William Everhart. Big crowds lined the streets for this celebration. Note that Shirley MacLaine was starring in My Geisha at the Harris Theatre, and the ever-popular Wilson's Hamburger Shop is shown on the right. (Courtesy of Dan Smith.)

THE SNOW SLIDE, 1957. Nance Marohn had an idea for a snow slide. Thirty men donated time in building this 16-foot-high platform with a 30-foot ramp on it. The slide down was 45 feet in length. It sat at the top of the hill at Arlington Park, and sleds slid east to west down Park Street. (Courtesy of Dave Riegle.)

A 1955 YELLOW T-BIRD. This eye turner was owned by Emory and Rema Stuart. Neighbor girl Mindy Rinehart Lotz stands by the car. It came out in the fall of 1954 and had a yellow interior with black carpet, 292 V8 engine, four-barrel carburetor, automatic transmission, power steering, and radio and cost $2,875. The Stuarts used Pink Liquid Glass Polish, and the car was garaged all winter. (Courtesy of Juanita Rinehart.)

106

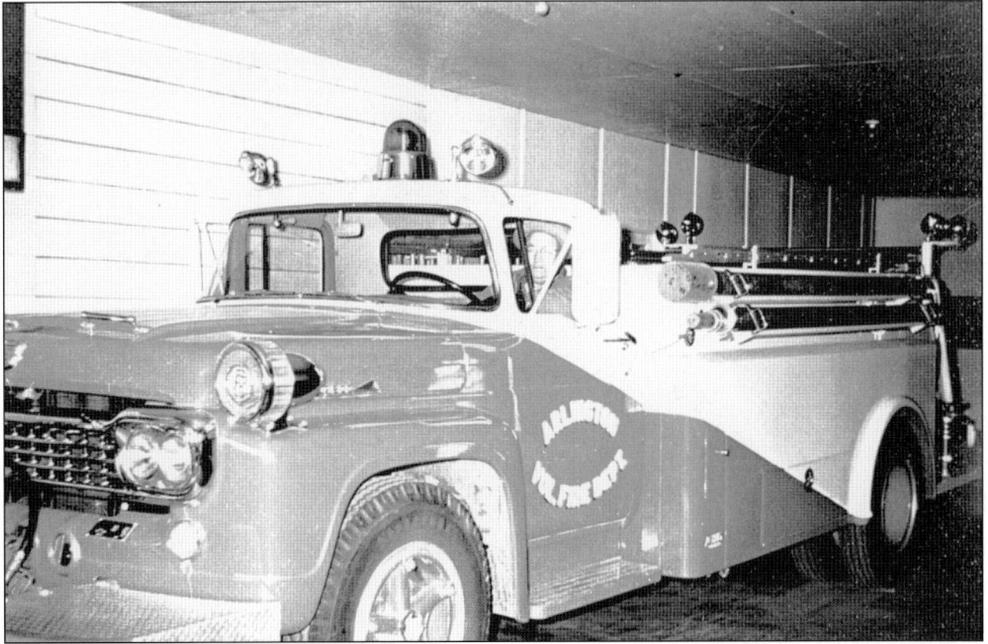

A 1958 Ford Fire Truck. Fire Chief Leonard E. "Pickle" Snyder is shown in a new red and white fire truck. It had a water-holding capacity of 1,000 gallons and pumping capacity of 500 gallons a minute from the pump on the front of the truck. It also carried several hundred feet of hose and ladders. It was taken out of service in the late 1990s. (Courtesy of Leslie Lazenby-Hunsberger.)

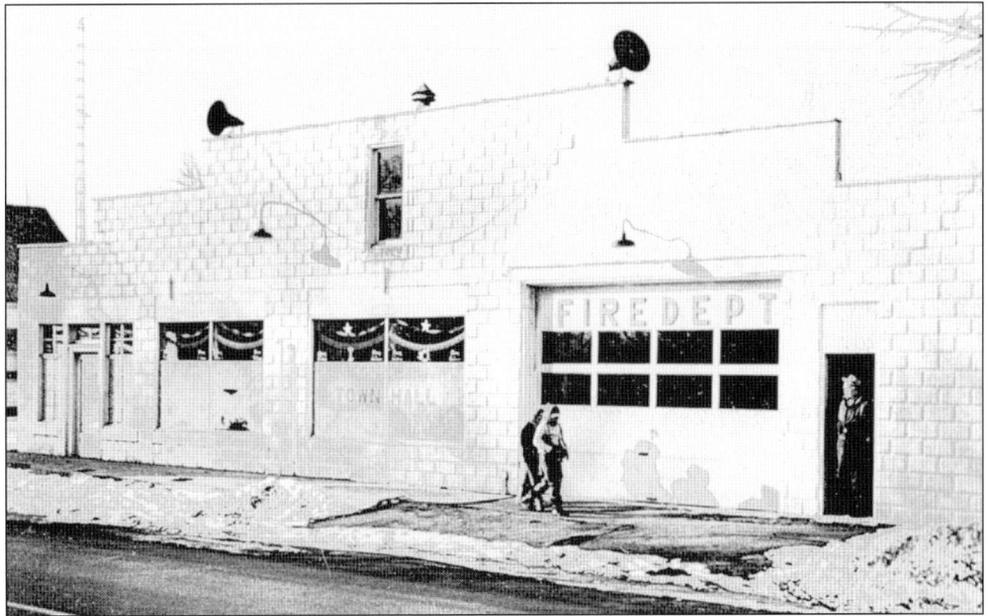

Fire Department and Town Hall Building, 1980. This building is pictured decorated at Christmastime. The two speakers on top always played Christmas music. Santa always came to the building around Christmas to distribute a sack of goodies to the town children. The building housed five fire trucks and had a meeting room used by the fire department, town council, and Boy Scouts. (Courtesy of Leslie Lazenby-Hunsberger.)

LUTHERAN CHURCH ADDITION. In 1965, an addition on the south side of the church added an office, a small kitchen, and a large multipurpose room with long rooms off either side of it that could be partitioned off with movable curtains into Sunday school classrooms. (Photograph by Leslie Lazenby-Hunsberger.)

METHODIST CHURCH ADDITION. Construction was completed by 1956 of a brick addition of classrooms, a kitchen, and a dining room to the west end of the church. In 1964, the parsonage on Main Street was sold and a new brick ranch home built on Cumberland Street. (Photograph by Leslie Lazenby-Hunsberger.)

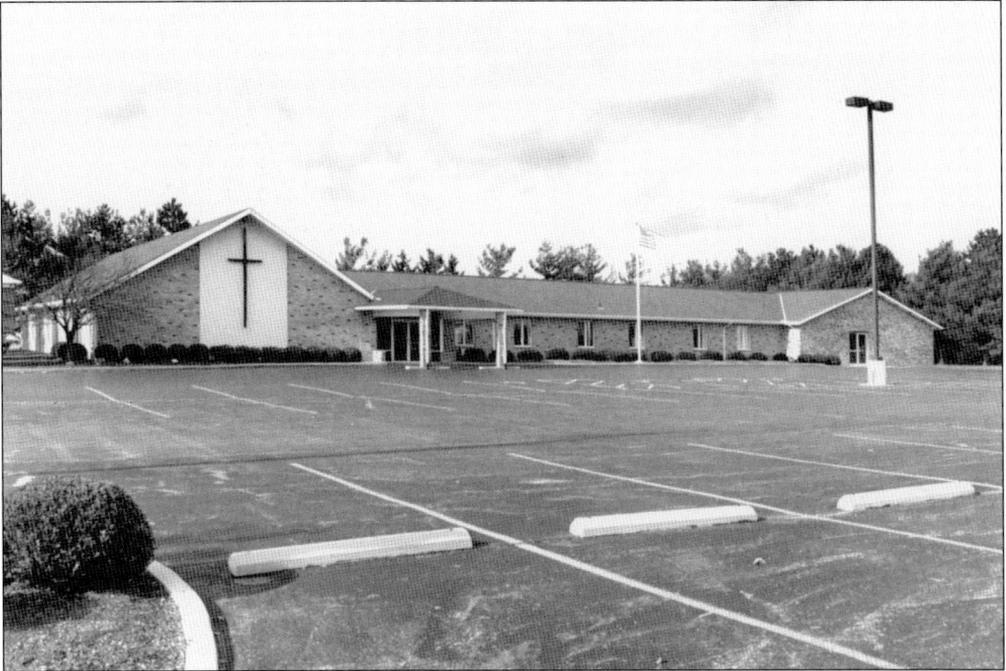

BIBLE FELLOWSHIP CHURCH, 2007. The new church was built on Fellowship Drive in 1973, and classrooms for a school were added in 1975. The school was discontinued in 1979. Jerry Kellogg is the current pastor, serving since August 1990. (Photograph by Leslie Lazenby-Hunsberger.)

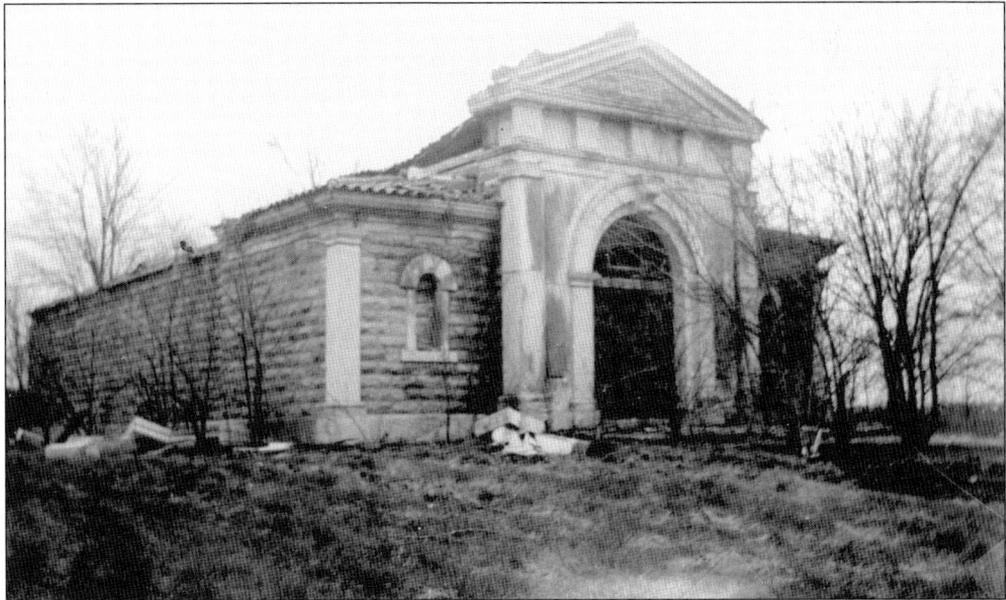

MAUSOLEUM, 1953. The mausoleum was torn down in 1953 due to damaged locks on the front doors, broken windows, plaster that had fallen off the ceiling, and debris covering the floor. The roof went bad first, and then the water and frost got into the walls and caused deterioration. (Courtesy of Ruby Jolliff Gehrish.)

WATER SUPPLY AND WASTEWATER TREATMENT PLANT. The water tower has served the village since 1934. In 1977, water softeners were installed in the water system. In 1978, the town wastewater treatment plant was being constructed. In 1979, residents began filling in their septic tanks and tying into the new system. (Photograph by Leslie Lazenby-Hunsberger.)

ARLINGTON GOOD SAMARITAN HOME. A committee was formed in 1969 to raise $1,000 to purchase the site, prepare for utilities, and have seed money to build the 50-bed senior center. Construction costs were a half a million dollars, and it was completed in 1972 at 100 Powell Drive. It is operated by the Good Samaritan Society of Sioux Falls, South Dakota. (Photograph by Leslie Lazenby-Hunsberger.)

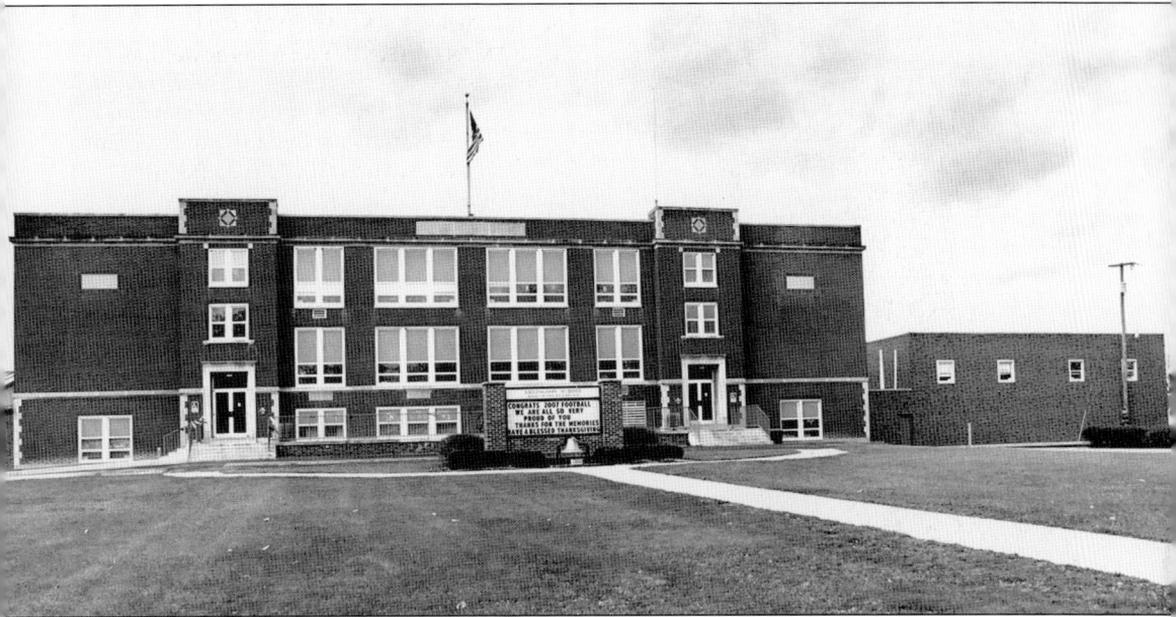

ARLINGTON SCHOOL ADDITION, 1978. An addition to the north end of the school added a new kitchen, a cafeteria, a vocational agriculture shop, an industrial arts shop, a choir room, a band room, and new locker rooms. Prior to this new addition, the vocational agriculture classes had had to use the one-room Ellis school building that had been brought into town and located a few feet north of the school. The old cafeteria that was tucked under the auditorium became the new high school library, and the old kitchen was converted into a teachers' lounge. (Photograph by Leslie Lazenby-Hunsberger.)

THE BLIZZARD OF 1978. On January 26, 1978, record amounts of snow fell quickly after a night of rain, thunder and lightning, high winds, and falling temperatures. The village was without power, water, and telephones for two days. Pictured here by a drift that has Route 68 down to one lane is Brad Jolliff. (Courtesy of Keith Jolliff.)

MAIN STREET IN THE BLIZZARD OF 1978. The town was dug out by local construction workers with the Army Corps of Engineers opening up roads to the rest of the county. There were no shoveled sidewalks, so everyone walked in the street. School was closed for weeks, and students had to make up 12 days, including three Saturdays. (Courtesy of Keith Jolliff.)

Five

A Bedroom Community
1981–2007

The bustling business district of Arlington's past has faded. The number of businesses continues to dwindle as people drive to bigger cities for a greater variety of products. In the old business section of Arlington are empty buildings and stores converted to apartments or torn down for a parking lot or grass. The old Hotel Gay building that was later used as a hardware and then an antiques shop is now apartments. The Dorney Building on East Liberty Street that once housed the library, a dance studio, and a delicatessen is now apartments too. The Wertenberger furniture store, later a hatchery, is now apartments. There is only one grocery store, a bank, a pharmacy, two eateries, a drive-through, a small hardware store, a gas station, a beauty/barber shop, an insurance agency, an elevator, and a photography studio. The beautiful architecture of the Farmers and Merchants Bank and Stella's Soda Grill buildings are missing. The business buildings that housed the *Arlingtonian*, Rodabaugh produce, and hardware, in lots 9 and 10 of the original plat, have been torn down. The north feed mill is gone, and the emergency medical service building sits in the front of its lot. The tracks of one of the mighty railroads that brought growth and prosperity to the new town have been vacated.

But the number of residences continues to grow with new additions of Apple Tree Grove, Crawford, and Hickory Grove. The community has added another church, expanded two of its churches, added the Arlington Manor senior apartments, Orchards of Arlington assisted living, a physical therapy center, a new doctor's office, a new town hall/fire station, a new pool, a water treatment system, and an emergency medical service, enlarged the park with more soccer fields and ball diamonds, and put on an addition to the school. And although the town no longer has its summer homecoming to bring the community together, large numbers of Arlingtonians gather at the school or park for sporting events. They visit one another at church and chat at the grocery store or post office. It is still a small community that knows its neighbors and a great place to live.

SESQUICENTENNIAL PARADE, 1984. The committee of Larry and Rindy Crates, Junior and Annette Weihrauch, and Dick and Shirley Match worked to organize a grand celebration for Arlington's sesquicentennial. A history book was published, and there were pioneer day activities, food, and a parade featuring floats, bands, and antique machinery. Pulling the old fire truck are, from left to right, Larry Evans, Dean Mengert, Jim Wehrle, Jody Weidman, Terry Huffman, and Bob Elsea. (Photograph by Leslie Lazenby-Hunsberger.)

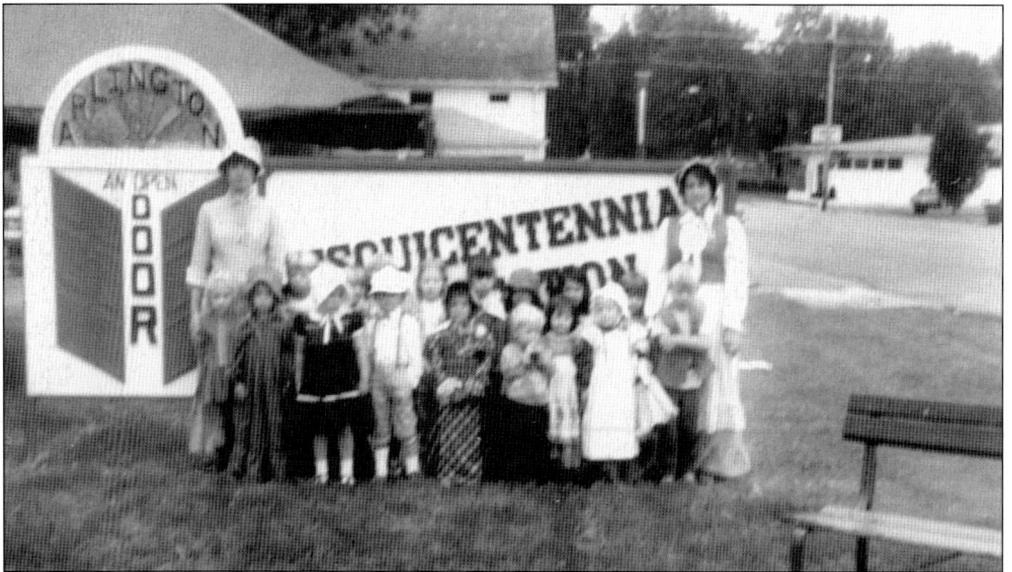

"ARLINGTON, AN OPEN DOOR," SEPTEMBER 14–16, 1984. This sign was posted on lot 4 after Stella's was torn down. Bright Beginnings preschoolers include, from left to right, (first row) Bethany Bell, Carrie Thomas, Andy Heacock, Sara Businger, Nathan Anderson, Cheryl Williams, Amie Davis, and Michael Heacock; (second row) unidentified, Greg Sanderson, unidentified, unidentified, Emily Biedelschies, Danielle Philips, Brittany Garman, unidentified, and Philip Hindall. The teachers are Deb Anderson, left, and Paulette Davis. (Courtesy of Deb Anderson.)

114

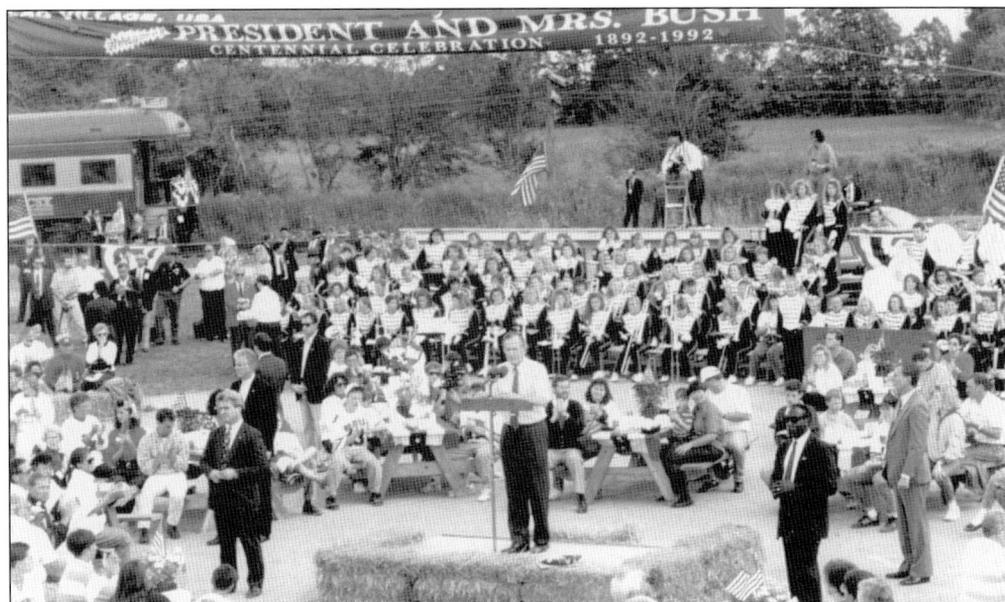

PRESIDENT BUSH VISIT, 1992. On September 26, 1992, Pres. George H. W. Bush came into town on a train campaigning for reelection. He arrived late on a hot day. A welcome sign greeted them, the school band played, and photographers and secret service men were everywhere. Box lunches were served, and he gave a speech standing on bales of straw. (Courtesy of Nancy Stearns.)

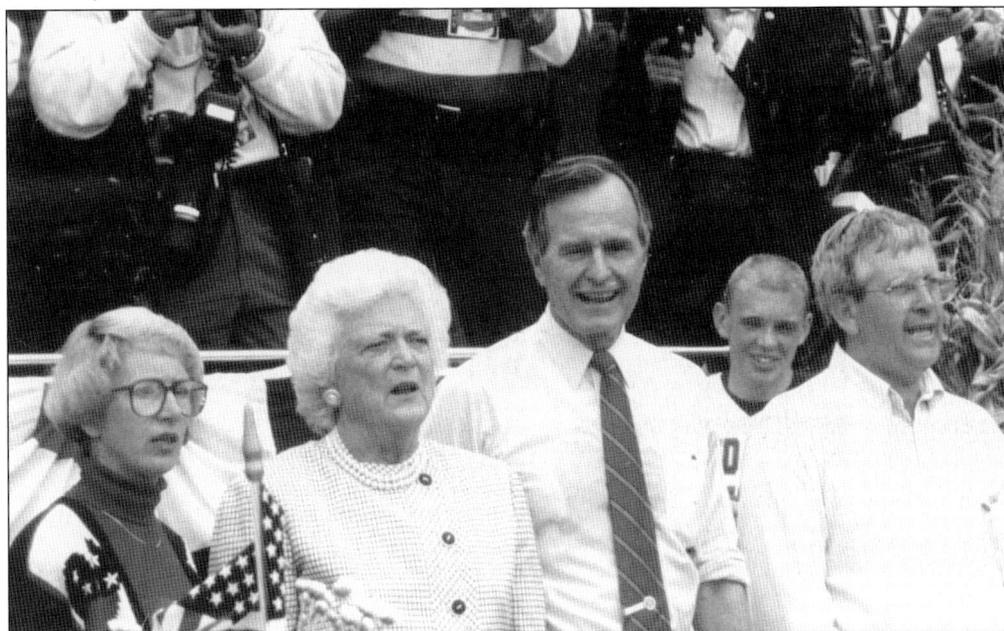

GEORGE AND BARBARA BUSH, 1992. With Arlington being strongly Republican, President Bush was warmly received, and excitement was at a feverish pitch in preparation for his visit. He shook hands, kissed babies, gave a few autographs, and made his way through the crowds. Pictured are, from left to right, Lori Suter, Barbara Bush, President Bush, and Mayor Dean Suter. (Courtesy of Dean Suter.)

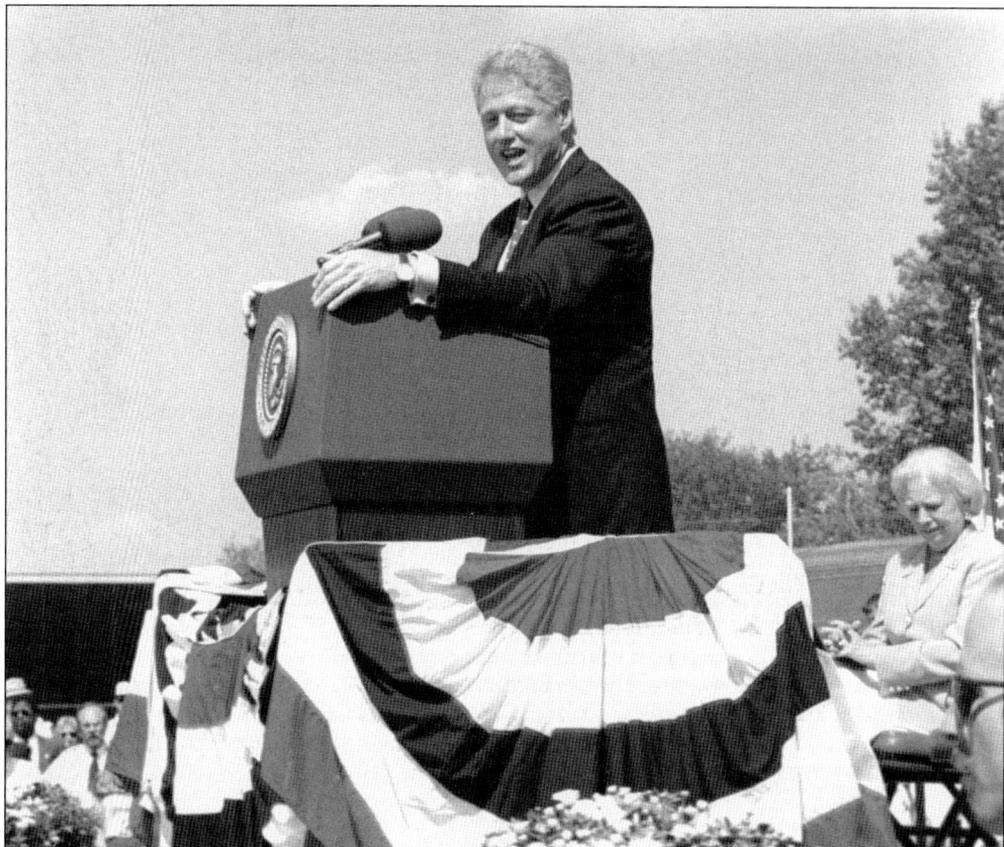

PRES. BILL CLINTON, 1996. On a very hot August 26, 1996, Pres. Bill Clinton arrived in Arlington Park by passenger train. He spoke and shook hands with the crowds along with his daughter, Chelsea. Many of those attending were from out of town and came with signs, which the locals were told was not allowed. (Courtesy of Paula Deter.)

ADMITTANCE TICKET, 1996. Four years after Pres. George H. W. Bush visited, Pres. Bill Clinton campaigned on the same route. The park provided an open area easy to secure, and all the wiring done in preparation for Bush's visit was still available, so Arlington was chosen for a second presidential visit. Clinton ate some of Terry's barbecue chicken and loved it! (Courtesy of Evelyn Steinman.)

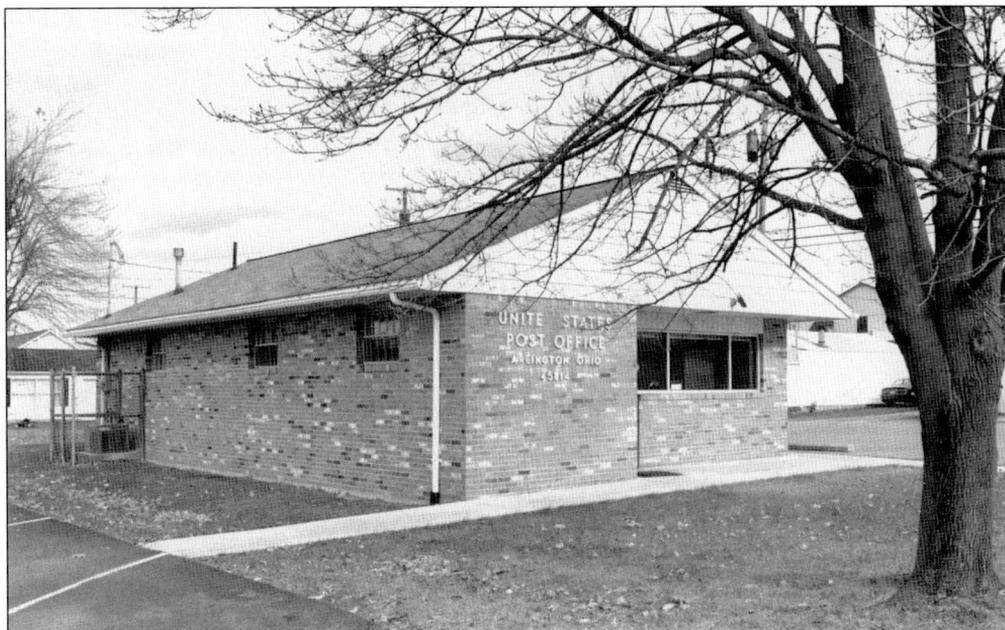

THE POST OFFICE, 2007. This post office was built in 1975 and is located at 120 West Liberty Street. It employs four people, and the postmaster is Doug Van Atta. Previous locations were on Main Street and Liberty Street. Changes in the last 25 years have been the self-stick stamps, computers, and electronic scales. A first-class postage stamp costs 41¢. (Photograph by Leslie Lazenby-Hunsberger.)

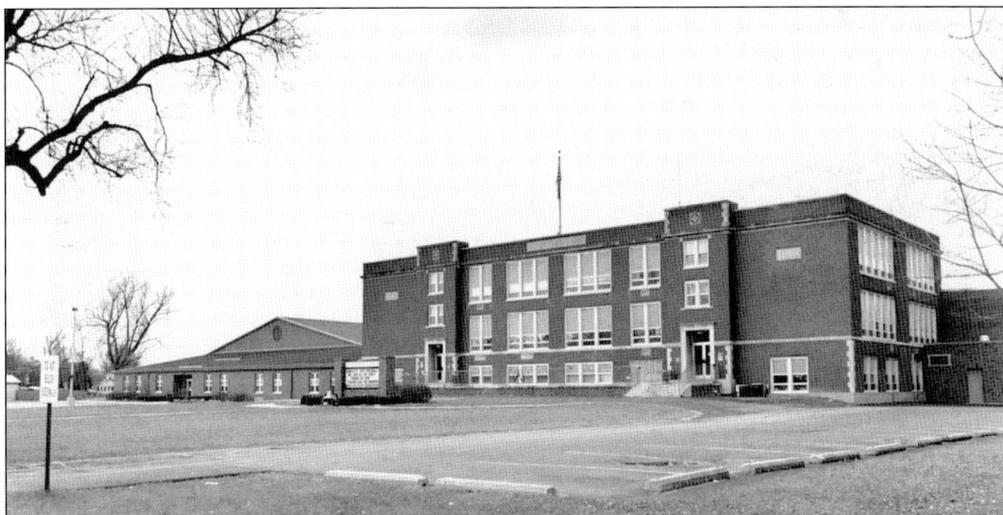

THE ARLINGTON SCHOOL, 2007. The school is located at 336 South Main Street. The fourth addition of a large gymnasium, second- and third-grade classrooms, restrooms, an elementary library, and locker rooms were added to the south side of the building in 1992. There are 323 high school students and 304 elementary students. There are 46 teachers and 81 total employees. (Photograph by Leslie Lazenby-Hunsberger.)

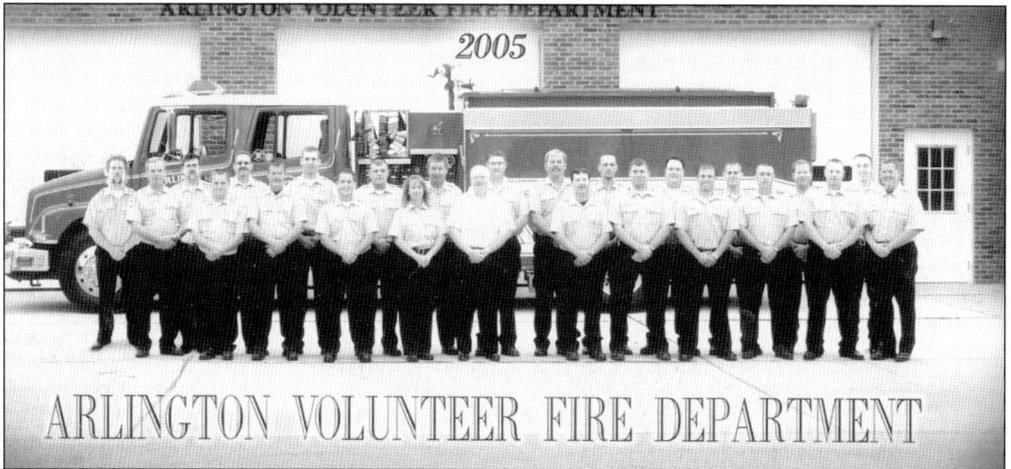

ARLINGTON FIRE DEPARTMENT, 2007. Firefighters must reside in the Arlington school district, be 18 years of age or older, and have a high school diploma. The fire chief is Al Latta, and there are 29 firemen. The fire station is located at 204 North Main Street. There is one tanker, one boat, two grass trucks, and two fire engines, the newest one costing $270,000. (Photograph by Leslie Lazenby-Hunsberger.)

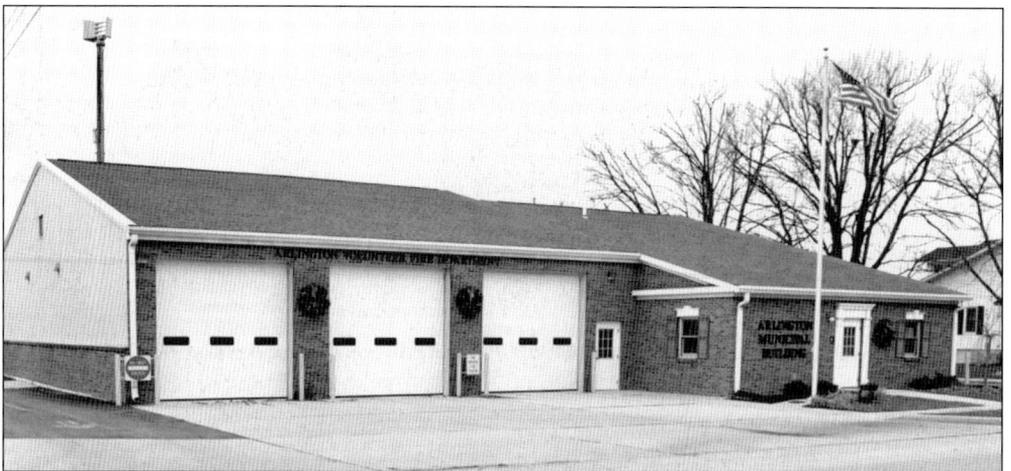

MUNICIPAL BUILDING, 2007. The new municipal building at 204 North Main Street was built in 1996. It contains a front lobby, clerk's office, map/storage room, restrooms, and council meeting room complete with a kitchen. In the fire department area is a garage for all the fire vehicles and a radio room and office. The three-bay fire garage has front and rear doors for six vehicles. (Photograph by Leslie Lazenby-Hunsberger.)

118

GOOD HOPE LUTHERAN CHURCH, 2007. The church is located at 300 South Main Street. The current pastor is Rev. Steve Ramsey. In 2001, a house to the south was torn down to build a parking lot and addition of Sunday school rooms and a multipurpose room. In 1989, the church added a 1913 organ in the sanctuary. (Photograph by Leslie Lazenby-Hunsberger.)

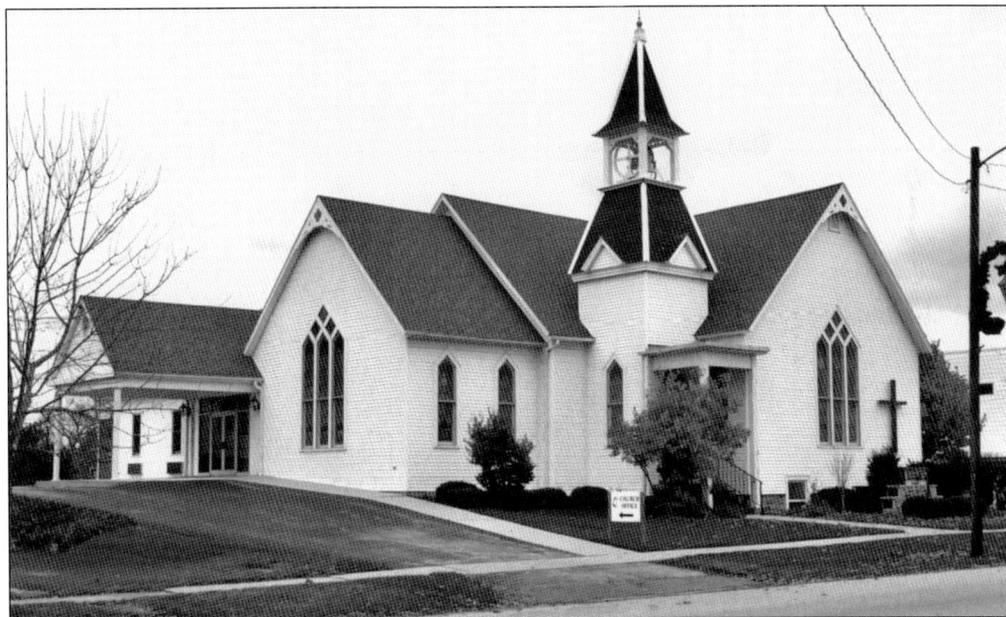

ARLINGTON UNITED METHODIST CHURCH, 2007. The church is located at 230 North Main Street. Harry W. Scott has been the pastor since 1998. In the last 25 years, the membership has grown to 470, and there are two services instead of one. In 1987, the sanctuary was expanded and a portico added. From 1975 to 1986, Donald Shaver was pastor, and from 1987 to 1998, it was Mark W. Rowland. (Photograph by Leslie Lazenby-Hunsberger.)

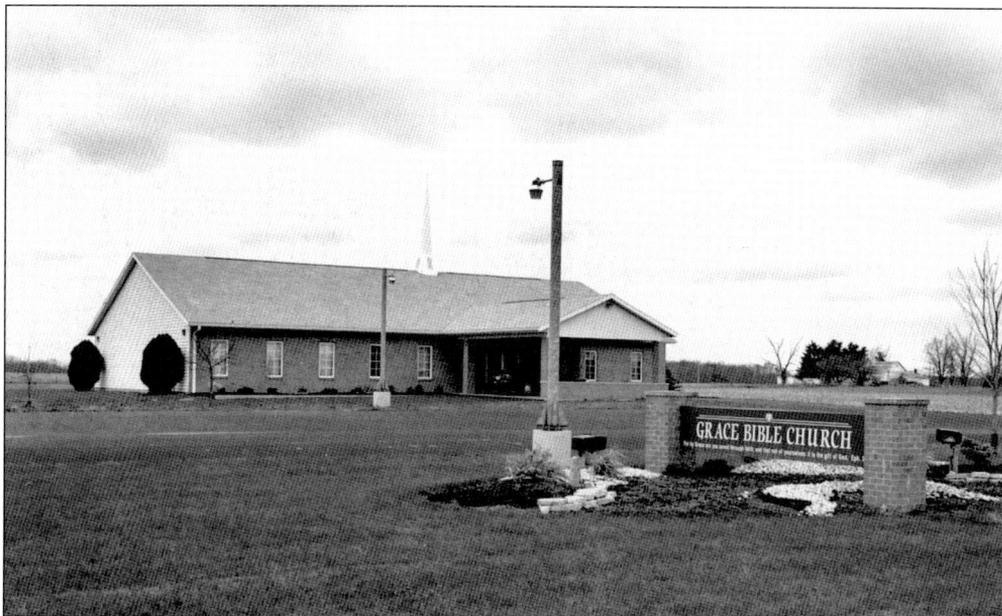

GRACE BIBLE CHURCH, 2007. Grace Bible Church started holding services in an empty building in 1989. Needing more space, it used the Arlington School music room for many years. In 1992, a church was built at 400 Powell Drive. It has grown from 40 members to 70 members. The current pastor is Rex August. Previous pastors were Harry Randolph, Glen Coats, Harold Rettig, and Tom Willow. (Photograph by Leslie Lazenby-Hunsberger.)

ARLINGTON EMERGENCY MEDICAL SERVICE, 2007. The new station was built in 1997 at 516 North Main Street. The Appleseed Joint Ambulance District began operation on January 1, 1982. The people on the new squad for 2007 are Denver Weihrauch, Lori Mills, Bob Elsea, Tom Ylhainen, Kate Westenhaver, and Todd Richards. (Photograph by Leslie Lazenby-Hunsberger.)

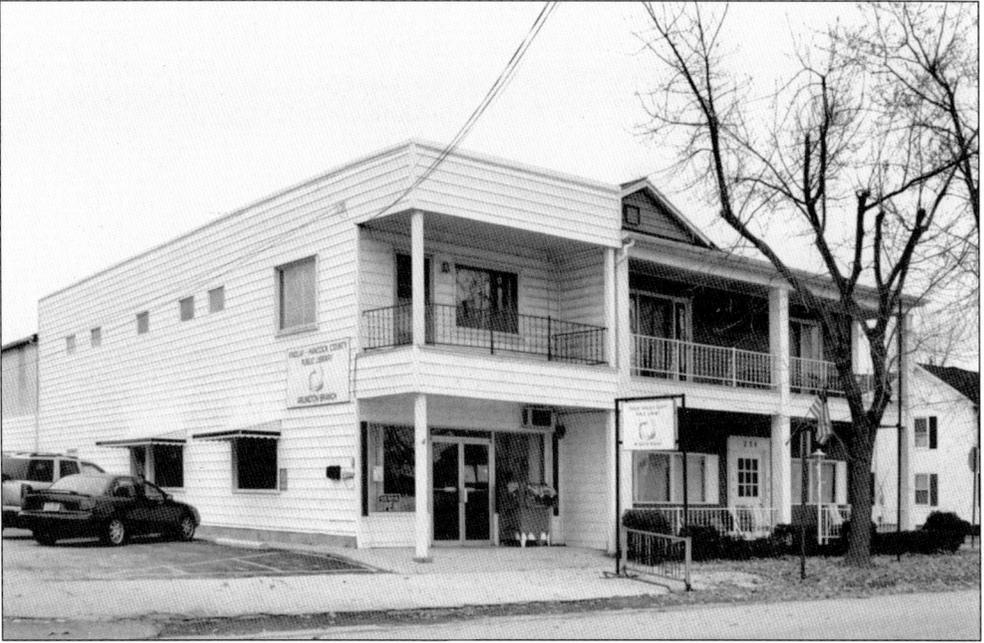

ARLINGTON LOCAL LIBRARY, 2007. This branch of the Findlay-Hancock Library is located at 232 North Main Street. The branch first opened in Arlington in 1985. Previous libraries were community run by the Arlington Community Center Club on North Main Street and the Dorney Building on East Liberty Street. (Photograph by Leslie Lazenby-Hunsberger.)

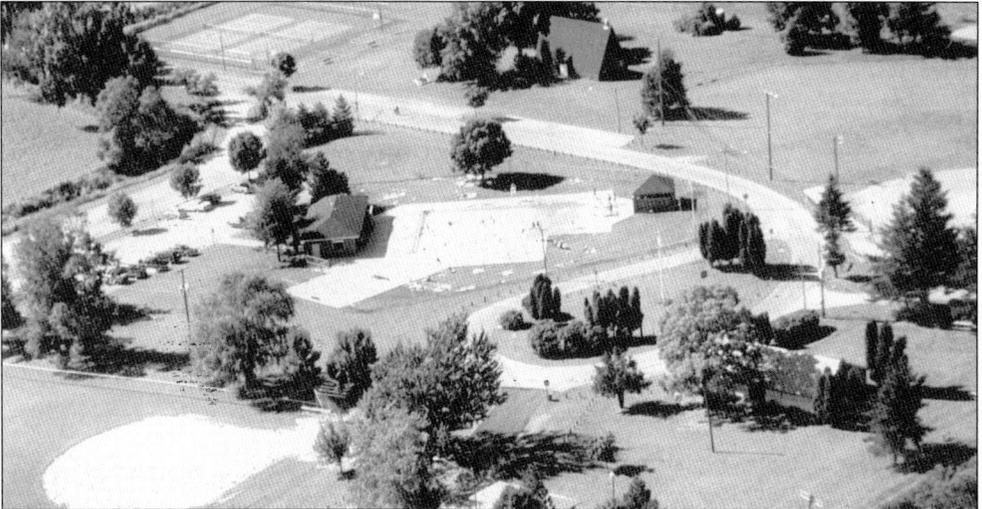

ARLINGTON POOL, 2007. Located in the Arlington Community Park, the original pool was replaced in 1994 at a cost $400,000 in grants. The pool holds 160,000 gallons of water and is made of stainless steel. There are wading and diving areas, and it is handicap accessible. The rates are $2 for a day pass, $60 for a single pass, and $95 for a family pass. (Photograph by Leslie Lazenby-Hunsberger.)

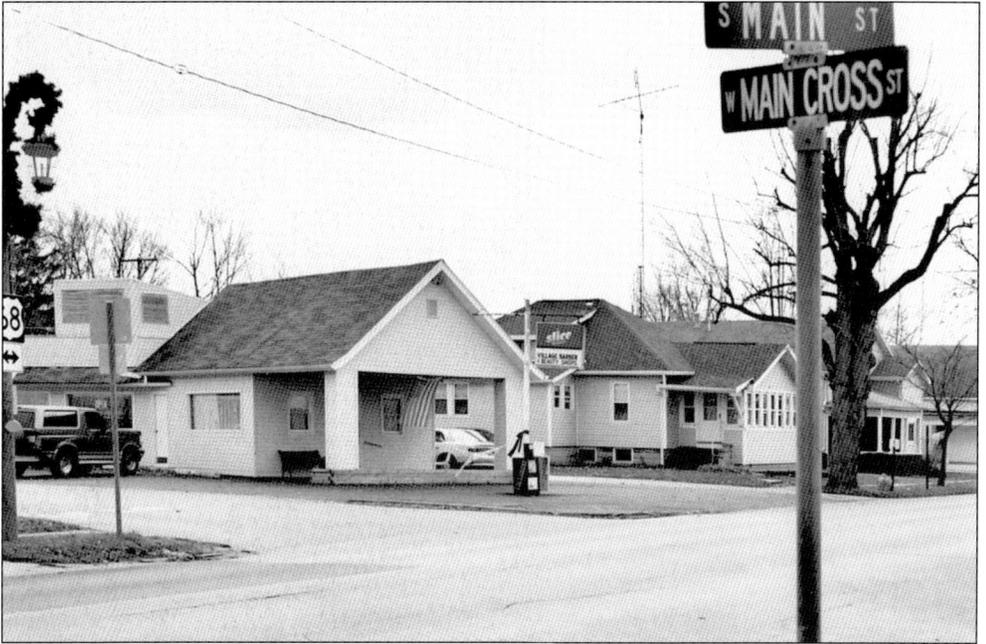

ARLINGTON VILLAGE BEAUTY AND BARBER SHOP, 2007. The shop is located at 201 South Main Street. There are two parts of the shop. Norma Reigle operates the beauty shop that faces Main Street while her husband, Dave, operates the barbershop, which faces Main Cross Street. It opened in 1976 at this location. (Photograph by Leslie Lazenby-Hunsberger.)

THE LIBATION STATION, 2007. The Libation Station is located at 100 South Main Street. It opened around 1986 and was the town's first drive-through/carryout. The owner/manager was Jeff Drummelsmith, but since 1999, Bill and Kim Kennedy have owned it. Their most popular sales are Pepsi, Mountain Dew in 20-ounce bottles, and lottery tickets. (Photograph by Leslie Lazenby-Hunsberger.)

ARLINGTON CAPE, 2007. In 1990, Keith Daniels began this wholesale business of cleaning and tanning hides. Roughly 1,000 pounds of skins a week are processed, and it takes five days from start to finish. He ships them out to taxidermists in the eastern United States. The most popular cape is the white-tailed deer. During the fall peak season, a half dozen people are employed. (Photograph by Deb Anderson.)

LOG CABIN, 2007. This cabin is located on East Liberty Street where the Arlington Methodist Protestant church was. The log cabin was discovered inside a building being torn down on West Sandusky Street, Findlay, in 1988 and moved to Arlington. The Eagle Creek Historical Organization owns the log cabin and has a 99-year lease on the land. (Photograph by Leslie Lazenby-Hunsberger.)

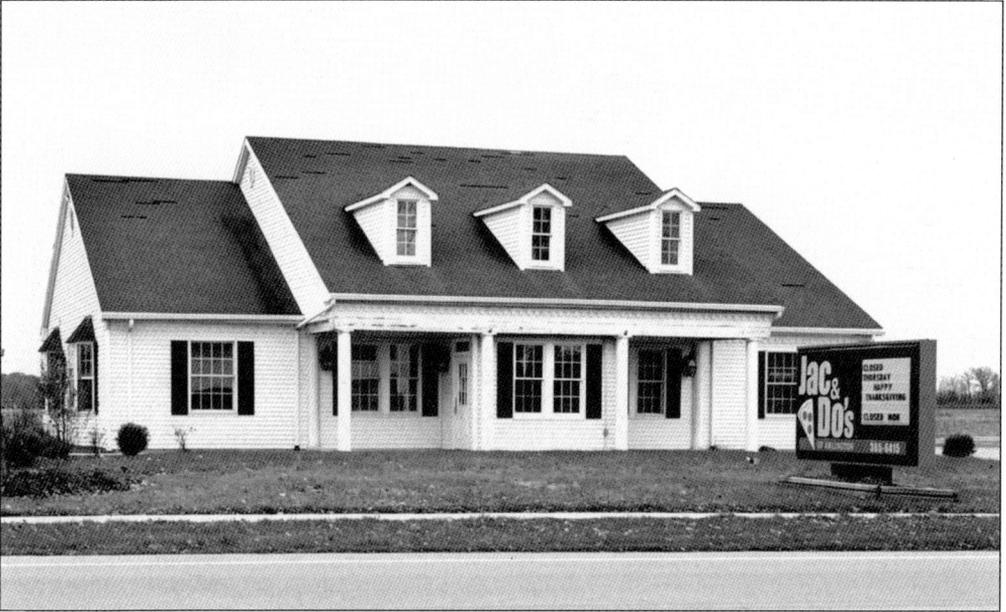

JAC AND DO'S, 2007. Jac and Do's is located at 631 North Main Street. The owner/manager is Rita Zaitoun. The business sells 75 to 100 pizzas a week. It was Nick's Family Restaurant from 1997 to 1999. Before that it was Clifton's Family Restaurant. Originally a group of investors built the Appleseed Restaurant after the original Appleseed bowling alley/restaurant burned. (Photograph by Leslie Lazenby-Hunsberger.)

THE FARMERS COMMISSION COMPANY, 2007. This grain elevator is located at 301 East Summer Street. Farmers bring in corn, soybeans, and wheat. The manager is Ben Warnbrod. The grain is shipped by train to Vermont, Maine, Florida, and Alabama. Previously it was called the Arlington Elevator and Supply Company, New Horizon Coop, New Generation Coop, and since March 2007, the Farmers Commission Company. (Photograph by Leslie Lazenby-Hunsberger.)

THE IGA, 2007. This IGA store, located at 400 North Main Street, was built in 1967. The business has 10,000 square feet but only uses 8,000 square feet for selling products. The bakery was added in 1996. In the 1970s–1986, Harlow Traucht was the owner. Since 1986, Larry Lovell has been the owner. It employs 25 people. The IGA is open 85 hours per week. (Courtesy of Leslie Lazenby-Hunsberger.)

HUNTINGTON BANK, 2007. This building was built in 1966 by the Farmers and Merchants Bank. In 1979, it merged with and became Mid-American Bank. It was also the Ohio Bank and then in 2001 Sky Bank. In 2007, it became Huntington Bank. The address is 100 North Main Street, and the bank has eight employees. The double drive-through was added in 1987. (Photograph by Leslie Lazenby-Hunsberger.)

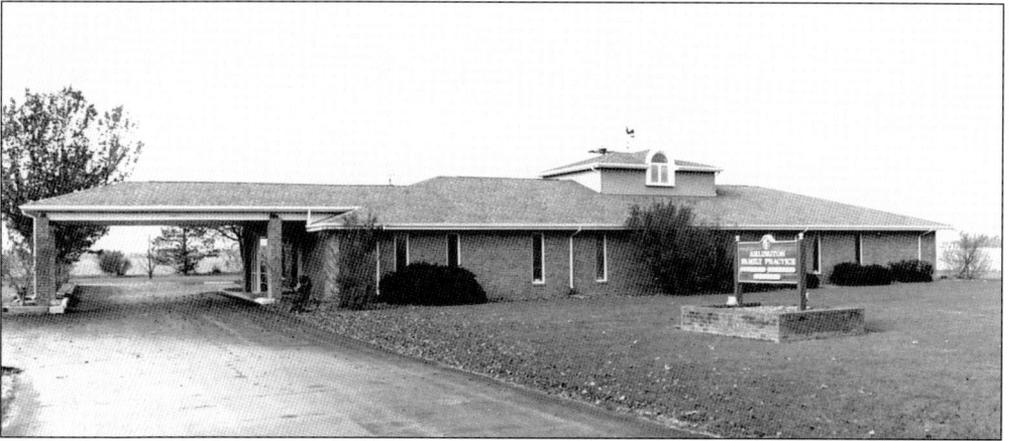

ARLINGTON FAMILY PRACTICE, 2007. The new Arlington Family Practice opened in August 1987 at 906 North Main Street. Dr. Mark Penn was the former town physician. Dr. Stephen Freshwater started the current office in 1987, and Dr. Michael Walton joined the practice in 1992. They also employ two LPNs and one X-ray technician. (Photograph by Leslie Lazenby-Hunsberger.)

ARLINGTON VETERINARY CLINIC, 2007. The small animal veterinary clinic of Jamie Rausch is located at 500 South Main Street. He took over the practice of Emily Walton in 1998. Walton's clinic served all animals from 1981 to 1987 and small animals from 1987 to 1998. Walton purchased the business from John Solt, whose family had the business for many years. (Photograph by Leslie Lazenby-Hunsberger.)

APPLESEED SERVICE CENTER, 2007. The British Petroleum station has been owned by Fred Borkosky since 1989. His business is located at 133 South Main Street. It sells about 9,000 gallons of gasoline per week. It can hold up to 24,000 gallons of gasoline in three storage tanks. The building was built in 1962. It was a SOHIO gas station until 1991. (Photograph by Leslie Lazenby-Hunsberger.)

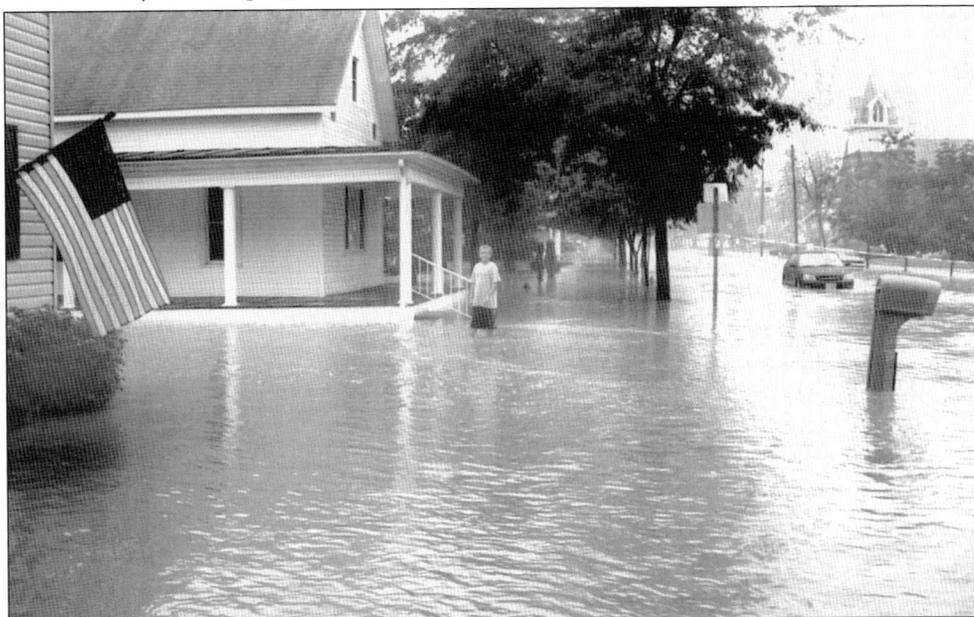

FLOOD, 2007. During the night, around nine inches of rain fell over the area, and residents awoke on August 20, 2007, to the largest flood in their memory. This picture was taken on Main Street at Main Cross Street facing south. Sixty residents were rescued by boat, and considerable monetary damage was incurred. The bridge at the south entrance to the park was destroyed. (Courtesy of Aleta Yates.)

ACROSS AMERICA, PEOPLE ARE DISCOVERING
SOMETHING WONDERFUL. THEIR HERITAGE.

Arcadia Publishing is the leading local history publisher in the United States. With more than 3,000 titles in print and hundreds of new titles released every year, Arcadia has extensive specialized experience chronicling the history of communities and celebrating America's hidden stories, bringing to life the people, places, and events from the past. To discover the history of other communities across the nation, please visit:

www.arcadiapublishing.com

Customized search tools allow you to find regional history books about the town where you grew up, the cities where your friends and family live, the town where your parents met, or even that retirement spot you've been dreaming about.